Symbols and Rebuses in Chinese Art

SYMBOLS AND REBUSES IN CHINESE ART

Figures, Bugs, Beasts, and Flowers

FANG JING PEI

TEN SPEED PRESS
Berkeley | Toronto

🔟

Ten Speed Press
PO Box 7123
Berkeley, California 94707
www.tenspeed.com

Distributed in Australia by Simon and Schuster Australia, in Canada by Ten Speed Press Canada, in New Zealand by Southern Publishers Group, in South Africa by Real Books, and in the United Kingdom and Europe by Airlift Book Company.

Cover design by Valerie Brewster, Scribe Typography
Text design by Betsy Stromberg

Library of Congress Cataloging-in-Publication Data
Fang, Jing Pei.
Symbols and rebuses in Chinese art : figures, bugs, beasts, and flowers / Fang Jing Pei.
 p. cm.
Includes bibliographical references and index.
ISBN 1-58008-551-2 (pbk.)
1. Art, Chinese—Dictionaries. 2. Symbolism in art—Dictionaries. 3. Signs and symbols—Dictionaries. I. Title.
N7340 .F36 2004
709'.51'03—dc21 2003010952

First printing, 2004
Printed in Hong Kong

1 2 3 4 5 6 7 8 9 10 — 08 07 06 05 04

To Winifred Yen Wood and Dr. Colin Johnstone.
Their vision, dedication, loyalty, and courage are
symbols of their inspirational character.

CHRONOLOGY

Neolithic	10th–early 1st millennium B.C.E.	
Shang Dynasty	c.1600–1050 B.C.E.	
Zhou Dynasty	1050–221 B.C.E.	
Qin Dynasty	221–206 B.C.E.	
Han Dynasty	206 B.C.E.–220 C.E.	
Western Han Dynasty	206 B.C.E.–8 C.E.	
Eastern Han Dynasty	25–220 C.E.	
Three Kingdoms	220–265 C.E.	
Jin Dynasty	265–420 C.E.	
Southern and Northern Dynasties	420–589 C.E.	
Sui Dynasty	581–618 C.E.	
Tang Dynasty	618–907 C.E.	
Five Dynasties	907–960 C.E.	
Liao Dynasty	907–1125 C.E.	
Song Dynasty	960–1279 C.E.	
Northern Song	960–1127 C.E.	
Southern Song	1127–1279 C.E.	
Xixia Dynasty	1038–1227 C.E.	
Jin Dynasty	1115–1234 C.E.	
Yuan Dynasty	1279–1368	
Ming Dynasty	1368–1644	
Hongwu	1368–1398	
Jianwen	1399–1402	
Yongle	1403–1424	
Hongxi	1425	
Xuande	1426–1435	
Zhengtong	1436–1449	
Jingtai	1450–1456	
Tianshun	1457–1464	
Chenghua	1465–1487	
Hongzhi	1488–1505	
Zhengde	1506–1521	
Jiajing	1522–1566	
Longqing	1567–1572	
Wanli	1573–1619	
Taichang	1620	
Tianqi	1621–1627	
Chongzhen	1628–1644	
Qing Dynasty	1644–1911	
Shunzhi	1644–1661	
Kangxi	1662–1722	
Yongzheng	1723–1735	
Qianlong	1736–1795	
Jiaqing	1796–1820	
Daoguang	1821–1850	
Xianfeng	1851–1861	
Tongzhi	1862–1874	
Guangxu	1875–1908	
Xuantong	1909–1911	
Republic Period	1911–1949	
Cultural Revolution	1949	

Contents

Acknowledgments

Many years ago I was privileged to know the collector and dealer Alice Boney, who was the doyenne of Chinese art. Among the many people that she introduced me to was Lawrence Sickman, the scholar and then-director of the Nelson Atkins Museum in Kansas City. As was her custom when entertaining, Miss Boney always first served tea or alcoholic beverages to her guests. Invariably the topic then turned to Chinese art, with which she and her guests were all consumed. I vividly remember that day when Lawrence Sickman first picked up Miss Boney's ashtray, respectfully chastising her for using a rare seventeenth-century Japanese porcelain for such use. He then picked up a seventeenth-/eighteenth-century carved bamboo figure of a lohan, a Buddhist who has attained nirvana (identified in this book as the Xianglong Lohan, who was surrounded by a dragon). What followed was a long discussion on who this figure represented and the fact that the knowledge of symbolism in Chinese was rapidly disappearing among collectors. As a psychiatrist, a profession where inquisitiveness and searching for origins are a part of one's necessary makeup, these comments spurred my interest in the symbolic meanings in Chinese art.

I wish to acknowledge the scholars who have included information on symbols and rebuses in Chinese art in their works, both here in the West as well as the many scholars in the East who freely gave of their time and knowledge. I would be

remiss not to mention Wang Pei Huan, the former director of the Shen Yang Palace Museum who is widely published in China but unknown in the West, for her willingness to freely share her wealth of knowledge. Although I never was privileged to meet C. A. S. Williams or Wilfram Eberhard, they were certainly smitten by this subject. They exhibited early interest and provided major contributions to the understanding of Chinese motifs in their respective books. To the many collectors and dealers who shared their ideas and questions as well as access to their private collections and photographic material, I am most grateful, for their generosity shows their true interest in Chinese art. To Jocelyn Chatterton, Amy Clague, H. Fabrega, Roger Keverne, J. J. Lally, A. Hengtrakul, Beverley Jackson, G. Croës, Chris Hall, Gerard Hawthorn, and those who wish to remain anonymous, I am thankful. Scholars and writers in fields other than Chinese art, such as the photographic critic and editor John August Wood, broadened my perspectives in my field of interest. I thank them. To Phil Wood of Ten Speed Press, I am grateful for his interest and friendship. Last but not least, to my friend and fellow writer Tou Lin Lin, my thanks for her input, suggestions, and invaluable assistance with Chinese translations.

Introduction

People seldom give much thought to symbols because they are so common. They are ever present—in all countries, societies, locations. They are simply an accepted mode of communication. *Webster's Dictionary* defines a symbol as "something that stands for or suggests something else by reason of relationship, association, convention or accidental but not intentional resemblance."[1] A symbol may be a depiction, object, word, or even a sound. It is a message that is knowingly conveyed between persons.

Symbols within a society are dynamic. As the society undergoes changes, so do the meaning of the symbols. In the various strata of an individual society, each may have symbols that are unique to that particular stratum. Like those of the larger society, these symbols and their meanings are also dynamic. Symbols date to the earliest times as one of the most basic forms of communication. In most societies, as the culture formed and the written language developed, symbols were replaced by words or phrases. While symbols continued to exist, their level of importance as a means of direct communication became greatly reduced.

In the Chinese culture, the evolution of symbols and their meanings took a slightly different and unique path. One of the reasons for this is that the Chinese language is tonal—the tone of voice used to express a syllable affects its meaning. Rather than the visual symbols being replaced by the written language, in China the symbols themselves evolved into the written language. The earliest symbols or

pictograms became the basis for the written character. In the Chinese culture, the early Neolithic peoples, who lived approximately 3000 B.C.E., painted pictures on their pottery that represented items from and actions in their daily lives. These depictions might be described as stylistic. Wavy lines frequently represented the waves of the sea or ripples on a river, and fishnets were represented by a series of perpendicular lines crossed by horizontal lines. Drawings of fish and animals were rudimentary, but certainly conveyed that they existed at that time.

From these depictions, the Chinese language itself developed. A simple drawing of a mountain developed into a written character meaning mountain. A simple stick drawing of a man developed into the character for man, and the like. In the course of time, these characters evolved into other characters in order to incorporate and communicate more complex meanings, ideas, and ultimately concepts. Combinations of basic characters formed meanings that were more elaborate. A most basic example, oversimplified to demonstrate this progression, is shown in the character for mountain, *shan,* which developed from a picture of a mountain. This character, when later combined with water, *shui,* forms *shanshui,* which becomes the word for landscape, in actuality a picture combining a mountain with a river. Another example that shows clearly the progression from a simple character to ones that are more complex is the word for wood, *mu.* The character for wood is a simplified shape of a tree. When two wood characters are placed together, it becomes the word for woods. When three are placed together to form a single character, one on top and two at the bottom, it becomes the word for forest.

As Chinese society became more complex, so did life itself. The natural progression led to increased complexity of thought, which the written language had to accommodate, while the foundation or building blocks remained the basic pictograms. What is constant within the vast borders of China is the written character. From province to province, various dialects are spoken with no consistency in verbal communication, each dialect basically a separate verbal language with no bridges from one to another. It is the written character that remains the same and is comprehended by all who are literate. (As Japan borrowed its written language from China, the same consistency extends to Japan.)

The verbal constructs of the Chinese language also contribute to the uniqueness of Chinese symbolism. Chinese is a tonal language. In the various Chinese dialects, as opposed to the written language where each character is meaning-specific, each verbal sound may have different meanings, depending upon the tone in which the sound is uttered. In Mandarin, for example, there are four specific tones. The same utterance or verbal sound in each of the four tones will give at least four different meanings. Additionally, some utterances in the same tone may have different meanings that can only be clarified by the context of the sentence. While

the characters are meaning-specific, two different characters may have the same sound and tone, thereby giving two entirely different meanings.

This unique feature of the Chinese language allows for what are known as "rebuses," or visual puns. As an example, the characters for happiness and bat are entirely different. However, the pronunciation for both words is exactly the same, both in tone and pronunciation. Symbols of bats were frequently depicted on porcelains expressing a rebus, a wish for happiness. When five bats are depicted, a slightly more complex rebus is imparted. Known as *wu fu,* it is a wish for one to be the recipient of the five happinesses of health, long life, riches, love of virtue, and death by natural causes.

In the course of time, symbols were impacted by influences other than language. Wars, folklore, religion, economics, disease, life expectancy, and environmental factors all played, and continue to play, important roles in the development of symbols in Chinese society and culture. This is particularly evident during times of political upheaval that produced highly dramatic changes in the society. These changes highlight the fact that the evolution of symbolic communication is dynamic and ongoing, as well as highly influenced by and reflective of the past. With the greater communication between all countries both physically and in terms of various media, what has developed in the present is a new symbolism, a more extensive one that further provides a global means of communication.

Other major factors have also affected or impacted the world of Chinese symbolism. First, the human ability to survive the challenges posed by habitat and climate has been a recurrent theme. Survival required food and protection against the elements. In order to provide themselves with food, the Chinese relied heavily on nature—water, the sun, and earth—to produce *fan,* the grains of rice and wheat on which they subsisted. Since these elements were beyond the control of humans, the Chinese imparted great significance to the being or creature who controlled these elements. This "being" was the dragon or fishlike creature that lived in the skies and controlled the rains needed for plant growth. The dragon was thought not only to control the rains but also all of the waters. Over time, these beliefs became increasingly more elaborate, evolving into the existence of four Dragon Kings—Ao Qin, Ao Jun, Ao Guang, and Ao Shun—each ruling a sea but living in the Crystal Palace. Even with the passage of time, when people no longer believed in the actual existence of the dragon, its symbolism carried over into other areas of importance, such as the scholar who was compared with the ao fish. As the ao fish had the ability to transform itself from a common fish and fly into the sky to become a full-fledged dragon, so did the scholar have the ability to transform himself from a humble student into an important court figure. Ultimately, the symbol of the all-powerful dragon was imparted to the emperor, the first of whom was said to have been fathered by a dragon.

Second, the theme of striving for power and status greatly influenced Chinese symbolism. As early as the Han dynasty (206 B.C.E.–220 C.E.) and continuing through the Qing dynasty (1644–1911) when it was abolished by the Dowager Empress Cixi in 1905, appointment of persons to the court or positions of state were limited to those who could pass the Civil Service Examination. This examination and recruitment system was highly influenced by Confucian philosophy, which stressed true merit rather than the appointments of those who simply possessed social status or privilege. The examination had the goal of appointing those whose values, intelligence, and sense of commitment could be predicted to enhance Chinese culture by dedicated service regardless of social standing. However, the requirements of rote memorization of Confucian classics achieved the exact opposite goal, and those who were able to achieve success in the examination, which required a least a decade of study, were monied families with prestige and privilege since others could not afford the time devoted simply to study. Even though attempts to reform the system were made in the Ming and Qing dynasties, the basic system remained in effect until the Empress Cixi was forced by leading Chinese intellectuals to abandon it. For the hundreds of years that the examination system was used, a widespread account, both popular and folk as well as literary and intellectual, existed that detailed the ordeal that it posed to scholars. This was a common theme of stories and anecdotes, which constituted a rich source of symbols. The theme of passing the examination and its promise as a ticket to a life of title and position was a dominant motif of this symbolic complex.

Third, the three great religions of China—Buddhism, Daoism, and Confucianism—each with its own diverse inventory of ideas, myths, rituals, and moral traditions added to the richness and complexity of Chinese culture, and yet another layer to the symbolism. It is remarkable that the three religions lived in harmony with one another and further borrowed elements from each another, while imparting their own symbolism to the culture.

In the case of Buddhism, which entered into China through travelers along the Silk Road from India, the symbols of Indian Buddhism underwent changes as the peoples of China adapted it for their own use. While most of the basic tenets were kept, nowhere is this adaptation more exemplified than in the case of the Goddess of Mercy, Avalokiteshvara, a symbol of purity that opposes all things evil. Once adapted into Chinese culture, she became a symbol of goodness to all Chinese, not just Buddhists. In another example, Shou Lao, one of the Star Gods, is distinctly Daoist in origin. While he remains the symbol of longevity, his adaptation has been so complete that he is no longer associated directly with any religion, but rather symbolizes a wish for a long life for all Chinese people. By the same token, while Confucianism typically includes symbols of wishes of a male child, in China this

wish is no longer associated with any distinct religion. The wishes for long life, male progeny, and filial piety, while each is colored or influenced by one of the three great religions, have been adopted into the folk stories of all the Chinese religions, and thus ultimately and symbolically incorporated into Chinese culture in general.

Fourth, while economics has not played an overt role in the symbolism of China, it has influenced symbolism more subtly. When an important resource was specific to a particular locality, the economy of that area likewise grew in importance, and with this importance came prosperity. With newfound prosperity, artisans and others would flock to the area to reap the benefits of the stronger economy. The attraction to and emotional resonance with this economic change found their way into folk stories of the resource's power and attributes; from these folk stories would grow symbols. An example of this is the *duan* stone (so named because the Duanxi River flows along the foot of Mount Fuke where the stone is mined), which was found and mined in Zhaoqing in Guangdong Province of Southern China. Owing to the *duan* stone's fine quality, great strength, ability to retain moisture, and fine-grained surface on which to grind ink, Guangdong became famous for it as early as the Tang dynasty (618–907 C.E.). The stone could not be found elsewhere, and with its fame, it became an important economic commodity. Since it brought prosperity to the area, qualities such as repelling evil were attributed to the stone. It also became a symbol of the scholar since all scholars used inkstones for writing.

After the fall of the Qing dynasty in 1911, there is little doubt that the Chinese gradually lost the knowledge of meanings ascribed to various symbols and rebuses that had previously been important parts of the culture and symbolic language. Creativity declined during this period, which particularly had an impact on rebuses. While a few of the most obvious symbols, such as the dragon and bat, retained their meanings, during the last quarter of the twentieth century, the majority of the population had no understanding at all of symbols or rebuses, viewing the designs simply as designs. The late great professor of Chinese studies and author of many books on Chinese art Schuyler Cammann stated: "After the Fall of the Ch'ing Empire, when unsettled conditions made it possible to seize power by force, without having to pass civil service examinations or win promotion by merit (or wealth), the symbols of aspiration became meaningless. The Chinese people, plagued by famines and civil wars as the result of the breakdown of central control, became cynical and lost faith in auspicious symbols in general. This explains why few modern Chinese can interpret the symbols on the dragon robes. The meanings of even the common ones are now almost completely forgotten in the land of their origin."[2] Cammann wrote these words in 1952, without having seen the effects of the Cultural Revolution on the coming generation. In retrospect he might have found additional factors contributing to the loss of symbolic understanding.

Fifth, as Cammann mentioned, in the late nineteenth and early twentieth century, China was plagued by a number of hardships. Famines were severe, and with the exploding population, there were starving masses and civil unrest. While not unaware of the civil unrest and problems of the land, the courts also faced the forced opening of trade with the West, trade that included commerce in opium, which was destructive to the Chinese people. During this period of time, while there was a marked decline in the quality of cultural items such as porcelains, paintings, and textiles, those same products were replete with the symbols of prior generations. It might even be said that, especially during the late nineteenth century, items were overdecorated with these symbols. This is particularly evident in folk textiles where one sees prolific use of symbols on hats, shoes, vests, and baby clothing. Even though the Civil Service Examination had lost its original importance and significance since court positions could be acquired through corruption and open purchase, the rebuses that dealt with a wish to attain a high position through passing this examination were repeated over and over. It was as if the symbols were endowed with a life of their own, now possessing a decorative value rather than the original intellectual, philosophical, and artistic dimensions originally intended.

Finally, it was the influence of the Communist government that ultimately would have the greatest impact upon the decline of the understanding of symbolism and rebuses. The dictums of Chairman Mao mandated that all that was old should be dispensed with. The use of symbols, rebuses, religious figures, and religions were all strictly forbidden. In one relatively short time span, one generation of a country, an extensive history was in essence lost. Folktales were not to be repeated. Symbols were replaced by the sayings of Chairman Mao. Dress of old was replaced by functional dress. Filial piety was dispensed with, and all those who held positions of influence and wealth were dispersed to the countryside. This single generation had no exposure to or teaching from the ancients. Likewise, the following generation was deprived of this knowledge as well.

In the late twentieth century, with the relaxation of the rigidity of the Communism of Chairman Mao and the opening of China to the West, attention turned to creating a new economy. No emphasis was placed on knowing or understanding historical China. This generation had no knowledge of its symbolic history. Not only was there no interest in this area, neither was there a substantial body of knowledge nor educated teachers to pass on China's cultural history. China had entered into a new symbolism, which some scholars call a "global symbolism." This global symbolism now included symbols influenced by those cultures and countries that have direct trade with China. And, while decorative motifs remain, with each decade, ancient symbols and rebuses are pushed further and further into the background of common knowledge.

These symbols and rebuses are a far cry from what Westerners think of as decorations. They had significant meaning and imparted a message that had origins in language, folklore, religion, and history. They were not simply decoration in the Western manner of providing a picture or ornamentation on an object. With few exceptions, even today a Western person views a flower on a piece of eighteenth-century imperial porcelain as "a rose is a rose is a rose." This book was written with the hope of providing a greater understanding of the symbols and rebuses that adorn the wares of pre–nineteenth century China; symbols that imparted meaning, an important factor in understanding Chinese art and history.

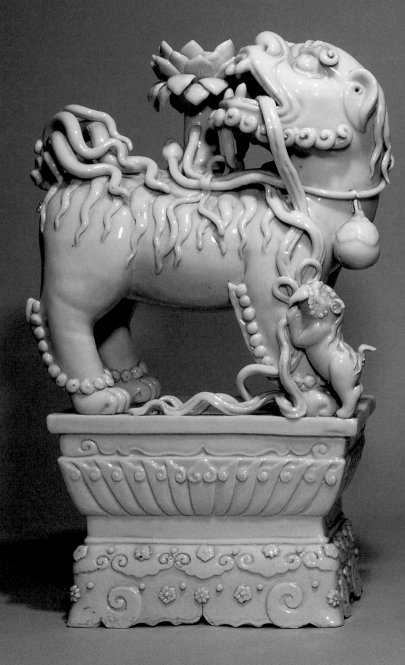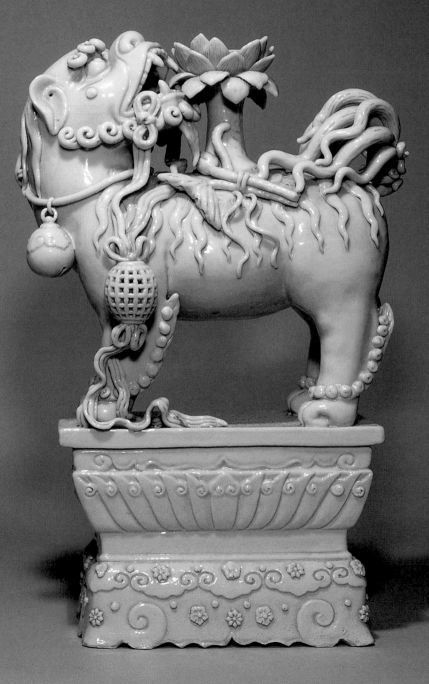

Symbols from
A to Z

Alarum Staff

A Buddhist attribute, a staff that is carried to ward off creatures (*see* Sistrum).

Alms Bowl

The bowl, representing his stomach, is one of the Eight Precious Things of the Buddha. The stone bowl of Buddha was said to have held great powers. Legend tells that near Orisa, two men came upon Buddha and offered him barley mixed with honey. But in keeping with an example set for the community of monks, the Buddha would accept only food that was offered in an alms bowl. Four Guardian Kings immediately offered Buddha four bowls made of precious stones, but Buddha refused these, for they were not appropriate to his teaching. The Four Guardian Kings then offered him four bowls made of common stone that Buddha accepted (*see* Lokapala). He piled these upon the other four bowls to form but one vessel, which was used to hold the offering of the two men. This one vessel symbolizes respectful offerings to others and came to be one of the Six Personal Things of a monk.

At the time of a Buddhist's entry into the priesthood, he is presented with four objects—staff, robe, alms bowl, and water container, each of which has symbolic meaning. The alms bowl, or begging bowl, symbolizes humility, which is an attribute both of Sakyamuni Buddha and Amida Buddha. In depictions of Sakyamuni Buddha, the bowl is held in one hand alone, while in depictions of Amida Buddha, it rests in both of his hands on his lap. The alms bowl is more commonly seen in Chinese statues and paintings.

A

B

 A Lohan holding an alms bowl.
Soapstone, eighteenth century,
2⅞ inches high.
Horacio Fabrega Jr. Collection.

 B Box of carved amber.
Liao dynasty (907–1125 C.E.),
4⅜ inches long.
Ji Zhen Zhai Collection.

Amber

Amber, *hu po,* is the fossilized resin of coniferous trees. Mentioned in Chinese literature as early as the Han dynasty (206 B.C.E.–220 C.E.), it is native to Southern China and was utilized first for medicinal purposes and later as a medium in Chinese art. Its symbolic meaning is that of courage and strength, derived from its name that translates as "the soul of the tiger." Chinese folklore maintains that when a tiger dies, its soul enters the ground and becomes amber. Medicinally amber takes its supposed benefits of giving strength and fortitude from the attributes of its name.

Many objects in Chinese art are carved from amber. In the earliest dynasties, beads were carved from amber and perhaps worn as amulets. In successive periods, small containers, small vessels, and religious articles, such as Buddhist rosaries, were constructed from amber. In the late Qing dynasty, figures were popular subjects and frequently other substances such as glass were made to imitate amber.

Amitabha

Amida Buddha, or Amitabha, the Buddha of Boundless Light, did not appear until the fourth or fifth century and is said to be derived from a sun god. He is depicted with his body rising from dark clouds or mist with rays of light streaming from his head. A popular Buddhist figure, he is said to preside over the Paradise of the West, the resting place for the souls of the pious.

In Chinese art, Amida Buddha appears primarily in the stone sculptures and paintings of the Sui and Tang dynasties. In the Qing dynasty, sculptures of the Amida Buddha are relatively rare.

Amphora

The amphora is the vessel that holds the water of purification and is one of the attributes held by Guanyin, the Buddhist diety of compassion and mercy (*see* Guanyin). A vase with a flaring rim and an elongated body that tapers toward the base, it is one of the shapes of the treasured peach bloom–glazed scholarly items of the Kangxi period.

Ananda

Ananda was the son of Buddha's stepmother. He was summoned by Buddha before Buddha attained nirvana and was told that if any person should ask "Where is God?" his answer should be "He is everywhere." Hearing this from Buddha, Ananda wept knowing that Buddha's passing was to be soon. Seeing Ananda's sorrow, Buddha stated, "Ananda, it was for realizing this blissful state that I had striven all these years. You are looking only at my earthly body. . . ."

Ananda became an *arhat* (*see* Lohan) and gained great fame for taking part in the compiling of the Buddhist canon as well as for being the favorite disciple of Buddha. Ananda plays a lesser role of importance in Chinese Buddhism than in Indian Buddhism.

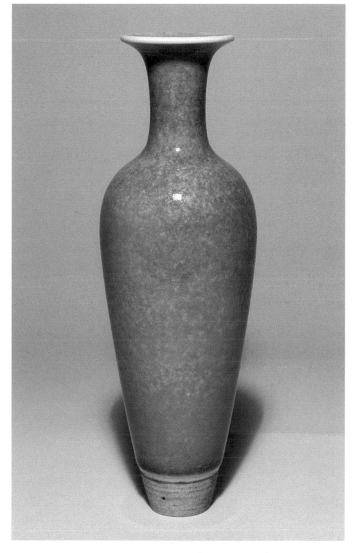

□ Amphora vase with peach-bloom glaze. Kangxi mark and period (1662–1722). Ji Zhen Zhai Collection.

Ancestral Tablet

The ancestral tablet, *zu xian pai wei,* is a symbol of filial piety. During the rite of ancestral worship, the names of one's ancestors are inscribed on the tablet. The soul of the individual is said to remain on this tablet, which is then placed on an altar dedicated to members of the family or clan. Tablets are arranged according to hierarchy. Not only are these tablets revered, but advice is also sought from deceased family members through them. Special ceremonies for worshiping the spirits of the deceased are celebrated at the Qing Ming Festival at the end of the second moon. On the fifteenth day of the seventh moon, a Buddhist worship ceremony, the Festival of Departed Spirits, is held for all the souls who have died that have no family member to worship their departed souls.

The legendary figure Shen, the second of the Three Legendary Rulers, is frequently associated with filial piety. In the narratives of the three trials of Shen, he refuses to punish his father, who held Shen in great disfavor, or his stepbrother even though they had tried to have him assassinated.

□ Woodblock of an ancestral tablet. Ji Zhen Zhai Collection.

Animal Kingdom

The animal kingdom in Chinese culture is divided into five major classes following the Chinese philosophic custom of classifying objects into numbered categories.

The divisions were separated into the naked beasts, man; the feathered, represented by the phoenix; scaly creatures, represented by the dragon; those with shells, represented by the tortoise; and fur creatures, represented by the qilin. The representative creature in each of the categories holds particular significance in Chinese culture. The use of five categories also follows the philosophic importance emphasizing the number five—the five elements, five noxious creatures, the fifth day of the fifth month being a significant day to ride one of poisonous creatures, and so on.

Ant

The ant draws its symbolic meaning from its physical stature. Tiny in size but accomplished in its efforts by sheer numbers and determination, the ant is the symbol of virtue, determination, and dedication. As a symbol, it is seldom utilized as a design element.

Ao Fish

The ao fish is a mythological fish. Its origin is recorded in the classic Han dynasty book on mythological fables, *The Book of Mountains and Seas (Shanhaijing).* Folklore claimed that seeing the ao fish in a dream the night before a scholar took the Civil Service Examination was a favorable sign. The word *ao* is related to the examination as well. The three top-scoring candidates had their names posted on the imperial bulletin board, *ao tou,* announcing their success.

There is a famous recorded folktale in which a scholar with the highest score on the examination was to be awarded the customary golden rose by the emperor. However, when the emperor saw the facial deformity of the scholar, he was repulsed by his appearance and refused to award him the rose. Instead, he awarded it to the second-place candidate. The deformed scholar was so distressed that he threw himself into the sea only to be rescued by a sea monster known as *ao.* The story says that the scholar went to heaven, inhabited a constellation, and became an arbiter of the destinies of men of letters. There are those who believe that scholar is Kuixing, the patron saint of scholars, also known as the God of Literature (*see* Kuixing).

A

B

Ape

(*see* Monkey)

Apple

The apple draws its symbolic meaning from the similar-sounding word, or homonym, for peace. The meanings of both words, apple and peace, *ping,* are distinguished only by their contextual use. Symbolically, the apple expresses a wish for peace and also expresses the beauty of the female. The apple blossom (wild apple blossom, *hai tang*) is but one of the many beautiful flowers that connote feminine beauty. Yang Gui fei, the celebrated, beautiful concubine of the Tang Emperor Ming Huang, was known as *hai tang nu.*

The rebus *yu tang fu gui*—formed by the combination of the wild apple, *hai tang,* and magnolia, *yu lan*—has the meaning of "may you be rich and honored" as *fu gui* translates to "prosperity and prestige." *Yu tang* is also the name for Jade Hall, which is synonymous with the Hanlin Academy, the scholarly academy of the Ming dynasty. Therefore, this phrase implies a wish for attainment of high rank in Jade Hall.

◻ A Celadon screen with biscuit design of ao fish. Ming dynasty, sixteenth century. Ji Zhen Zhai Collection.

◻ B Woodblock depicting an apple. Ji Zhen Zhai Collection.

It should be noted that the word for disease is also a homonym for the word *apple,* and therefore neither this fruit nor depictions of it are appropriate as presents for the sick.

Apricot

The apricot, *xing,* is the symbol of a beautiful woman. It is also the symbol of the second month. In Southern China, branches of the apricot tree are laden with this fruit *(bai guo)* and are called *bai guo zhi* meaning "a hundred apricot branches." A branch of apricot came to symbolize a wish for one to have a hundred sons.

All parts of the apricot and apricot tree have been utilized in Chinese herbal medicine and are listed in the earliest compendium of remedies.

Apsaras

Apsaras are known as Celestial Angels. They are the female angels of Buddhism and live in Sukhavati, Amitabha's Paradise. They are most often depicted as floating in the air with long garments streaming behind them. In sculptures, they often surround the head of the Bodhisattva. Sometimes they are depicted playing or carrying lutes or flutes and holding lotus flowers. When Buddhism was adopted into the Chinese culture, apsaras, an Indian term, were known as *Tien ren,* who wore scarves of five colors blowing in the wind, five being an auspicious Chinese number.

Apsaras are most frequently seen in the stone sculptures and paintings of the Sui and Tang dynasties. Apsaras only infrequently appear in art of the Qing dynasty; however, the famed contemporary artist Zhang Daqian (1899–1983) studied the Mogao cave paintings at Dunhuang from 1942 to 1944 and, inspired by the murals, created many paintings using apsaras as the subject matter.

Arhat

(*see* Lohan)

Arrow

The arrow is a symbol for unity. This symbolism is illustrated by the old Chinese folktale in which a father gives an arrow to each of his sons and tells him to break it, which each easily does. He then gives each son several arrows that are bound together and asks each to break the arrows. None can break them. The father then explains that a group of arrows is a symbol of strength in unity.

The arrow and bow are attributes in Buddhism. They symbolize weapons against evil. However, these attributes were never fully incorporated into Buddhism in China and are seldom seen in Chinese art.

Artemisia Leaf

The artemisia leaf is one of the Eight Ordinary Symbols, the others being the dragon pearl, golden coin, lozenge, mirror, stone chime, books, and rhinoceros horns. It is documented that in 1759, the emperor issued laws specifically prescribing the design elements that were to be included on the dragon robes that were required court attire. The dragon robes worn by those below the emperor were to include the Eight Precious Things. This group evolved into the Eight Ordinary Symbols, which in the passing of time became a decorative group of symbols. One of these symbols was the artemisia leaf, which symbolized the driving away of evil.

The symbolism of the artemisia leaf evolved from the story of Hung Huang, a rebel who captured the city of Chang an and gave orders to his generals to slay all the inhabitants of the city except those whose doors were hung with a wreath of artemisia leaves, a sign that they were to be spared. Hence, the artemisia leaf kept evil from their doors.

As part of a decorative motif, artemisia leaves are usually seen with the total group of Eight Ordinary Symbols (or some combination thereof) on porcelains, cinnabar lacquer objects, and folk textiles, but the noted scholar Schuyler Cammann commented, "[I have] never seen this [referring to the artemisia leaf] used on a dragon robe."[1]

Ash

Ash, *hui,* symbolizes riches and also is believed to have the physical ability to drive away evil spirits.

Ash and soot were the main ingredients for ink sticks. They were combined with sticky rice paste, pine resin, and substances to repel insects, forming a mixture that was then placed in molds to form cakes of various shapes. These cakes were allowed to dry and were frequently decorated. When combined with water, ink sticks and cakes formed natural ink. Ink and ink cakes symbolize the repelling of evil spirits and are prized by scholars as one of the Four Treasures of the Scholar. Ink symbolizes the strength of the written word.

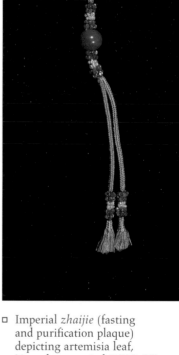

□ Imperial *zhaijie* (fasting and purification plaque) depicting artemisia leaf, Yongzheng period (1723–35). Ji Zhen Zhai Collection.

Aubergine (Eggplant)

The Chinese eggplant, *qiezi,* is a long, rounded vegetable that is said to resemble the shape of the face with a stem end that resembles a cap. This resemblance to a cap on the top of a head came to symbolize an official wearing his formal head-dress. When depicted in paintings, eggplant symbolically expresses a wish for one to attain an official position. A painting of eggplant was therefore an auspicious gift to a scholar.

It should be noted that the eggplant in contemporary China takes on an entirely different, and derogatory, meaning. Eggplant is slang for "penis."

Auspicious Animals

The tradition of using auspicious animals, real or mythological, as an expression of good luck has a long history in Chinese culture. These auspicious animals are called *rui shou* and are portrayed both in painting and sculpture. Many can be seen in the classic book on mythological fables, *Shanhaijing (The Book of Mountains and Seas),*[2] compiled during the early Han dynasty. This book, a compendium of Chinese mythology, contained many chapters; only fourteen of them survive today. *Rui shou* take on highly interesting shapes and forms, perhaps portraying combinations of features of various animals that might express the whims of an artist or convey a special message.

Avalokiteshvara

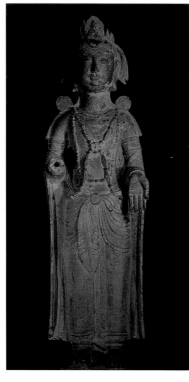

□ Sandstone sculpture of Avalokiteshvara. Tang dynasty (618–907 C.E.). Collection Anunt Hengtrakul.

Avalokiteshvara is a bodhisattva, a future buddha, whose essence is that of enlightenment. He is also known as the lord who looks down and is sometimes known as Padmapani. The outstanding feature of Avalokiteshvara is compassion. The concept of bodhisattvas is especially important in Mahayana Buddhism.

Depictions of Avalokiteshvara in Chinese art undergo a considerable change from the earliest period when Buddhism entered China in the Han dynasty to the Qing dynasty. While male in form during the early period, during the Qing dynasty, Avalokiteshvara takes a distinctly Chinese form of a female (*see* Guanyin).

Axe

The axe, or *fu* (same sound as the words for bat and happiness but with a different tone), has many symbolic meanings in Chinese culture, each being slightly different but all relating to the fact that the axe is a weapon.

The axe is one of the Twelve Symbols of the Emperor. The twelve symbols collectively represent the emperor and are said to have their origin with the mythical Emperor Huang Di. However, there is no definitive proof to substantiate this as fact. What is known from ancient documentation is that these twelve symbols appeared on the imperial sacrificial robes in the Han dynasty and in successive Chinese dynasties. During the Ming and Qing dynasties, these twelve symbols appeared on less formal as well as formal robes. As one of the twelve symbols, the axe symbolized a sacrificial weapon, the emperor's power, and the ability to punish.

The axe is one of the attributes in Buddhism. The axe is said to symbolize the removal or destroying of evil, which might conflict with Buddha's law or doctrine. As a folk symbol, the axe is a symbol of intermediaries.

The axe is also an emblem of the God of Carpenters, Lu Ban, a figure who lived about the time of Confucius. There are many folktales about this legendary figure, but one of the most popular is one in which the men of Wu killed Lu Ban's father. As a result of this and in an act of filial piety, he carved an effigy figure out of wood with its arm pointing toward the State of Wu. A great drought came to the State of Wu that lasted until its inhabitants came and begged Lu Ban to remove the figure. After consideration and payment for retribution for the death of his father, he chopped off the pointing hand of the figure. As the pointed hand fell, so did the drops of rain, ending the great drought.

Depictions of the axe, other than as one of the twelve symbols appearing on imperial robes, usually take the form of a weapon held by warriors, symbolizing power. During the Ming and Qing dynasties, sculptures of warriors and guardians are frequently depicted with an axe in hand. *Famille verte* porcelains—an enamel palette developed in the seventeenth century with predominantly green colors—are commonly painted with decorations of warriors with axes. The physical appearance of the axe varied from period to period. While not a hard and fast rule, during the Ming dynasty, it was depicted with part of the handle showing while during the Qing dynasty, it is depicted as a simple blade.

◻ Axe, detail from twelve-symbol imperial robe. Eighteenth century. Linda Wrigglesworth, Ltd.

Azalea

The azalea in Chinese is *du juan hua,* meaning "cuckoo flower." The naming of the flower comes from its brilliant red color, as it is said that the cuckoo bird sings until its throat is bloody. This flower symbolizes feminine beauty and is depicted on porcelains of the Qing dynasty.

The azalea is also a medicinal herb, in spite of the fact that it is poisonous. Its medicinal use is based on the theory of counteracting one poison with another. It is primarily utilized in paralysis and strokes in traditional Chinese herbal medicine.

Badger

The badger, *huan,* symbolizes happiness. This comes from the fact that *huan* also has the same sound as the word meaning to be happy.

The badger is usually depicted with the magpie, rarely alone. When a badger is depicted with a magpie flying, it conveys a wish for happiness, both on earth and in heaven. If the magpie is perched on a branch when shown with the badger, the depiction expresses a wish for happiness in one's future.

Bamboo

Bamboo, *zhu,* has the same sound as the word for wish, and thereby attains its symbolism and use as a pun.

Bamboo is a plant that has been associated with China throughout its long history. It plays an important part in the lives of the Chinese not only in artistic areas such as carving, sculpture, musical instruments, and writing implements, but also is utilized in food, furniture, and utensils, as well as a tool in and of itself. It encompasses every phase of Chinese life and knows no class distinction. With its great importance, it has much symbolic meaning, as well as being the subject of folklore. Bamboo symbolizes humility, endurance, righteousness, flexibility, dignity, and gracefulness—all qualities that the scholar strives to emulate. This is reflected in the Chinese saying, "The hollow interior section [humility] of a bamboo tree is the guidance [teacher] of a person." Bamboo as the symbol for a learned scholar with dignity and righteousness is shown in the proverb honoring a scholar, *zhu jie xu xin shi wo shi,* which translates to the scholar being as cheerful as bamboo in the wind. It refers to the scholar not only being as graceful as the swaying bamboo, but his integrity also being as strong as the stalks of bamboo. The bamboo sections are said to represent the steps to higher knowledge. Bamboo is also an attribute of the Goddess of Mercy.

Bamboo is one of the Three Friends of Winter, the others being prunus and pine. The triad symbolizes endurance by its ability to live throughout the harsh winter. The Three Friends of Winter occur repeatedly in Chinese art through the centuries.

Bamboo together with prunus represents the unity of a husband and wife. When one pictures one's parents or the elderly with a picture of bamboo and prunus, *zhu mei* (bamboo, prunus) *shuang xi* (double happiness), the combination represents marital bliss.

In folk art, children setting off fireworks symbolize a wish for peace, *zhu bao* (announce) *ping an* (peace). This symbolism arises from the fact that bamboo at one time was utilized to construct fireworks, whose sound was said to drive off evil

spirits. "Bamboo" and "to wish" are homonyms, *zhu,* and the words for "to explode" and "announce" are homonyms, *bao.*

Bamboo is formed by a series of joints between nodes called *jie. Jie* is also a homonym for integrity, which bamboo also symbolizes.

There are many species of bamboo. Spotted bamboo is highly prized for its markings and is associated with the folk tale of Da Shun, a paragon of filial piety and successor to the legendary Emperor Yao. Da Shun, a son of a blind father who remarried and had another son by his second wife, was treated with great cruelty by both parents. In spite of their cruelty, he continued to honor them while they continued to bring him great harm, including burning his home to the ground. Emperor Yao heard of Da Shun's great devotion in spite of his parents' cruelty and rewarded him by giving to him

□ Bamboo libation cup
with bamboo design.
Seventeenth/eighteenth century.
Ji Zhen Zhai Collection.

his two daughters in marriage as well as making him heir apparent when he was only twenty years of age. Throughout Da Shun's long life—he attained the age of one hundred and nine—he was revered and honored. It is said that, at his death, the tears of devotion of his wives fell onto bamboo, causing it to spot, and such was the beginning of spotted bamboo.

One of the classical twenty-four folktales that demonstrate filial piety involves bamboo. In this famous tale, a mother who is deathly ill longs for soup with bamboo shoots in the midst of winter. As the ground is so frozen, her son is unable to fulfill her wish and in his despair cries so copiously that his tears fall to the ground like the rains of spring. His tears warmed the ground and the nourishing shoots of bamboo sprang forth enabling him to fulfill his mother's desire.

Banana Leaf

□ Chinese painting, "Studio in the Banana Grove," by Qi Baishi (1864–1957). Former Alice Boney Collection; Ji Zhen Zhai Collection.

The banana leaf is one of the Fourteen Precious Objects of the Scholar. It is also one of the vehicles of Damo, the first patriarch of Chan Buddhism. An important Buddhist figure, he is said to have carried the teachings of Buddha from India to China. Folklore records that he eventually traveled to the Shaolin Monastery where he meditated and founded Shaolin kung fu. The Shaolin Monastery remains in existence today and tales of Damo abound. In Chinese sculptures and painting, Damo is frequently shown standing on a banana leaf that carried him over the waters.

In Ming and transitional porcelains (those made between the end of the Ming and the early Qing dynasty), banana leaves not only occur as part of the subject matter but also are utilized as a stylized border pattern. A favored subject in Chinese painting is scholars in the banana grove. The fruit is rarely depicted in Chinese art, except in the realistic carved ivory models of the Republic period (1911–49).

Bapo

Bapo is a type of painting, unique to the later Qing dynasty, that in Western art would be considered trompe l'oeil. *Bapo* refers to "the eight brokens," or *jinhuidui,* piles of broken ashes. It consists of various bits of calligraphy, painting, and the like, uniquely depicted on paper or porcelain in a collage format.

It is said that the broken or partial pieces of painting, calligraphy, and objects symbolically represent the disintegrating antiques and society and the disruption of culture of the late nineteenth century. *Bapo* does not appear after the fall of the Qing dynasty and appears to be unique to the nineteenth and early twentieth century.

Bat

The bat, often looked upon as a nasty, frightening rodentlike creature in the West, is a symbol for happiness to the Chinese. It is the most well known of symbols, owing to its pronunciation. The words for bat and happiness have the same sound, *fu.* And so, the depiction of the bat in Chinese art takes on special significance. Not only does it have a symbolic meaning when pictured alone, but it has other meanings when depicted in various forms:

□ **Bats with clouds:** *hong fu qi tian,* a wish for vast happiness to the heavens.

□ **Bat with coins:** *fu dao yan qian,* a wish for happiness to arise before one's eyes.

A Embroidery detail of bat with peaches. Nineteenth century. Jocelyn Chatterton Collection.

B Five bats design. Detail from silk embroidery chair cover, Qianlong period (1736–95). Ji Zhen Zhai Collection.

- Bat with peaches: *fu shou shuang quan*, a wish for happiness and a long life.

- Bat with a musical stone (*see* Musical Stone) in its mouth: *fu qing*, a play on words meaning happiness and good fortune.

- Bat with two catfish suspended from a chain together with a *ruyi* (*see* Ruyi) and lotus: "For ten thousand years may one have continued happiness," from the saying *wan nian lian fu*.

- Bats depicted upside down: *fu dao*, "Happiness has arrived."

- Red bat: *hong fu*. The word for red, *hong*, has the same sound as the word for enormous. A red bat brings the wish for enormous or great happiness.

- Two bats colored red or on a red background: "Vast happiness extended to the heavens" from the phrase *hong fu qi tian*, meaning "red bats attaining the sky"

- Two bats: *shuang fu*, a wish for double good fortune

- Five bats: *wu fu*, the wish for the Five Blessings of health, long life, riches, love of virtue, and death by natural causes.

- Five bats with a *shou* (*see* Shou) character: *wu fu peng shou*, the wish for the Five Blessings with an emphasis on longevity.

- Five bats depicted being captured: "May every sort of joy be retained by you."

- Five bats with a box: *wu fu he he*, the wish that one might have a harmonious life with the Five Blessings.

The bat in its many forms is arguably the most frequently used symbol in every medium in Chinese art. When utilized on porcelains of the Qing dynasty, it is seen both as a primary decorative motif as well as a background or secondary motif. In Mandarin court robes, however, it does not appear until the Qianlong period. It should be noted that the bat is has also been utilized in Chinese medicine for centuries.

Bathing

Bathing, *xizao,* is a symbol for purifying or cleansing one's inner self. In Chinese art, it does not represent eroticism. To bathe before the marriage ceremony, a customary act, represents a cleansing of oneself and making oneself pure. Bathing also has symbolic meaning in Buddhism, as on the eighth day of the twelfth month, Prince Gautama became Buddha. On this day, Buddhist temples are cleansed, symbolizing the washing away of evil.

Bean

The flowers of the bean pod, commonly called snow peas, *dao dou,* are a delicate light pink in color. When the pods appear, they are long and in the shape of a butcher's knife, from which the name comes. The first part of the name, *dao,* is a homophone for *dao,* to attain. Hence, carvings of this bean are an auspicious gift meaning a wish for one to advance one's career. Carvings and paintings of the bean were popular during the Qing dynasty.

Bean Curd

Bean curd, *dou fu,* is a staple food derived from soybeans. Its white color is a symbol of purity. It is auspicious to give bean curd in its dry form, *dou gan,* which is a wish for one to rise to be an official, *da guan.* This symbolism is based on these close-sounding words.

Bear

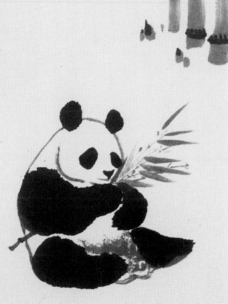

◻ Detail of Chinese painting depicting a panda bear. Ink on paper, by Wu Zuoren (b. 1908). Private Collection.

The bear symbolically represents strength and bravery, owing to the natural qualities of this beast that once was common in China. A male symbol, it connoted a fifth level military official on Mandarin squares (*see* Mandarin Square) during the Qing dynasty.

The most common bear in Chinese art, and the one particularly associated with present-day China, is the panda. However, black and grizzly bears are also found in China's northern areas, perhaps having migrated from neighboring countries. The numbers of these animals have dwindled since bears were once a food source that was also said to have medicinal qualities. They are listed in the ancient compendium of Chinese medicines. The bile of the bear is said to be an effective treatment for convulsions and eye and liver ailments. In present-day China, bear bile is sought by practitioners of traditional Chinese medicine. To gourmets, it is considered a delicacy. Both these associations have contributed to the endangerment of bears in China.

A folktale explains that at one time were only *bai xiong,* white bears, in China. One day, a young girl befriended a cub and its mother and they played daily. Once when they were together, a leopard appeared and attacked the frightened young cub. The little girl threw stones at the leopard to frighten it away, but rather than run away, the leopard turned on her and killed her. When the mother bear returned and found the dead girl, the mother bear and others tore up the ground in great sadness, and as they wiped their eyes, the fur of their eyes, paws, and bands of their bodies turned black. From that day forward, there were no longer white bears.

As an art motif, figures of the bear appear early in Chinese art. The most rare examples are three-dimensional figures that were carved in jade during the Shang dynasty. During the Zhou dynasty, the bear appeared as finials and during the Han dynasty, they were often seen in the form of feet that were cast in bronze and inlaid with silver and molded in pottery. These feet held vessels constructed both in pottery and bronze. With the exception of late Qing dynasty and contemporary folk textiles, bears do not appear on textiles. In paintings, the bear is a somewhat rare subject except with twentieth-century artists, the most famous being the panda bear paintings of Wu Zuoren (b. 1908).

Beard

The beard in China represents age and the reverence for elders with the honoring of filial piety. With age came wisdom and scholarship. Chinese paintings convey this symbolism by depicting sages and scholars with long beards. A red beard is said to represent bravery.

One folk legend, akin to the Western legend of Rip Van Winkle, is of a bearded male of great age named Wang Zhi. A Daoist figure, Wang Zhi is said to have lived in the third century B.C.E. The legend relates that while gathering wood for a fire, Wang Zhi came upon men who were playing a game of chess. One of the men gave him a strange and curious-looking fruit that he could not identify, but he ate it anyway and found it delicious. He apparently lost track of time for when one of the men told him that he should go home as he had been there for such a long period of time, he found that his clothes had yellowed with age, his beard was white and long, the tools that he carried had rusted, and the wood that he had collected now had rotted. He tried to find his way back home, but no one knew of its place or his family. He went back to the mountains and was said to have attained immortality.

The contemporary artist Zhang Daqian (1899–1983) born in Szechwan and arguably one of the two greatest painters of the twentieth century, at a very early

□ The painter Zhang Daqian.
Circa 1955.
Ji Zhen Zhai Collection.

age sought to revere and honor the life of the early scholars and painters. He was known to have dressed in traditional Chinese clothing and grew a beard, which he kept his entire life, that symbolized knowledge and reverence for age.

Bee

In contrast to the West, bees are not popular in China. While they are raised in the some rural areas, they are by no means common, nor is honey sought after. Symbolically, the bee, *mi feng,* and its honey both have sexual connotations. The bee is likened to a male who is drawn to the flower, which represents the female.

Bees also symbolize the coming of prosperity if they are seen swarming near one's house, and they are a symbol of industry.

Bees depicted in art form a rebus that expresses a wish for a good harvest of the five grains (the word for bee, *feng,* has the same sound as the word for harvest, *feng*). Depictions of bees in Chinese art are not a popular subject and are primarily seen in contemporary paintings. Perhaps the most famous paintings that include bees are those by the famed contemporary artist Qi Baishi (1864–1957).

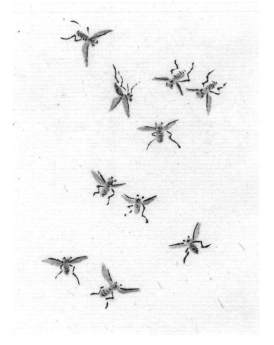

□ Woodblock depicting bees. Ji Zhen Zhai Collection.

Begonia

The begonia, *qiu hai tang,* means "autumn apple." Its name implies that its flowers are likened to the flower of the apple. This delicate flower symbolizes wealth and office.

In spite of the fact that the flower symbolizes wealth and power, the begonia has not gained favor for either depictions or as a gift. Its disfavor has its genesis in a folktale in which the begonia forms from the tears of a woman whose love has gone away. Therefore, while it is not an appropriate gift for a woman, the begonia has come to represent unrequited love.

Bell

The bell appears in China in many forms and has many uses. It is utilized in the Confucian, Daoist, and Buddhist religions. Early examples usually consist of sixteen bells made of metal of graduated size that were affixed to a wooden frame. These bells were elaborately cast with *tao tie* masks (*see* Tao Tie Mask). They were also constructed of pottery.

The most common symbolic meaning associated with the bell is that the sound was said to drive away evil spirits.

When the bell, *zhong,* is found as a motif associated with the military, it takes on a different meaning, that of dedication and obedience. However, when the bell

is seen in motifs primarily in the eighteenth and nineteenth centuries, it most likely expresses a play on words since the words for "bell" and "to pass a test, or to achieve" are homonyms, *zhong.* The depiction of a bell or the gift of a bell expressed a wish for a scholar to pass his examination and rise to a high civil service position. The bell was a visual expression of a good wish.

There are examples of late Guang Xu robes where a design motif of a bell is used together with a *ruyi* scepter to form the rebus *Zhong kui* (referring to the Demon Queller), meaning "avoid danger." Zhong Kui is a mythological protector who drives away evil.

Bi

The *bi* is a disk of jade with a circular opening in the center that was first found in the Liangzhu culture of China (c.3300–2200 B.C.E.). This area is in the vicinity of Hangzhou, in Zhejiang Province, and represented one of the most important Neolithic cultures.

The exact meaning of this ritual object of jade is speculated to be a representation of the sun or roundness of the heavens, *tien yuan.* During the early periods, the *bi* was placed on the dead, usually on the chest.

Birds with Long Tail Feathers

Birds with long tail feathers were popular subject matter for paintings, porcelains, and embroideries, particularly during the Ming and Qing dynasties. As they were colorful and visually appealing, they became popular on export wares of the nineteenth century.

A bird with long tail feathers, *shou dai niao,* meaning "bird with silk streamers," is a symbol for longevity. The word for a silk sash is *shou dai,* and forms the pun on the word for longevity.

Dai dai shou xian is a rebus that combines *shou dai niao* with rock *(shou)* and daffodil *(shou xian).* It means that every generation in one's family should enjoy longevity.

□ Album painting for the Moghul market depicting bell. Nineteenth century. Phil Wood Collection.

Bixia Yuanjun

Bixia Yuanjun is a popular Daoist deity of the Ming and Qing dynasties who is called the Sovereign of Clouds of Dawn. She is known for compassion.

Like the Queen Mother of the West, Xi Wang mu, Bixia Yuanjun has a phoenix in her headdress, and the two are often confused with one another. However, while the Queen Mother has a single phoenix headdress, Bixia Yuanjun always has three phoenixes in hers.

Boar

The boar, owing to its habitat, represents strength and the wealth of the forest. The origins of this symbolism lie in its value as a food resource, dating back to a time when boars were plentiful and highly prized for their meat. It is one of the zodiac symbols and is also an animal in the Chinese horoscope.

The boar appears in Chinese art most frequently as a tomb figure of the Tang dynasty, where it represented a prized food animal that would accompany the deceased to the nether world. Before the destruction of the Summer Palace, Yuan Ming Yuan, it held realistic cast figures of the animals of the zodiac, one of which was the head of a boar.

Boat with Official

The word for boat, *chuan,* has the same sound as the word for generation, *chuan,* thereby forming the basis for puns. Depictions of an official standing in a boat expresses a wish that a scholar would become an official and remain so for generations, passing the title and status from son to son.

Schuyler Cammann documents an unusual eighteenth-century robe in the Seattle Art Museum that depicts the rebus *guan* (hat, referring to an official) *dai* (belt) *chuan* (passing on) *liu* (to flow), which conveys the hope that the family of officials will continue on for generations. There are many examples of paintings and jade carvings from the same period as this robe that represent the same rebus.[3] However, this representation should not be confused with the following folk story that symbolizes man's quest for eternity.

The famous folk story "Rafting on the Heavenly River" explains the saying "the Heavenly River connects with the sea." A man lived on the beach, and every August he saw a raft appear on the sea on exactly the same day. He had an ambition to float along the Heavenly River, so he built a raft, loaded it with supplies, and finally set off. For the first dozen days he could distinguish the moon and the sun, but later he

□ The Goddess Bixia Yuanjun. Cast bronze, Ming dynasty (1368–1644). Courtesy of Roger Keverne.

could not tell night from day. One day he reached a city with walls and grand buildings. He asked a man where he was and the man responded, "Go back to Chengdu. Visit the hermit and seer Yan Jun Ping, and you will have the answer." When he arrived in Chengdu and visited Yan Jun Ping, he was told, "One day a guest star disturbed the Buffalo Star." On counting the days, they discovered that it was exactly the day when the man reached the shore of the Heavenly River on the raft.[4]

Bodhi Tree

The bodhi tree represents the place where Sakyamuni Buddha spent seven years of penance meditating while seeking to be free from the problems of life and worldly pleasures. Following this period, he attained enlightenment.

The bodhi tree has great significance in the art and culture of India, where Buddhism originated as one of the early religious movements. During the Eastern Han dynasty, when there was travel between India and China via the Silk Road, Buddhism was introduced to China and became one of the country's important religions. Absorbed into Chinese life and culture, this form of Buddhism reflected changes from the Buddhism of India. One significant change was the importance of the bodhi tree. The bodhi tree never attained the importance in China that it had in India in terms of religious significance and thus was incorporated into Chinese art to an even lesser degree. Depictions of Buddha beneath the bodhi tree exist in the early paintings of the Tang dynasty, which were discovered in the famous Silk Road site, Dunhuang. However, representations of the bodhi tree elsewhere in China and during later periods are rare.

Bodhisattva

The bodhisattva, an enlightened being in Mahayana Buddhism, is one who is prepared to attain nirvana but has chosen to postpone it for the purpose of saving the living. The bodhisattva symbolizes the enlightened that have dedicated their being to others. The bodhisattva has reached the ultimate degree of saintship and in his next reincarnation will be a buddha.

The image of bodhisattva in Chinese art from the early Han dynasty, when Buddhism was introduced into China, to the Qing dynasty undergoes a change unique to China. By the Qing dynasty, the bodhisattva, initially a male figure had evolved into Guanyin, the Goddess of Mercy, a female figure who is clothed in enveloping robes and is sometimes depicted holding an amphora.

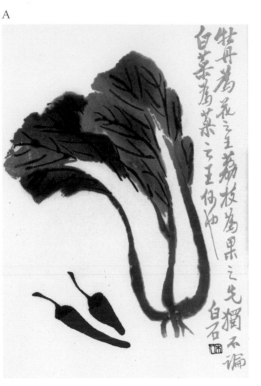

A

B

[Chinese calligraphy inscription]

Bok Choy

Bok choy, a member of the cabbage family, is characterized by large white stems with dark green leaves. It is grown in Southern China and is particularly popular with the Cantonese. It is a symbol for abundance. When depicted with the radish, it forms the rebus *qing qing bai bai,* whose meaning is derived from the deep green *(qing)* leaves and white *(bai)* stalks, representing that the character of a person is clean, unsoiled, and unimpeachable. It appears primarily in the later Qing dynasty, particularly in paintings and jade carvings.

Perhaps one of the most famous Qing Dynasty jade carvings is the Taiwan National Palace Museum's jadite carving of bok choy with a grasshopper. In this carving, the grasshopper symbolizes fertility while the bok choy symbolizes abundance, a most auspicious wish for a newly married couple.

Books

Books are one of the Eight Precious Things and one of the symbols of the scholar. It was a custom for families to place before one's baby four items—coin, book, tortoise, and banana. If the baby grasped the book first, it was an auspicious sign: he would be a scholar and achieve greatness as well as riches. Books are also a symbol for warding off evil spirits. This symbolism reflects the importance and power of knowledge in driving away ignorance. A great deal of emphasis was placed on memorization of the classics in order to pass the legendary Civil Service Examination. It was said that the scholar who could repeat the classics by memory had the power to drive away evil and those spirits who would do him harm.

Books, *shu,* when depicted together with red apricot blossoms form a rebus, *shang shu hong xing,* meaning "May you pass your examination and achieve high rank;" *shang shu* meaning "important court official," *hong xing* meaning "red apricot blossom."

Bow

The bow and arrow symbolize the birth of a boy and were also used to symbolize the driving away of evil spirits from the newborn. The latter is an influence of Buddhism, where the bow and arrow represent weapons against evil. In early Chinese folktales, it is customary to shoot arrows into the air on the third day following the birth of a child. The symbolism of the bow and arrow further emphasizes the importance of a male child in Chinese culture. A depiction of a man shooting arrows into the sky expresses a wish to have many sons.

Box

The box, *he,* is a homonym for the word for harmony. It is also a homonym for the word for lotus *lian he,* often referred to as *he.* Depicting a *ruyi* scepter (*see* Ruyi) and a box with lotus leaves, *he he ruyi,* is a visual rebus expressing "May you have your wish with harmony." The box is also associated with the Heavenly Twins, who are sometimes depicted with a box containing a lotus leaf (*see* He He).

The symbolism of the box is no doubt related to the fondness of the Chinese for boxes of all sizes and shapes. Some of the most prized objects of the Qing emperors, particularly the Emperor Qianlong, were lacquer boxes in the form of piled scrolls and books.

Brahma

Brahma is the creator in the Hindu trinity. In that trinity, Brahma created, Vishnu preserved, and Shiva destroyed, in an endless cycle of destruction and creation, not unlike the Daoist dance of yin and yang (*see* Yin and Yang). Brahma was adapted both into Buddhism and into Daoism, but rarely depicted in Chinese art. The adoption of Brahma into Buddhism and Daoism is but another example where religions in China absorbed concepts from one another peacefully.

Bridge

The bridge, as in reality, connects one side with another. Therefore, the bridge, *qiao,* symbolizes bringing together two different entities. It is much utilized in Chinese literature, poetry, and particularly in painting.

B

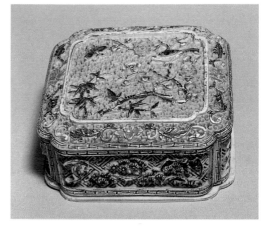

□ A Zitan wood box in the shape
of a *ruyi.* Qianlong period
(1736–95).
Ji Zhen Zhai Collection.

□ B Carved ivory box reputed
to be from the Summer
Palace, Yuan Ming Yuan.
Yongzheng period (1723–35).
Ji Zhen Zhai Collection.

A

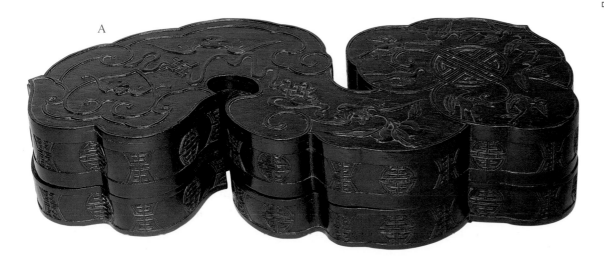

A
B

□ A Detail of scholar crossing
bridge from backsplat
of a scholar chair.
Cinnabar lacquer,
eighteenth century.
Ji Zhen Zhai Collection.

□ B Woodblock depicting a broom.
Ji Zhen Zhai Collection.

Many folktales involve a bridge. Perhaps the most popular is of "Niu Lang and Zhi Nu" ("Cowherd and the Weaving Maid"). In this story, the lovers, Liang Shan bo and Zhu Yingtai, were separated by a river. The gods allowed them to be together for only one day each year, on the seventh day of the seventh month. On this day, magpies would build a bridge for them to close the gap between them and end their separation.

Bronze

One of the most remarkable facets of Chinese history is the fact that during the Xia dynasty, from about 2000 to 1771 B.C.E., bronze was produced for weapons as well as ritual vessels used by the ruling class. Excavated materials from the Neolithic period give evidence that pottery vessels were fired at such high temperatures that they were highly durable. These high temperatures also melted metals such as copper, and therefore bronze was developed at a remarkably early period. The bronze pieces that were produced during the Xia dynasty copied those vessels that had been previously created in clay, making the functional aspect of the bronze vessels the same as their pottery prototypes.

Historical records written at a much later time identified the legendary rulers of this early period as the inventors of such things as writing, agriculture, and government. The last of these rulers, Yu, the founder of the Xia dynasty, is said to have had the ability to control floods and had nine sacred bronze vessels cast, each of three legs, which became symbols of the right to rule. According to the *Shu Jing (The Book of Documents)* written during the Eastern Han dynasty, these nine vessels were sent as tribute from the nine provinces.

Recent archaeological excavations fail to confirm the actual existence of the Xia, a mythological dynasty. Some scholars correlate the Xia with the Erlitou culture, but other scholars feel that the Erlitou was an early period of the Shang dynasty. Despite the debate concerning the existence of the Xia, the bronze vessels and weapons of that early time had a great impact on the Shang and Zhou dynasties and established that China had an astounding bronze culture early in its history.

Broom

The broom, *sao,* is the emblem of Shi de, who together with Han shan lived in the monastery of Guo Qing. It is documented that they were two Daoists who spent most of their time in the monastery kitchen speaking gibberish. The significance of their speaking gibberish is not known. Strangely enough, the broom has come to symbolize wisdom.

It is customary to sweep the house on New Year's Eve, symbolizing the sweeping away of the evils of the past year. It is bad luck to sweep one's home on New Year's Day, as one would be driving away good luck.

Brush

The brush is one of the Four Treasures of the Scholar. Perhaps the most crucial tool for the scholar in theory and use, it is an extension of the artist's hand and arm through which his creative energy is channeled. Chinese scholars believe that weakness of character and, certainly, lack of practice is betrayed through every nuance of the brush's motion that transferred the ink to paper. The character of the brushstroke is a term frequently used in describing the quality of calligraphy, the highest of the arts in Chinese culture. Brushes varied in shape, size, and structure. The most basic were simple, composed of animal hair and bamboo. More elaborate brushes were of lacquer, jade, and glass as well as elaborately carved bamboo, and held all types of rare animal hair.

□ Brush. Red lacquer inlaid with gold, seventeenth century. Ji Zhen Zhai Collection.

The word for brush in Chinese, *bi,* is of the same sound as the word for certain, *bi ding.* This homonym is depicted visually in paintings expressing assuredness. *Bi ding ruyi,* the rebus of "May you certainly get all you want," is formed by the pen with a bar representing money and a *ruyi* scepter (*see* Ruyi).

Another rebus is formed with the brush in the center of the Wheel of the Law (*see* Wheel of the Law). This design is seen in Mandarin robes of the middle Qing dynasty and forms the rebus *bi zhong* ("center" or "hit the target"), meaning "I shall certainly succeed."[5]

Buddha

Born into the Sakya clan, Gautama Siddhartha's symbol was the lion. He is known as the Sage of Sakya or Sakyamuni, or the Lion of Sakya. He lived a sheltered life in the royal palace of his father between c.563 and 483 B.C.E., ignorant of the outside world, as his father did not want his young prince to grow to be a holy man. Information on his factual life is shrouded in legend, but it is said that at the age of thirty-five, Sakyamuni attained enlightenment sitting under the bodhi tree, the tree of enlightenment. Having obtained enlightenment, he began to teach, expounding the doctrine of the Four Noble Truths and the Eightfold Path. The Four Noble Truths are the existence of impermanence, the arising of suffering because of wanting, the cessation of suffering, and the noble path. The Eightfold Path is the right way of conducting oneself to achieve salvation. At the age of eighty, Buddha entered into a trance and died in the Sala Grove in Kushinagara, and his ashes were then enshrined in stupas throughout the world.

Buddhism came to China in the second century C.E. through travelers on the Silk Road. It soon became accepted in China and, along with Daoism and Confucianism, occupied an important part of religious thought in China, perhaps even greater in importance than in its native India. In spite of the fact that all three religions established themselves in China, they all lived together in harmony and assimilated aspects of each other. The Chinese centered their Buddhist worship on the manifestation of the Amitabha, who gave salvation to all those who repented their sins in his name. The bodhisattva Guanyin, the Goddess of Mercy who was to become an important figure in Chinese culture, frequently attended Amitabha. Guanyin, or Avalokiteshvara, came to represent motherly virtues and compassion. After Buddhism became ensconced in China, images of the Amitabha on the lotus throne appeared in temples throughout the land. Buddhism gradually underwent a transformation taking on characteristics unique to China.

Buddhist figures naturally followed the entrance of Buddhism into China during the Han dynasty. A legend tells the story of the Ming emperor Liu Zhang, who dreamed of a strange golden man and called his ministers together to solve the mystery of the identity of this person. One of his ministers said that a sage called Buddha, who had lived in ancient India, fit the description of the man in his dream. Believing that this was the person in his dream, the emperor dispatched one of his attendants accompanied by many soldiers to Tianzhu to seek Buddhist scriptures. They returned not only with Buddhist scriptures but also with statues of the Buddha, which were said to be the first of such images to come to China.

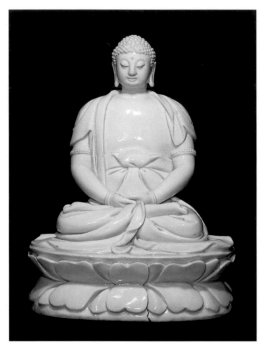

□ Buddha.
Dehua ware, eighteenth century.
Ji Zhen Zhai Collection.

Buddha's Footprint

Legend recounts that when Buddha felt that he was approaching nirvana, he went to Kusinara and faced south. His footprint was said to have left an imprint in the stone for posterity. This imprint came to symbolize this important event as well as Buddhism itself. The footprint contains Buddhist symbols that are called the Seven Appearances—swastika, fish, diamond mace, conch shell, flower vase, wheel of the law, and crown of Brahma. The footprint of Buddha has less symbolic importance in China than in India.

Buddha's Hand (Citron)

Known to the Chinese as *fu shou,* or "Buddha's hand," this fruit is an inedible but fragrant citrus fruit that is composed almost entirely of rind. It has long tendrils that are said to resemble the fingers of Buddha, and hence means longevity. *Fu* also means happiness and *shou* means longevity. *Fu shou* serves no nutritional purpose,

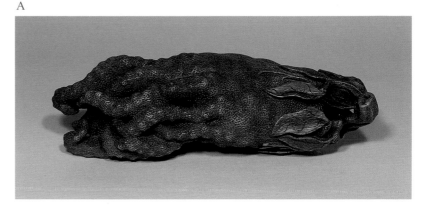

A

but it is commonly placed on Buddhist altars as an offering and symbolizes wealth.

Depictions of a child holding a peach, Buddha's hand, and a pomegranate express the wish "May you have happiness, many sons, and long life."

Buddha's hand with a butterfly, *die,* expresses a wish for a very long life, usually the age of eighty *(die).*

The Buddha's hand is frequently seen in paintings during the Ming and Qing dynasties. During the Qing dynasty, it was often fashioned in porcelain, bamboo, wood, and ivory.

In contrast to a religious symbolism, the fruit bears a resemblance to a hand grasping money. Therefore *fu shou* became a good luck talisman for gamblers.

Butterfly

The butterfly, *die,* is a symbol for joy and conjugal felicity. The butterfly commonly appears in art motifs with a variety of subjects as *die* has the same sound as the word meaning "to repeat." Therefore, a butterfly with any symbol takes the meaning of doubling the wish of the symbol pictured.

Butterflies in Daoist thought symbolize dreamlike thinking and a reflection of Zhuangzi philosophy in the floating, illusive, and transient mundane world. At the same time, butterflies also symbolize love and romance and the pursuit of females. The butterfly is also the subject of love in many folktales, such as that of Liang Shan bo and Zhu Yingtai (commonly known as the Liang Zhu Tragedy), written by the Ming master storyteller Feng Menglong (1574–1646). This story concerns the same star-crossed lovers who were separated by a bridge (*see* Bridge). It tells of a young male scholar Liang and his classmate Zhu Yingtai, a female scholar, and Liang's own ignorance and foolishness, which caused his early death. Subsequently, in despair, Zhu Yingtai commits suicide at his grave.[6] They were later buried together and after death they were transformed into a pair of large butterflies. Hence, pairing butterflies is a symbol for romance and dedicated love. And, as the butterfly leaves its former body and cocoon behind to find a new life, the butterfly is also seen as representing freedom of the soul.

The butterfly in Chinese is commonly utilized in another pun, since its name *die* has the same sound as the word meaning eighty years of age.

When the butterfly *(die)* is pictured with the cat *(mao),* it symbolizes a wish for long life, since the cat and butterfly have the sound of the word *mao die.*

Six butterflies together relates to the Chinese rebus *liu die* (pronounced *liu de*), meaning six butterflies. The phonetic sound of *liu* means six and *die* means old

B

□ A Buddha's hand.
 Bamboo, eighteenth century.
 Ji Zhen Zhai Collection.

□ B Porcelain vase with
 butterfly design.
 Kangxi mark and period
 (1662–1722), 7 1/8 inches high.
 Charles Tiee Collection.

□ Informal robe with
one hundred–butterfly pattern.
Nineteenth century.
Hanley Collection.

age (same sound but different characters), the latter referring to old age or eighty years old. According to the Chinese lunar calendar and astrological cycles, eighty years is a full cycle for a person's life and is called *hua jia zi,* that is, "flower *jia zi*" or "flower eighty-year cycle." In ancient times, it was an important birthday celebration.

Butterfly and plum blossoms for a visual rebus symbolize longevity and beauty.

In that the butterfly represents joy, beauty, and marital bliss, it is a frequent subject of exquisite porcelains of the Qing dynasty, particularly the Yongzheng period.

Cactus

The cactus, *xianrenzhang,* meaning "hands of the immortal," is believed to have the power to ward off evil spirits. It is also used medicinally to cure intestinal ailments. Folk use of the cactus involves the practice of *feng shui,* the auspicious arrangement of objects in interior or exterior spaces. A large thorny cactus is placed in a room to confront and counter an evil direction. It is believed that the sharp thorns of cactus penetrate the invisible "spirit body" of ghosts, hooking them to the plant until exposure to the light of the rising sun can kill them. Depictions of the cactus in Chinese art are rare.

Cake

Ceremonial cakes have a long tradition in Chinese folk art and were used in sacrificial rites for ancestors, worship of the gods, and funeral rites. Through the centuries, these customs have carried over and become associated with various holidays and other occasions.

One of the earliest of these customs is the making of babylike figures on the fifteenth day of the seventh lunar month to pay homage to one's ancestors. The unusual shape, called *liantiwawa,* joins together several of these figures, some of which do not have heads. When viewed from the side, the cake appears as a complete child. The symbolic meaning is that of "joining."

Cake of sweet rice, *gao,* is made for the New Year. One type that is made with radish has the meaning of good luck. The New Year cake, *nian* ("year") *gao,* has the

auspicious meaning of "a wish to obtain higher status." It is auspicious to say *"lian lian gao,"* which means a wish every year to be more important.

The Kitchen God by folk tradition controls the fortunes of one's family. In Chinese homes, a shrine to the Kitchen God is above the stove. On the twenty-fourth day of the last month of the lunar calendar, offerings of cakes and other sweets are made to him. The day after his birthday, it is said that he goes to heaven to report the deeds of the family to the Jade Emperor (*see* Jade Emperor).

Camellia

The camellia, *chun guang,* literally translates to "mountain tea." The flower represents a young female's beauty as well as spring and the regeneration of another year.

When the camellia is depicted with the magnolia blossom, which represents spring, a wish for longevity is conveyed. The camellia is sometimes depicted with a bird with long tail feathers, conveying the blessing "May spring radiance be everlasting," *chun guang chan ghou,* an expression for longevity.[7]

Can Nu (Lady Silkworm)

Silk is an important commodity in the history of China. A folktale, "Can Nu," or "Lady Silkworm," relates the origins of silk and is one of the most famous examples of filial piety. In the story, a young girl missed her father as he was away from home on business so much of the time. One day while grooming her horse, she said, "I'd marry anyone who would bring my father home." The horse suddenly galloped off out of sight. In the next town, the father saw the horse. Thinking that something was wrong as his daughter's horse had come to him, he returned home. He asked his daughter why she had sent her horse to him, and she said that she had not but that her beloved horse must have known how much she missed him. For this, her father gave the horse special food, but the horse would not eat and merely reared up. The girl remembered what she had said to her horse and told her father. Her father, angered at the thought that the horse was thinking of marrying his daughter, had the horse killed and its skin laid out to dry.

The girl played with the skin and suddenly the skin enveloped her and carried her away. After searching for her, the father discovered the horse skin in a tree with a caterpillar next to it. His daughter had been transformed into this caterpillar, Can

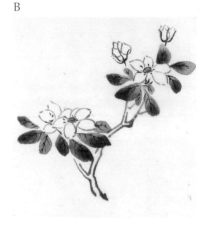

□ A Cactus album leaf by Qi Baishi (1864–1957). Horacio Fabrega Jr. Collection.

□ B Woodblock depicting camellia. Ji Zhen Zhai Collection.

Nu, Lady Silkworm. As she waved her head from side to side, a silk thread came from her mouth. And so, silk came to China.

Cangue

Westerners, particularly during the nineteenth century, were intrigued by the punishments of China, and numerous books were written on the subject for sale in the West. Moreover, photographs of criminals were highly popular. The *cangue*, a word derived from the Portuguese word for yoke, was one of the punishments provided for minor infractions in the Qing dynasty code, which was based on Confucian ethics. It was a symbol of humiliation. Not unlike the stocks of colonial New England, the Chinese *cangue* is a heavy square wooden collar that was locked around the neck of the criminal. The collar was approximately three feet square and weighed twenty-five pounds, and provided great humiliation to the wearer since it did not allow for one to feed oneself. Moreover, written statements were affixed on the surface of the collar that detailed the crimes committed for all to view.

Canopy

The canopy represents one of the Eight Buddhist Symbols signifying charity and spiritual authority, and the attainment of enlightenment (*see* Eight Buddhist Symbols). It is said to be a symbol of the sacred lungs of the Buddha.

During the eighteenth century, the Eight Buddhist Symbols became a decorative motif that was frequently depicted on lacquers and porcelains and in carvings. Its symbolic meaning had evolved into a purely decorative motif.

Carp

The carp is a hardy fish that endures in the harshness of weather and became a symbol of the scholar who perseveres through scholarship. It is said that the carp has the ability to swim upstream against the current, not unlike the scholar who perseveres through difficult studies. This symbolism is directly connected with the myth of the carp turning into a dragon at the Dragon Gate Mountain. This myth has had lasting appeal as it likened the most difficult feat of the scholars in passing the Civil Service Examination to the divine feat of the carp of leaping untold heights and turning into a dragon, the most magnificent of all beasts.

The carp spouting a pavilion from its mouth, a vision known as "sea monster market," *shen shi*, sounds similar to *shengshi*, which means "success."[8]

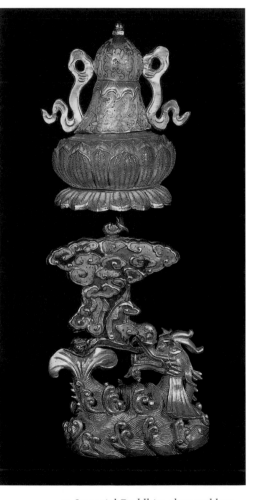

◻ Imperial Buddhist altar emblem surmounted by the royal canopy. Gilt bronze and enamel, Yongzheng Period (1723–35). Ji Zhen Zhai Collection.

The word for goldfish, a member of the carp family, is *jin yu.* It forms a play on words, as it sounds like the phrase "gold in abundance," *jin yu.* The depiction of goldfish symbolizes a wish for plenty and wealth. The goldfish is said to express the rebus *xi jian da li,* "happy to see good fortune," *xi* meaning "happiness," *jian* meaning "see," and *da li* meaning "big fortune."

A goldfish in a pond, in actuality or in painting, expresses the wish "May you have a prosperous household," *jin yu man tang.*

Another rebus involves depicting a carp with a lotus, *jin yu tong he,* which is a wish for riches gold and jade *(jin yu)* together *(tong),* represented by the lotus *(he).*

The carp also carries the meaning of fertility and children since it bears many eggs when spawning. When symbolizing fertility, carp are usually shown in a pair and, thus, the carp is a popular New Year's decoration. There are instances where a child is depicted perched on the back of a carp. This does not represent fertility but rather Zi Ying, a notable Daoist. A fable tells how one day Zi Ying caught a carp and rather than eat it, he kept it in a pond and fed it regularly. In a short period, it grew to be ten feet with horns. Zi Ying worshiped the fish, but the fish said that he was merely the vehicle that would take him to heaven. At that, he mounted the carp and it flew away.

A figure that is sometimes confused with Zi Ying (who is depicted with a winged carp) is the figure of Kin Kao, who was known as the recluse of Chao. According to folk legend, Kin Kao lived by a river and spent his time painting fish. One day the King of Fish came to him and offered to lead him through the river world. Kin Kao spent over a month traveling in the river world and when he returned, he taught that fish should not be killed. He then dove into the river never to be seen again. He is depicted standing on the back of a carp or reading a book on the back of a carp.

The carp also represents an auspicious wish for advantage as the word for carp, *li,* is similar to the word for advantage, also *li.*

The carp has been utilized as a design motif for many dynasties. In the Ming dynasty, it is most famously depicted on the *wu cai* imperial fishbowls—large enameled bowls to hold fish. In the Qing dynasty, a variety of scholar objects are fashioned in the shape of a carp, to give the scholar encouragement and to remind him to persevere. In the late Qing dynasty, when export wares became popular in Europe and the West, the carp, rather than conveying a symbolic meaning, became an important decorative motif. Vases, dishes, and the like were made in the shape of carp.

Cash

(*see* Coins)

A

B

□ A Woodblock depicting castanets.
Ji Zhen Zhai Collection.

□ B Waterdropper in the shape
of a cat. Glazed pottery,
Liao dynasty (907–1125 C.E.),
45/8 inches long.
Ji Zhen Zhai Collection.

Cassia Tree Blossoms

The cassia tree blossoms in the eighth lunar month, the time of the ominous Civil Service Examinations for the scholar. Bowls decorated with cassia tree blossoms were said to celebrate a scholar's success. On these bowls, rabbits were sometimes depicted grazing under the cassia tree. The rabbit and tree are both symbols of the Moon Palace of the Immortals and were used for joyous celebrations as well as birthdays. The passing of one's Civil Service Examination was indeed a time for rejoicing as it was a key to riches and success.

"Cassia," *qui,* is a pun on the word for "to return," *qui,* both having the same sound, which is reflected in the fact that the cassia tree is a symbol of the Moon Palace of the Immortals. Folktales record that the cassia tree of the Moon Palace grew to such extremes that it had to be continually cut, but once cut, it grew again or "returned."

Castanets

The castanets evolved from one of the original *ba bao,* or Eight Precious Things. They became one of the decorative emblems in the late Qing dynasty on porcelains and lacquers. They are seen on Mandarin robes of the middle and late Qing dynasty.

One of the Eight Symbols of the Daoist Immortals (the others being flower basket, lotus, flute, sword, magic fan, gourd/crutch, and bamboo rattle), it is the symbol of Cao Guo jiu (930–999 C.E.), patron saint of the theater, who is portrayed holding his emblem, a pair of castanets.

The castanets have a rather unique appearance, not at all like the castanets known in the West. They appear as two brass slabs that are struck together by priests during ceremonies.

Cat

The cat is not indigenous to China, but was brought from the Middle East. The name for cat in Chinese, *mao,* has a similar sound to the cat mewing. Cats have a dual symbolism in China, one good and one bad. Because it eats mice that eat silkworms, it has the symbolism of being the protector of silkworms. In this protective image, pictures of cats are hung on walls in areas where silkworms are grown. In a similar vein, as cats can maneuver in the dark, cats are felt to be able to ward off evil spirits, as well as the problematic destructive disease-carrying mice. Hence, lamps with images of cats were placed on the floor at night and the flickering candlelight, which showed through the mouth and eyes of the cat image, was a deterrent to

mice. In most instances, the cat is a symbol of longevity. This comes about as *mao* is a homonym for seventy. Double cat paperweights of jade are not uncommon, particularly during the Qing dynasty. The Chinese words for double cats are *shuang huan* and these two words are a homophone to twin happiness, *shuang huan* (same sound but different characters).[9] Therefore the symbol for two cats is double happiness.[10]

The Chinese word *huan* also means a badger, a catlike burrowing animal with a long tail. Double badgers similarly mean doubled happiness. The Chinese word for happiness comes from the two words *huan xi*, and doubled happiness *shuang huan xi* is abbreviated as *shuang xi*, referring to doubled joy and happy events such as marriage.

Quite the opposite of the above positive symbols, cats also can symbolize coming hardship and loss of wealth. This may have roots in the fact that when one loses money, one's property becomes debilitated, which attracts rats and mice. Hence, when a cat comes to a house, it is not looked upon as a favorable sign.

Catfish

The catfish is distinguished from other fish by its characteristic whiskers. The fish derives its punning power not from its appearence of being old or from its strength, but rather from its name, *nian*, a pun on the word for year, *nian*, which has a similar sound. Schuyler Cammann states that the catfish is seen on a late Qing Mandarin robe and has this meaning: "May I year by year have ten thousand happinesses," *nian nian wan fu.*

Another rebus depicts a single catfish lying on two swastikas with red bats hovering about it, *wan wan nian hong fu*, which means "For ten thousand times ten thousand years, may I have vast happiness."[11] *Wan* meaning "ten thousand" and *hong fu* meaning "vast happiness."

Chang E

Chang E, also known as Tai yin xing jun (meaning Star Lord of Supreme Yin), is the Daoist moon goddess. Her story is recorded in the Western Han fairy-tale book, *Shanhaijing,* which tells that the beautiful goddess lives in the *Guanghan Gong,* Broad Cold Palace, in the moon. Established by the Tang dynasty as a Daoist goddess, she stole the elixir of immortality from her famed archer husband, Hou yi. On discovering the treachery of his wife, he chased her to retrieve the stolen elixir, but she swallowed the potion and escaped to the moon where she lives forever in the company of the hare, her friend and companion. Hou yi in turn resides on the sun.

□ Lozenge-shaped dish with catfish design. Ming dynasty, Tianqi period (1621–27). Ji Zhen Zhai Collection.

▢ A Painting of cherries by
 Qi Baishi (1864–1957).
 Ji Zhen Zhai Collection.

▢ B Woodblock depicting cherry
 blossoms.
 Ji Zhen Zhai Collection.

As she, and the hare, is associated with the moon, she symbolizes longevity and immortality. She is worshiped at the Autumn Moon Festival, the night of the full moon of the eighth lunar month. The hare is frequently depicted grinding the herbs of immortality.

Chao Fu

The translation for *chao fu* is "court garment." These are the most formal robes, robes of state, which were required to be worn by officials for court rituals. Strict requirements concerning these garments were set forth by the emperor. High court officials were also buried in their *chao fu* signifying their official position. *Chao fu* are not as commonly found as the informal court robes since they were burial dress for officials.

Cherry

The cherry, *yingtao,* symbolizes happiness and feminine beauty. During the Qing dynasty, the cherry fruit was frequently not depicted in painting on porcelains but rather hinted at with color. High-quality cups and bowls were produced in the imperial kilns in a cherry color, thereby simulating the fruit. These cups frequently have seeds or seed pods painted on the interior. A cherry-colored glazed cup or bowl with many seeds on the interior is a visual rebus for a wish for a woman to bear many sons.

Cherry Blossom

The flower of the cherry tree represents the fourth month. The blossom as well as the fruit represents femininity. As one of the fruits of the garden of the goddess Xi Wang mu, it represents longevity. The cherry blossom can also represent the upheavals of female puberty. The cherry blossom was frequently a *famille rose* palette subject of the fine porcelains of the Yongzheng period (*see* Famille Rose).

Chestnut

The chestnut, *li,* is close in sound to the word meaning property, *li.* It represents a wish for wealth. As a food item or in paintings, it is paired with dates, *zao,* at weddings, representing a wish that many sons may come soon, *zao.* The chestnut is frequently seen as the subject for feeling pieces or toggles—meditation stones—that scholars carried, obviously expressing their internal wish for wealth and a son.

The chestnut when combined with the date forms the rebus *zao li zi,* expressing the wish that one may have sons soon.

Chi Fu

The *chi fu* are semiformal court robes. This category includes the *lung bao,* commonly called the dragon robe, which is better known than and mistakenly thought to be the most formal robes. More *chi fu long bao* survive today than the formal *chao fu,* since the latter also served as the burial dress for court officials.

Chi fu had strict requirements that were set forth by the emperor even though they were semiformal robes. The overall design of the robes was a depiction symbolizing the emperor ruling over the earth and the universe. The most common color for scholars was blue.

Chicken

Chicken, one of the six domestic animals, symbolically takes on the same meaning as the phoenix. As it represents the female, it symbolizes a good marriage. Folk stories assert that if a female chicken crows, it has the omen of a female-run government.

The chicken is perhaps best known for its design on the so-called "chicken cup," which appears in the Chenghua period (1465–87) of the Ming dynasty and later is repeated during the Qing dynasty in slightly different forms. These rare cups depict a rooster, hen, and chicks in a setting of peonies and rocks. This design expressed a wish for wealth and sons. Another interpretation is that it is "a rebus that means 'successful official with riches and honor' *(gong ming fu gui).* . . . The artist counted on the viewer to say 'a rooster is crowing near the peony flowers'; rooster is pronounced *gong ji* and to crow is *ming,* creating the combination *gong ming.* The peony flower is sometimes called the 'flower of riches and honor' *(fu gui hua),* which completes the rebus."[12]

During the Qianlong period (1736–95), the rooster, hen, chicks, rock, and peony were sometimes combined with a boy who stands with one leg raised. This boy is identified as Jia Chang, a highly erudite youth who trained cocks for the emperor. In this depiction, the boy is said to be "waiting on tiptoe," *qiao zu er dai,* which also means to expect something soon, for example, a hope for an early rise to a civil service position.

As a food item, when a whole chicken is served, it emphasizes the unity of the family. Yet to fishermen, killing a chicken is an ill omen. It is taboo to kill a chicken on board a ship. This is related to days of old when fishermen killed chickens as an offering to Buddha when there was illness aboard. The killing of chickens became associated with illness and became taboo.

In contemporary times, the word for chicken, *ji,* is a slang word for prostitutes.

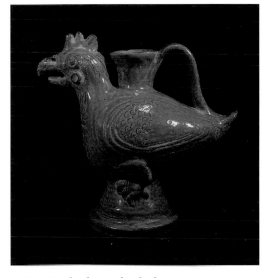

□ Ewer in the form of a chicken.
Jin Dynasty (265–420 C.E.).
Ji Zhen Zhai Collection.

Children

Chinese folklore symbolizes the elephant as the bearer of wealth and treasures, including the most important role of being the carrier of male babies to barren married couples. Culturally, Chinese families have always been partial to male children as the male child provides the continuity of worship of family ancestors. While the male child is greeted with cries of joy, twin boys would be seen as double joy.

There are hosts of customs and traditions associated with the embracing of and wish for a male heir who will carry on the family lineage. For instance, a birth of a son is announced by having a bow hung on the door. Fruits such as oranges and pomegranates are given to the woman who has not yet had a son since the word for orange, *ji* is also the word for speedily and the pomegranate seeds are symbolic of fertility. During the Qing dynasty, twin boys were a popular symbol called "four happiness," *si xi,* because upon rotation it gave the illusion of four happy boys. Thus, four happinesses are boys in an ancient Chinese family.[13] Likewise, many amulets surround the male child to protect him from evil spirits. A usual one involves hats and shoes that are in the shape of a pig. It is the hope that the evil spirits will be fooled by the images of a pig and think the child unworthy, thereby averting the child from the dangers of the evil spirit.

The wish for many male children is reflected in many rebuses. Likewise, this symbolism is reflected as a design motif throughout the centuries, particularly those of the Ming and Qing dynasties.

The hundred boys pattern, commonly seen in Ming and Qing porcelains, is an obvious wish for many male sons. Variants on the depictions of children playing with *ruyi* scepters (*see* Ruyi), a child with a mouth organ *(sheng),* which is a pun for birth, all carry the same message.

Also frequently seen is the motif of five boys who hold a large fish forming the rebus *wu zi deng ke,* which means "May all your sons turn out to be officials."

A boy carrying bundles of twigs for firewood is frequently the depiction of Zeng Shen, one of the twenty-four paragons of filial piety. Legends tell that Zeng Shen, who was to become an assistant of Confucius, was devoted to his mother and father in spite of the fact that his father mistreated him. A story relates how one day as he was weeding in the field of melons, he accidentally cut through the roots of one of the melons. He reported this to his father who beat him unmercifully. For this, Confucius chastised him for not running away. But on another day while gathering twigs for his mother, he suddenly felt a pain in his heart. He raced home and found his mother with chest pain. This is said to be telepathy between a mother and devoted son.

One of the most common and charming representations of children is that of a boy breaking a water jar. This depicts the folk story of Si Ma guang, who is said

□ Porcelain vase with design of children. Qianlong mark and period (1736–95), 8 inches high. Ji Zhen Zhai Collection.

to represent intelligence and presence of mind. In this story, a group of boys were playing with a large jar filled with water when one of the boys fell into the water. While the other boys ran away in fright, Si Ma guang grabbed a rock and broke the jar, letting the water escape, thereby saving his friend's life.

Chimera

The chimera is a mythological animal with a body of a feline, sometimes with pronounced wings and clawed paws, that is usually depicted crouching, with one or two horns, a ridged backbone showing through the curling spirals of his body hair, flames sprouting from his armpits. It is believed that the chimera had its origins in the Western Han dynasty. Some believe that at that time they were known as *chiwen,* a mythical dragon that lived in the sea and had the power to produce rains. Emperor Wu of the Han dynasty was cursed by numerous fires in the palace and ordered, at the recommendation of the court geomancers, that *chiwen* be placed at each corner of the roof, replacing the phoenixes that had previously held this site. To assure that the *chiwen* would not escape and to affix them to their position, a sword was driven through each figure into the roof. By the early Song dynasty, the *chiwen* evolved into the chimera. Chimera, *bixie,* literally means to ward off evil and is the symbol of a guardian.

In Chinese art, the chimera is seen as early as the Han and Six dynasties period but occurs throughout the many dynasties following its early appearance. Perhaps the most famous chimera is the large stone sculpture along the spirit path to the Ming Tombs. Chimera became a favored small jade carving subject during the Song, Yuan, and Ming dynasties.

Chrysanthemum

The chrysanthemum belongs to the group known as the Four Nobles and is emblematic of a pleasant life, generosity, and retirement from public places (*see* Four Nobles). It is the symbol of late summer/early fall and represents the ninth, *jiu,* month. It also symbolizes joviality. Its Chinese name, *jiu,* is a homonym for "wait" or "long time" and therefore suggests patience and reflection. Messages of goodwill utilize the homonym for fine *(jiu)* and chrysanthemum: "May you have a long life."

The combination of the chrysanthemum with the plum, peony, and lotus is symbolic of the four seasons.

In Chinese art, the chrysanthemum has been the subject matter for paintings as well as a decorative motif on porcelains, particularly during the Qing dynasty.

□ A Chimera. Carved nephrite, Song dynasty (960–1279). Collection Anunt Hengtrakul.

□ B Iron painting of chrysanthemum. Seventeenth/eighteenth century. Gerard Hawthorn, Ltd.

The chrysanthemum in its many varieties has also been utilized for centuries in Chinese medicine for a variety of ailments including use as a tonic. Its petals are made into a tea that is said to have sedative powers. Small yellow and white chrysanthemum flowers are sun-dried for tea and brewed during summer. The tea is said to reduce body heat during hot days or during periods when one is stricken with a fever.

Cicada

An emblem of immortality and resurrection, the cicada is also called the maiden of Qi since the Queen of Qi was said to have become a cicada when she died. The symbolism of the cicada as immortal comes from the fact that as a larva, the first form of its life is spent within the earth. In its second phase, it becomes a pupa, emerges from the ground, and its shell-like covering splits open, from which comes the cicada as we know it. In early China, when the Chinese saw the cicada coming from the ground, they believed it was rising from the dead and was immortal. Hence, it is a symbol of neverending youth.

During the earliest dynasties, it was the custom for a cicada made of jade to be placed in the mouth of a deceased person to bring them immortality.

Cinnabar

Cinnabar comes from the mineral mercury. Its name originates from the Persian word *zinjifrah*, "dragon's blood," obviously relating to cinnabar's bright red color. As a medicinal substance, cinnabar has been utilized in Chinese medicine for centuries as it was believed to extend life. Countless folk stories tell of sages who lived extraordinarily long lives because they drank elixirs that contained cinnabar, used medicinally to promote longevity. Hence, cinnabar symbolizes longevity. Since the berries of the cassia tree mock the color of cinnabar, they too came to represent longevity. The name for cassia is a pun on the word meaning "to return," both *qui*. The cassia is also said to be the ever-growing tree that is present at the Moon Palace Garden.

But cinnabar is perhaps best known as an ingredient that is added to lacquer sap, which has been utilized in China since 200 B.C.E. Forming a characteristic type of red color and medium, cinnabar lacquer can be carved into fanciful designs. When cinnabar was ground and added to lacquer, numerous coats were placed over a wood or metal substrate until the desired thickness was achieved. The layers required months to build and, finally, carving was done through the lacquer to achieve desired designs. Many of the articles were produced in imperial workshops for the court. Cinnabar lacquer was most popularly used during the Ming and Qing

A

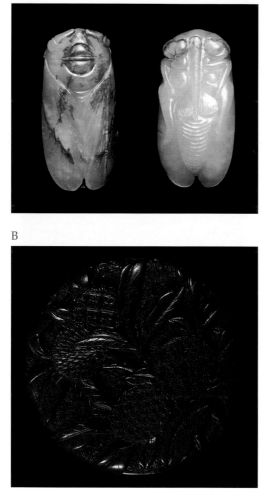

B

A Cicada. Nephrite,
 eighteenth century or earlier,
 1⁷⁄₈ inches long.
 Ji Zhen Zhai Collection.

B Cinnabar lacquer box.
 Sixteenth century.
 Ji Zhen Zhai Collection.

dynasties. Cinnabar's popularity with the emperors likely developed because of its symbolism of long life. A gift of cinnabar, then, brought with it an auspicious wish for longevity.

Cintamani Jewel

A Buddhist symbol, the cintamani jewel is the so-called "wish-granting" jewel, which is most often held by Avalokiteshvara and is capable of removing all suffering. It comes from the Sanskrit word *mani* meaning precious stone or pearl. In Chinese art, it is frequently depicted as being held by the Goddess of Mercy, Guanyin. In Buddhism, the brilliance of the jewel symbolizes the trinity—Buddha, his teachings, and his priesthood—while in Daoism it is an emblem of riches. It is also believed to symbolize the five elements of the universe—metal, wood, water, fire, and earth.[14]

The origins of the cintamani jewel are unclear. There is a Buddhist story of a merchant who was a paragon of filial piety. Seeking to provide for his needy father and mother, he brought them a jewel from the sea that came from the brain of a giant fish. Another story maintains that the giant jewel came from the brain of a *naga*, a mystical serpent, and that if one possessed it, he could escape from poisons and all manner of ills.

Clouds

Clouds, said to be formed by the union of yin and yang, are symbolic of the celestial realm, happiness, and good fortune. This positive symbolism no doubt is related to the fact that clouds are associated with rain, which is so important to an agrarian society. One of the earliest symbols in Chinese art, clouds can be seen depicted in crude line drawings as early as the Han dynasty. During the Song dynasty, cloud patterns took on a lobed form that appears somewhat like the head of a *lingzhi* fungus (*see* Lingzhi Fungus). Some scholars suggest that these clouds may in fact have been the prototype for the fungus of immortality. During the Ming and Qing dynasties, clouds became more curvaceous, often taking on a flamelike appearance. Clouds, which are depicted in five colors, are said to be an emblem of the Five Blessings (*see* Five Blessings). On imperial patterns on informal court robes, they are represented in depictions of the universe over which the emperor is the divine ruler. On the robes, they are represented in the vast areas of the skies above the mountain and water that are at the base.

Clouds undergo stylistic changes on court robes from the earliest reigns to the late nineteenth century, becoming increasingly more decorative and stylized, thereby giving important clues in the dating of garments as well as objects.

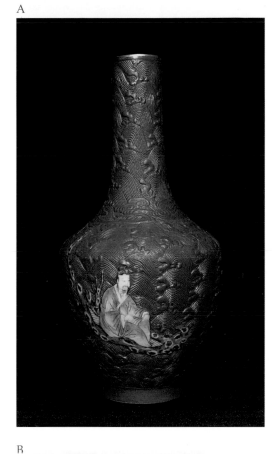

A

B

□ A Porcelain vase imitating cinnabar. Qianlong mark and period (1735–96). Ji Zhen Zhai Collection.

□ B Dragon among clouds on foliate celadon dish. Late Song dynasty (960–1279 C.E.), 7^5/$_8$ inches in diameter. Ji Zhen Zhai Collection.

Cock

A symbol of courage and faithfulness, the cock is also the representative figure of the tenth branch of the zodiac (*see* Rooster). Folk legends note that the cock protects one's home from fire. Enhancing its importance, the cock has long been used in Chinese medicine in addition to being an important food source. Noting its prolific symbolic representations, the cock has been subject matter for pottery, porcelain, paintings, and sculptures for centuries.

Cockscomb Flower

The flower known as the cockscomb takes its name from the shape of the comb of a rooster, which it resembles. The comb of the rooster, *guan,* has the same sound as the word for official, *guan.* Therefore, the cockscomb flower takes on the symbolism of an official. Depictions of the cockscomb flower express a wish that one may have fame as an official.

The cockscomb flower appears in eighteenth-century porcelains from the imperial kilns, albeit infrequently. In spite of the fact that it visually represents such an auspicious wish (to have fame as an official), for reasons that are unknown, it was not popular with artisans.

Coins

Coins have many symbolic meanings in Chinese culture, all of which have to do with wealth and riches. The coin is one of the Eight Precious Things. The name *huan fu,* or "round coins," was "applied to metal currency by Dai Kung in the eleventh century B.C.E." The coins were copper and described as "square within [referring to the hole to string the coin] and round without."[15] The round coin and square center represented the union of heaven and earth.

The coin is one of the emblems that is sometimes carried by the Daoist figure Liu Hai. While he is more frequently depicted with his three-toed frog, he is at times portrayed with a group of coins strung on a long cord. This latter depiction makes him a favorite talisman for gamblers. Representing wealth, two coins are a frequent symbol found over the entrances of stores. This symbol expresses a wish for wealth to be gained in this particular business.

The word for money, *qian,* is the same as the word for "before," which is the basis for the pun meaning "May riches and happiness be before your eyes." A string of nine coins symbolizes a wish for uninterrupted happiness. Therefore, a visual rebus is formed by nine coins.

□ Album painting for the Moghul market showing vase of cockscomb flower. Nineteenth century. Phil Wood Collection.

The number three, *san,* is the basis for the rebus, *lian san yuan,* a wish that one pass all three Civil Service Examinations. Three represents the cosmic trinity of the union of heaven, earth, and coins used by man to bring riches. Passing all three Civil Service Examinations would also bring riches.

In Chinese folk beliefs and feng shui practice, ancient Chinese coins symbolized good luck. Coins were carried as talismans to ward off evil. There is a folk custom of stringing a hundred coins together with red string and giving it to children on New Year's Eve. This is called *ya sui* money, *ya* meaning suppressing and *sui* meaning evil. Children are also given fruits on this evening that are called *ya sui* fruits, conveying the same meaning of suppressing evil.

Similar in meaning as having Liu Hai as a talisman for gamblers, it is the custom of travelers to carry a coin on a string. This may have been related to the custom of travelers carrying a round piece of jade that was also strung on a cord protecting them from evil.

□ Rug with coin design border.
Early twentieth century.
Ji Zhen Zhai Collection.

Colors

According to Chinese thought, the universe had five directions. Animal deities, five colors, five elements, and seasons symbolized these directions. The five colors of the Chinese universe were yellow, the center, associated with the emperor; red, the south, associated with fire and used for marriage and birth; black, the north, associated with the water element; blue, the east, associated with the element of wood; and white, the west, associated with metal and the color for mourning.

□ Yellow: Yellow, *huang,* has the same sound as the word for emperor. The color was reserved for the Qing emperor and his sons. A slightly different shade of yellow was worn by Buddhist priests; the dead were also buried in this color. Charms against evil were often written on yellow paper and pasted on doorways to drive away evil spirits.

□ Red: Red, *hong,* is said to ward off demons and evil. It also has the same sound as the word for enormous, *hong,* and therefore is a punning word when paired with other symbols. For example, *hong fu,* red bat, means enormous fortune and happiness. As the color red wards off evil, it is also the symbol for happiness

and blessings. The origins of the symbolic use of red are related to the early custom of making a sacrifice to the gods; an animal was slain and its blood smeared over the lintels and posts of doors. This custom was later replaced by the use of red paper. The color and symbolism extended to other customs such as the giving of money wrapped in red paper at New Year's, couplets written on red paper placed on doorways at New Year's, and the custom of a bride and groom partaking of cups of wine tied together with a red cord.

- **Black:** Black, *hei,* is the symbol for the north, the element water, as well as darkness. It also is a symbol for honor. A vase, *ping,* symbolizes peace, while a black vase is symbolic of peace and honor.

- **Blue:** The word for blue, *lan,* found in later literature actually refers to indigo. In early China, references to blue had ambiguous connotations: for example, blue-faced creatures were demonic; Kuixing, the patron saint of scholars, also known as the God of Literature, was depicted as blue-faced since he had committed suicide. In contrast, in later periods blue had very positive symbolic meaning in that it became associated with rank, privilege, and scholars and was the primary color of robes worn by court officials.

- **White:** To say that the Chinese consider white, *bai,* to be the color of mourning is not an accurate statement. At the time of mourning, clothes are worn that are of a natural fabric, unbleached and uncolored, basically ones that lack color or design. White, when seen as a color, has other significance—both positive and negative. It symbolizes purity, especially when it is shown in the form of a white lotus. And as with purity, it symbolizes virginity. It further symbolizes the autumn and wisdom that comes with age. Scholars who were not yet assigned to positions after passing their Civil Service Examination wore robes of white and depictions of scholars carry out this theme. The emperor never wore robes of white.

- **Brown:** Brown, *he,* was the royal color during the Song dynasty and usually represented the earth. After the Song dynasty, it was replaced by yellow, which symbolized the center, the emperor being the center of all existence. This is seen symbolically in Mandarin court robes where brown robes are fashioned for members of the imperial family and yellow is reserved for the emperor.

- **Rust:** The color rust, *che,* has come to symbolize banishment and punishment. The color is that of dried blood. The origin of this symbolism apparently lies with the Farmer God, Shen Nung, who, according to folk belief, whipped the kernels and seeds to release their essence. His whip was said to represent regeneration and was rust in color.

- **Green:** The royal color during the Ming dynasty and the color for spring and life. It was the color of the robes of the God of Literature. However, green, *lu,* also has a negative meaning since a green hat, *lu mao,* symbolizes a cuckold.

Conch Shell

The origin of the conch shell symbol may be twofold. One may be related to a mythical beast, a dragonlike monster called the *shen* monster that was said to have lived over the Eastern Sea. This *shen* monster had the power to change itself into any sea animal form and sometimes was pictured rising from a giant conch shell. This representation is sometimes seen on the base of Qing Mandarin informal robes, above the *lishui* stripe pattern, in the form of vapors with a pavilion rising from a frog or conch shell.

The other may be from the conch shell of India, which was used functionally as a trumpet. Sounds emanating from the conch shell were used to transmit messages from officers to the troops that they commanded. It would appear that the conch shell symbol was borrowed from its original purpose, a transmitting device, by Buddhism and incorporated into its beliefs to represent the transmitting of the word of Buddha, his teaching, to people. It then came to symbolize royalty, high rank, and the sacred lungs of the Buddha. It is one of the Eight Buddhist Symbols and one of the auspicious signs on the Footprint of Buddha. In Chinese Buddhism, it also came to signify a good journey.

The conch is not only a Buddhist symbol but also has folk meaning from the story of Xie Duan of the fifth century. This story tells of the orphan Xie Duan who was cared for by his neighbors after his parents had died. One day Xie Duan, who diligently worked the fields without complaint, found a large conch shell and pondered how it came to be in a farmland field so far from the sea. When he returned home, he put the beautiful shell into a large jar and forgot about it. The next day when he returned home from toiling in the fields, he found dinner prepared and waiting for him. Thinking that this was the work of his neighbors who were aware of his hard work and kindness, he went to thank them, but they indicated that they had no awareness of this good deed. At first he thought that they were protesting their kindness, as is customary, in order not to embarrass him, but as time continued, he began to believe them as he thanked them time and time again only to have them protest. He was perplexed. One day he returned home early and was startled to see through the window a beautiful woman appear from the shell in the jar. He secretly watched her as she lit a fire in the stove and began to cook a sumptuous meal, as he had become accustomed to find at his table. When he suddenly made himself known to her and humbly asked who she was, she revealed that she was a spirit sent from heaven. However, as he had now seen her, she could no longer remain on earth. She whispered that if he put rice in the conch shell, his supply of rice would be neverending and with that she suddenly vanished in a gust of wind.

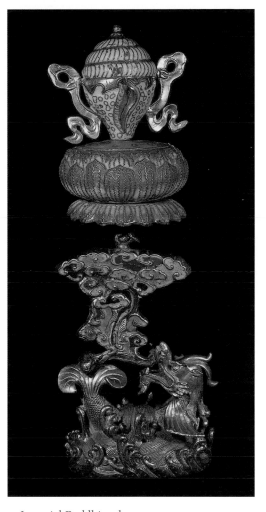

□ Imperial Buddhist altar emblem surmounted by conch. Gilt bronze and cloisonné, Qing dynasty, Yongzheng period (1723–35). Ji Zhen Zhai Collection.

In sculptural art, Xie Duan is depicted as a man who holds a conch shell or is sometimes represented solely by the conch shell. He and the conch shell represent goodness that comes to one who works hard.

Confucius

Confucianism (a Latinization of Kong Fuzi) founded by Confucius (551–479 B.C.E.), emerged toward the end of the Zhou dynasty. It became a major religion, one of the three great religions of China, until banned by the Communists. Its basis is belief in strict moral laws. Confucian philosophy emphasized filial piety, devotion to and honor of the family, education, and ritual. These were felt to provide a cohesive influence in maintaining and strengthening society with a great reliance on the past. For its examples, it turned to the time when China was ruled by sages who provided for both justice and peace. *The Confucian Analects,* or *Luen yu,* identified the sayings of Confucius as well as rules of conduct. *Twenty-Four Stories of Filial Devotion,* or *Ou Shu Si Jiao,* idealized how children made sacrifices for the love and honor of their parents. The five classic books of Confucianism included the classic *Yi Jing,* or *The Book of Changes,* and all landowners and nobles were required to memorize all five books. Archaic bronzes and ritual objects are symbols of Confucianism

In spite of the fact that Confucianism tended to oppose the worship of traditional gods and many of its teachings ran counter to the teachings of Daoism, it lived in harmony with both Buddhism and Daoism and many of its beliefs and customs were absorbed into Chinese Buddhism and Daoism.

◻ Cong. Nephrite, Han dynasty (206 B.C.E.–220 C.E.) or earlier. Private Collection.

Cong

The *cong* is a ritual jade object that was first found in the Liangzhu culture of China (c.3300–2200 B.C.E.). A squared tube of jade of varying lengths with a round interior, the corners sometimes had masks carved on their surface. Jade *cong* were made throughout the various periods and continue to be made today.

The exact symbolism for these ritual objects is not known. However, some scholars believe that the square represented the earth while the inner circle represented heaven. Ritual jades such as these were objects of the elite class and were said to show the relationship between man and heaven.

Constellation

The constellation, *xing,* is one of the Twelve Symbols of the Emperor and symbolizes the cosmic universe which the emperor rules and controls. It is one of the twelve symbols that are found on the robes of the emperor.

Coral

Coral, *shan hu,* is not native to China, but was first imported from the Middle East. Once it was available in China, it was commonly and frequently utilized as a medium for all types of decorative and sculptural work. It was absorbed into Chinese culture and took on symbolic meaning. It was one of the original Eight Precious Things (but didn't evolve into one of the Eight Ordinary Symbols), and beads of coral were woven into the finest court robes as well as court accessories. Coral also was incorporated into the finial of the hat of the second-rank civil official.

A folktale identifies coral as a tree that grows in the ocean and blooms but once every hundred years. It symbolized longevity and officialdom and was used most during the Qing dynasty. Coral of the eighteenth century, which has a more orange hue than the coral of the nineteenth century, is particularly sought after.

□ Symbol for constellation, detail from twelve-symbol imperial robe.
Eighteenth century.
Linda Wrigglesworth, Ltd.

Cosmos

The cosmos is depicted in the basic pattern combining symbols of the earth, water, and sky. This pattern, representing that over which the emperor ruled, is seen on many imperial objects, perhaps most clearly on the court robes of the Qing dynasty. There it is collectively represented by the earth, symbolized by the mountain in the center at the base of the robe; the sea, by the waves of the *lishui* stripe pattern beneath the mountain; and the vastness of the sky above, which is filled with clouds.

Crab

The word for crab, *xie,* is a homonym for the word for those who have passed the first examination toward official rank, *xie.* A crab is therefore symbolic of achievement.

Two crabs in the rushes forms a complex pun, *er jia chuan lu,* meaning "two suits of armor (crabs) through the rushes." This has the meaning "First place in the *er jia,* the second class of the court civil exam, of the jinshi degree."[16]

In folklore, the crab can repel bad magic and also restore a man's potency.

Crane

The crane is the symbol of longevity and also the emblem of superhuman wisdom. The crane's affinity for long life comes not from the crane itself but from the color of its white-feathered body, the white creature that dwells on the Penglai Islands, the home of the immortals. Folklore writing proclaims that the crane, *he,* can live more than six hundred years and has the ability to carry the souls of the dead to the Western Paradise. According to mythological tales, Xi Wang mu, the Queen Mother of the West, had a sacred crane that she used as her vehicle to travel between Penglai Islands and Earth. It is perhaps this tale that relates to the custom of placing a figure of a crane on the coffin during a funeral. This custom takes on the symbolic meaning of providing a vehicle for the deceased to travel to heaven. Although this custom is based on Daoist beliefs, it has been absorbed into Chinese culture in general.

The crane, along with the pine tree, is the most common symbol of longevity. However, when it is utilized in combination with the pine tree, it takes on a special meaning, *song he tong chun,* which wishes the bride and groom a long life together until old age. Hence, the crane and pine are frequently the subject decoration of marriage gifts.

While a pair of cranes represents a wish for a long marriage, a crane flying in the sky symbolically represents a wish for a rise in status.

The crane also symbolizes wisdom. When the crane is at rest, it appears to be contemplating.

Because a young crane responds to the cries of its father, an expression of true filial piety, the crane also represents closeness between a father and son.

When the crane, *he,* is pictured with a deer, *lu,* their names form a symbol meaning the universe or longevity, *lu he.*

The crane pictured standing in the rising tide signifies a wish for promotion to the first degree in the imperial court.

As a motif, the crane is seen in almost every medium. On Mandarin robes, it conveys a hope for a long life of the wearer and is usually depicted flying or curled into decorative medallions. It is the emblem of civil officials of the fourth grade, and therefore the crane is a symbol of rank and status.

A rather unique group consisting of the crane, stag, and toon tree, a combination found on old Chinese rugs, is called *he lu tong chun* and symbolizes a wish for official promotion in the spring or a wish for longevity.

□ Crane and pine.
Embroidery, eighteenth century.
Private Collection.

Cricket

Crickets symbolize summer, and records indicate that they were collected and kept as symbols of luck and virtue as early as 770 B.C.E. It wasn't until the beginning of the Tang dynasty that they were kept purely for their chirping or song. Hundreds of crickets were kept in cages in the imperial city so that their sounds could be heard everywhere. It is documented in the book *Kai Yuan Tian Bao Yi Shi (Affairs of the Period of Tian Bao,* 742–759 C.E.) that when autumn arrived, the ladies of the palace would catch crickets and place them near their pillows so that they could hear their sounds. The common folk also did this. However, it was further written that the sounds of the crickets were not entirely a pleasurable sound but rather "the concubines heard a reflection of their own sadness and loneliness in the cricket's chirp."[17] This statement referred to the fact that the life of the concubine was not a rich emotional experience but one that was indeed lacking.

The cricket was also a symbol of courage and high position. Its associations with courage stem from the popularity of gambling on cricket fights. Particularly during the nineteenth century, many materials relating to cricket fighting were produced, such as cages, fighting containers, ticklers (stimulating devices that consisted of a slender piece of bamboo fitted on one end with hairs), water dishes, and so on.

The cricket forms the basis for the rebus *guan jiu yi pin.* This rebus relates to the cricket, which also has the name *guo guo,* which sounds similar to *guan* (official); the chrysanthemum is called *jiu,* which sounds like the word "to sit"; and *yi pin* is a first-rank official. It likens the cricket sitting on a branch of a chrysanthemum to a scholar for whom it is wished that he could hop quickly to a high rank.

Crow

The crow is well represented in Chinese mythology, which identifies the crow, *wu ya,* as the center of the sun. The crow carries the sun to the crest of a leaning tree before it goes on its daily journey across the sky. The three-legged cock, which is on the sun disk, one of the Twelve Symbols of the Emperor (found on but not limited to imperial robes of the emperor), was said to be originally a three-legged crow. A Daoist legend tells that there were once nine crows on the sun and that the Earth suffered from the intense heat that they generated. The legendary archer Hou yi shot down all but one of the birds, and the heat dissipated.

Symbolically, the crow is seen as bearing both positive and negative omens. Representing the sun, it is said to be a symbol of filial piety as it provides care for

☐ A Detail of a painting depicting crickets by Yu Fei an (1888–1959). Horacio Fabrega Jr. Collection.

☐ B Incense container in the shape of a crow. Mother of pearl inlay, late eighteenth century. Ji Zhen Zhai Collection.

its aged parents. This symbolism is represented in the numerous depictions of the crow, particularly on porcelains from the imperial kilns. On the other hand, folk beliefs proclaim that the sound of the crow is an unlucky omen and foretells evil. Its crowing sounds like *yao* are deemed similar in sound to the Chinese word for "bite," *yao*. Many gamblers feel that the crow foretells of bad luck and if a crow is seen, one is warned that it is a bad-luck day.

Crystal

Crystal, *shuijing,* has the meaning of crystallized water. It is a symbol for clarity, purity, and honor. With such symbolism, scholars' objects fashioned from crystal were highly prized for these qualities were among the finest that scholars were to emulate. Crystal is also prized for its beauty and uniqueness.

Flawless, clear crystal also symbolizes sacredness and perfection and is said to ward off evil while bringing good luck. It further signifies solitude and soberness in behavior and thoughts. The Dowager Empress was known to prize crystal, feeling that it would ward off evil and would bring her good luck. One of the items that she prized most highly and wanted to be in her surroundings was a large ball of purest crystal, now located in the rotunda of the University Museum of the University of Pennsylvania. The symbolism of sacredness and perfection may be reflected in the home of the Moon Goddess, Chang E, which was called the *Guanghan Gong*, Broad Cold Palace.

Cups (Paired)

Paired cups are a symbol of filial piety since they represent sacrificial vessels to honor one's parents. They are one of the Twelve Symbols of the Emperor. One cup symbolizes strength, represented by an image of the tiger, and the other cup cleverness, represented by an image of the monkey.

Cypress

Cypress trees symbolize longevity. They convey a visual picture of age as they appear twisted, contorted, and aged and yet have new growth.

But the tree also has another meaning. Cypress, *bo,* is a homonym for the word for "earl," a position of title. The cypress when depicted expresses a wish for attaining a high position of title and can be seen on porcelains and in paintings.

A

B

□ A Crystal brush rest in the shape of a mountain. Eighteenth century.
Ji Zhen Zhai Collection

□ B Paired cups. Detail of imperial twelve-symbol robe.
Eighteenth century.
Linda Wrigglesworth, Ltd.

Damo

Bodhidharma, commonly known in Chinese as Damo, is documented as the first patriarch of Chinese Chan Buddhism.[18] Damo, shortened from P'u D'i Da Mo, was an Indian Buddhist monk who came by sea to South China circa 520 C.E. He had an audience with Emperor Wu Di of the Liang dynasty shortly after entering China, at which time he offended the emperor by advising him in the ways of true enlightenment, implying that his ways were not true. Having offended the emperor, he was not welcome; he traveled north and crossed the Yangzi River to start his own teachings of Buddhism through Chan (Zen) meditation. He was the founder of the Shaolin Monastery in the Song Mountains of Henan Province that was built in the Northern Wei period (386–534 C.E.). Legends tell that besides Chan meditation, he invented and developed a series of rigorous boxing exercises *(kungfu)* known as the *Shaolinquan,* which strengthened the physical bodies of the monks in addition to silent meditation that strengthened the mind. The training of *Shaolinquan* is still practiced today.

Legends about Damo are closely related to the way he is depicted. For nine years, he is said to have meditated facing a wall with intense concentration and dedication in the Shaolin Monastery. The intensity of his concentration for such a lengthy period led to folk depictions, particularly popular in Japan, of a figure without arms and legs, which he is said to have lost through disuse. He died in Loyang in 536 C.E., and a monument was subsequently erected to his memory at the monastery where he had kept his long vigil. He is also commonly depicted in paintings as standing on a blade of grass or banana leaf while crossing a river, or he is simply standing and floating, his arms covered by robes, staring with piercing eyes. This symbolizes his weightlessness on water. He symbolizes concentration, wisdom, soberness, and dedication.

It is also recorded that the tea ceremony was created in honor of Damo. Legend records that Damo was meditating and began to fall asleep. Angry at his lack of concentration, he tore his eyelids from his face and threw them aside. From the spots where his eyelids fell, tea plants began to grow.

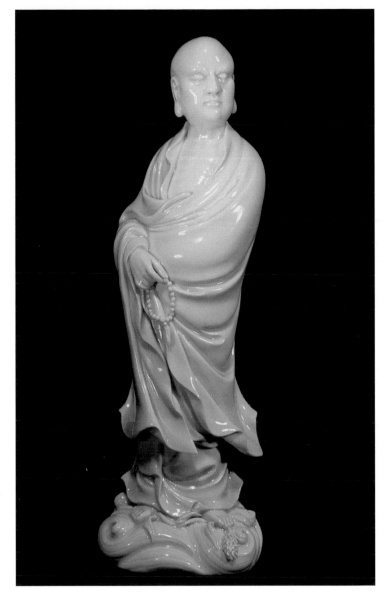

□ Damo.
Dehua ware, eighteenth century.
Ji Zhen Zhai Collection.

Daoism

Daoism is one of the three great religions of China. *Dao,* meaning road, has its origins as early as the Warring States period (475–221 B.C.E.), but it was not until the sixth century C.E. that the Daoist philosophy was developed based on earlier concepts. It became associated with the sages Laozi (Lao-tzu) and Zhuangzi and had a great influence on Chinese culture. Daoism teaches that there is no supreme god but rather that the Dao serves as a "guide for human behavior and experience." The *Daode jing,* the basis of Daoism, teaches the importance of cultivating simplicity, detachment, and virtue, and of living in harmony with the natural world.[19] Spiritual balance is sought through chants, rituals, and special charms in the pursuit of longevity and emotional health.

In spite of the fact that Daoism teaches that there is no supreme being, many gods evolved from folk heroes and beliefs. The concept of yin and yang, complementary forces, originates from Daoist philosophy that teaches that balance is ideal—it is the unity of opposites that should be sought and not the opposites of one another.

Date

The date fruit, *zaozi,* is a homonym for the word meaning early, *zao.* It is therefore a punning word and symbol for early arrival of sons, *zi.* When paired with the lichee nut, it has the meaning of a wish for many sons. The symbolic meaning of the date as well as the lichee makes it a favorite fruit for gift giving, particularly during holidays, as its wishes are auspicious. Both are frequently depicted in paintings and on porcelains. There could be no greater wish for the Chinese than a wish for many sons.

The date is sometimes pictured, albeit infrequently, with the cassia tree and has the symbolic meaning of a wish for many sons who will become civil servants, *zao sheng gui zi—zao* meaning "early," *sheng* meaning "give birth," *gui* meaning "prestige," and *zi* meaning "son." This arises from the symbolic meaning of the cassia tree, which in folktales grew in the Moon Palace to such enormous heights that it could hide the moon. To break a branch from this rapidly rising tree had the symbolism of passing the Civil Service Examination.

Deer

The deer symbolizes immortality and is the companion of the God of Longevity, Shou Lao. It is often pictured with fungus of immortality in its mouth and is said to be the only animal capable of finding the sacred fungus of immortality. Its being a symbol of longevity no doubt influences its use in Chinese medicine, where it has been an important ingredient for centuries. The ground horn of the deer is believed to extend life, and to this day, pulverized horn is made into pills and administered to prolong life.

The deer also represents filial piety. This representation comes from the folk-tale of Zhou Yan zi. This tale tells of a son whose father was ill. He longed to obtain the milk of a deer, which would give his father strength. To achieve his goal, he ultimately posed as a deer so that he could pass into a herd of deer to gather the milk.

The word for deer, *lu*, forms a homonym for the word for the salary of a Chinese official, *lu*, a pun on the word for wealth. It can also represent nobility and success in scholarship.

A depiction of a hunter stalking a deer is a visual pun, which means a person is gaining or seeking an official's salary.

Dipper Mother

The Dipper Mother, who is the mother of the stars making up the Big Dipper, is a Daoist figure. Appearing in the early Ming dynasty, the Dipper Mother is associated with the moon, Chang E, and Chang E's hare that grinds the herbs of immortality.

The Dipper Mother is worshiped by Daoist women who will give birth or mothers who hope to cure an illness. Figures of the Dipper Mother are usually characterized by her holding disks representing the sun and moon.

Dog

The dog is the eleventh sign of the Chinese zodiac. The dog, *gou*, has had a variety of symbolic meanings, but is most commonly seen as a symbol of fidelity and alertness. A dog arriving at one's home is said to portend future monetary gain.

The earliest representation of a dog in Chinese art is engraved on a Chinese bronze of the Zhou dynasty. During the third millennium B.C.E., it was the custom to place a dog at the feet of the dead. This custom was to protect the soul of the dead and accompany his spirit to heaven. Later dynasties, particularly the Han and Tang,

changed this custom by replacing the actual animals with representational figures of dogs made of pottery, both glazed and unglazed.

The dog is not seen on Chinese Mandarin court robes, formal or informal, nor is it commonly seen on imperial porcelains. During the Qing dynasty, for the export market, figures of dogs and porcelains with dog motifs were popular and made in all shapes, sizes, and glazes. These export items in the eighteenth century were of high quality but just as in imperial porcelains, there was a distinct drop in quality during the decline of the Qing dynasty. In folk art, particularly late folk art, it is a frequent motif, particularly on children's hats and clothing. A charm was made of hair from a dog mixed with that of the child and sewn in the garments of a child's clothes to prevent the child from coming into harm's way. This arises from a folk story where the Heavenly Dog, who is said to be the soul of a young girl, looks for a child so that she can be reincarnated.

The most famous dogs in China are no doubt the prized Pekinese, the "Buddhist Lion," which were the favorite of the Dowager Empress Cixi who also used the symbolism, Buddhist Lion, to keep alive her ties with Lamaist Buddhism (*see* Lamaism). Stories of her love of these little Buddhist Lions are legendary and there are countless accounts of her surrounding herself with these dogs in the palace.

Donkey

In contrast to the West where the donkey is seen as a stupid, stubborn animal that has little value for its beauty, in China the donkey is seen as an animal that works steadily through difficulties. And so, the donkey depicts qualities of the scholar that are admired. In paintings, it is the animal that the scholar rides to his mountain retreat and the animal that bears the loads of the scholar's belongings when the scholar seeks solace in far away places. The donkey, while being a vehicle for the scholar, conveys the meaning of a steadfast life devoted to simple goals and truths.

The donkey is also the vehicle of the Daoist Immortal Zhang Guolao, the wanderer. His donkey was known for its particular strange qualities (*see* Eight Daoist Immortals).

□ Detail of a painting depicting donkeys by Gao Qibei (1672–1734). Ji Zhen Zhai Collection.

Double Yang Festival

Double Yang Festival, *Chong Yang,* is celebrated on the ninth day of the ninth lunar month. It is the custom on this day to sew a cloth bag, fill it with dogwood branches, carry it to a mountaintop, and drink chrysanthemum wine. These rituals

are done to avoid disaster. Although kite flying was not part of the original custom, it has since been absorbed as part of the ritual of this holiday, perhaps owing to the saying "On the ninth day of the ninth moon, the howl of the wind fills the sky."

The origins of this celebrated day are related to the Han dynasty tale of Huan Jing and Fei Chang fang. In this folk story, Huan Jing was studying the immortal arts of the Daoist monk Fei Chang fang, who warned Huan Jing that on the ninth day of the ninth month a great tragedy would strike his home. In order to avert the chaos, his family was to sew dogwood branches into a bag, take it to the mountaintop, and drink chrysanthemum wine. Having great faith in his teacher, Huan Jing did so and when he and his family returned home after the ninth day of the ninth month, he found all his animals had been slaughtered. Huan Jing and his family would also have been killed if they'd been there. From that day forward, it has been the custom to do as Huan Jing did on the ninth day of the ninth month.

It should be noted that the ninth day of the ninth month is also a day for celebrating filial piety, a Confucian influence. On this day, Double Nine Cakes are eaten for good luck. This expresses the rebus of the homophoneous words for cake and high, *gao*.

Dove

The dove, *gezi,* represents longevity, filial duties, fidelity, and marital harmony. The connection of fidelity and marital harmony is born from the fact that doves are usually seen in pairs and the belief that doves mate for life, as the goose does. It is said that the dove's cooing is further a sign of harmony with one's mate, and whistles were made to simulate their sound. The attribute of fidelity is perhaps best shown by the dove paintings of the Tang and Song dynasties, in which pairs of doves stand on branches laden with fruit. During the Han dynasty, it was the custom to present the eldest member of one's family with a staff topped with a finial in the form of a dove, which symbolically expressed a wish for long life. The symbolism of filial duty comes from the manner in which the adult dove feeds its young its regurgitated, digested food.

Dragon

No other creature is more associated with China than the dragon, but unlike dragons in the West, the dragon of China is seen as a positive creature. Dragons were said to control the earth and the heavens from which the rains came to nourish crops. From the earliest times, dragons have been depicted on objects. There are some who believe that the dragon was actually a folklore expression of the alligator,

◻ Album painting for the Moghul market depicting doves. Nineteenth century. Phil Wood Collection.

which was originally found in the rivers of China but is now extinct. A writing from the Song dynasty describes the dragon as having the head of a horse and the tail of a serpent. It has nine "resemblances": horns like a stag, head like a camel, eyes like a demon, neck like a snake, belly like a sea monster, scales like a carp, claws like an eagle, pads like a tiger, and ears like an ox. Nine being a number of great significance, a yang number, the number nine in later dynasties became synonymous with being imperial.

The dragon permeates Chinese history, Chinese folklore, Chinese religion, and Chinese art. Indeed there are stories regarding the dragon in Buddhist and Daoist literature. The dragons of the Song dynasty had three claws; the origins of the five-clawed dragon that later came to symbolize the emperor is not really known. However, it is said that during the Mongol conquest of China in the Yuan dynasty, the Tartars introduced the idea of an imperial five-clawed dragon, perhaps to show superiority over the emperors of China. There are those who believe that as early as the Han dynasty, the five-clawed dragons symbolized the emperor, but the five-clawed dragons' actual dominance over the three-clawed dragons is mentioned in Yuan dynasty literature.[20] It was at the time of the Song dynasty that the three-clawed dragon was no longer seen in Chinese depictions. In 1652, after the fall of the Ming

A Dragon roundel.
Embroidery, seventeenth century.
Ji Zhen Zhai Collection.

B Imperial dragon brush rest.
Wanli mark and period
(1573–1619).
Ji Zhen Zhai Collection.

A

B

dynasty, the Qing emperor gave strict orders regarding imperial robes, and five- and three-clawed dragons were reserved for the emperor and his family. Four-clawed dragons were reserved for nobles and other high officials. This is not to say that five-clawed dragons did not symbolize the emperor during the Ming dynasty, for much of what was present during the Ming dynasty was carried over into the Qing. Moreover, we are aware of five-clawed dragons on robes of the Ming dynasty.

In addition to being one of the Twelve Symbols of the Emperor, the dragon is the symbol of the emperor himself; it is the fifth of the symbolic creatures of the Twelve Terrestrial Branches. The symbolism of the dragon and the emperor being as one had its inception in the third century B.C.E. with Gaozu, the founder of the Han dynasty. Emperor Gaozu, also named Liubang, was born of a peasant family and was one of the leaders of the peasant revolts in the late Qin dynasty, eventually leading to the establishment of the Han dynasty, which was to last more than four hundred years. Legends of Emperor Gaozu claim that his mother, who was without child, had a dream one evening that a dragon entered her and she subsequently became pregnant. Gaozu claimed that this omen indicated that he would be a ruler and that a dragon fathered him. The dragon also symbolizes goodness and, of course, power. It is also a guardian of treasure. Paired with the pheasant, it represents the entire natural world since the pheasant represents the kingdom of birds and the dragon the kingdom of animals.

The number nine that is associated with imperial dragons, a strong yang number, permeates the Chinese culture and extends to wishes made to newly married couples. The saying *"yi long jiu zi, ge zi bie"* is a common wish to newlyweds that translates to "The dragon has nine sons, each one different," expressing a wish for many sons.

Dragon and Phoenix

The symbol of the dragon and phoenix together exists as early as the State of Chu (500–223 B.C.E.), where they are seen in paintings on lacquers. But by the Han dynasty (206 B.C.E.–220 C.E.), they had become symbolic of the emperor and empress and were said to be present on earth only when the empire was a just one. The dragon and phoenix design therefore originally symbolized the power of the empire and became a design motif on imperial porcelains. As with most decorative motifs, over time the original symbolism lost its meaning. By the end of the Qing dynasty, the dragon and phoenix evolved into one of many decorative motifs. This is particularly evident in the late export wares of the nineteenth century that were sent to Europe, where dragon and phoenix vases were highly ornate, decorative, and produced in kilns throughout China without imperial supervision.

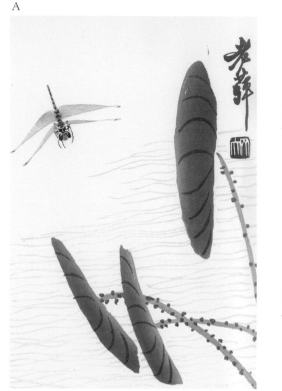

For the common people of China in the late Qing dynasty, the dragon and phoenix came to symbolize husband and wife together, particularly at the time of the wedding, where the woman was seen as being the empress for a day.

Dragonfly

The dragonfly, *qingting,* seems to have conflicting symbolisms. In some instances, it is a symbol of summer and warmth owing to the season when dragonflies are plentiful. It is also a symbol of vulnerability. Perhaps the latter symbolism comes from the fact that they often appear in the south of China before the typhoon season. In depictions, they are almost always seen with flowers, particularly the lotus. In these instances, they symbolize the beauty and pureness of the summer season.

Drum

Drums exist in all cultures, and in Chinese culture, the drum, *gu,* primarily symbolizes a call to a ceremony or military movement. Associated with religious ceremonies or war, the early drums of China were constructed of clay and covered with animal skins. Di Gu, of the late Zhou dynasty, is said to be the God of Music, who, in addition to inventing the drum, invented bells, chimes, and wind instruments.

A specific type of drum called a "fish drum" is the emblem of Zhang Guolao, one of the Eight Daoist Immortals (*see* Eight Daoist Immortals). The fish drum has a rather unique appearance, and frequently when Zhang Guolao is depicted, he is mistakenly thought to be holding a tube of bamboo. What he is actually holding is his emblem, the fish drum, which is a tube of bamboo with one end tautly covered with the skin of a snake. This instrument is played by tapping the skin with the fingers. Besides being the emblem of the Daoist Immortal, it is also the emblem of fortune-tellers. In the latter instance, the drum conveys a means of communicating with the spirits.

A cock standing on or near a drum is an emblem of peace. This meaning stems from the legendary rule of the Yao, said to be the first emperor of China who reigned in 2356 B.C.E. Legends tell that the drums that summoned the troops to battle fell into disuse during the rule of the Yao, a long period of peace and prosperity, and

☐ A Painting of dragonfly and lotus by Qi Baishi (1864–1957). Private Collection.

☐ B Drum-shaped jade paperweights. Eighteenth century. Ji Zhen Zhai Collection.

were cast away. The unusual combination of the cock standing on the drum signifies this time of peace.

Duan Stone

The *duan* stone is the most common of the stones utilized for inkstones. Mined in the Zhaoxian district of Guangdong Province, early texts of the Song dynasty such as *Yulin shi pu (Cloud Forest Stone Records)* record the desirability of these inkstones by scholars (*see* Inkstone). Du Wan, one of the Song connoisseurs of inkstones, identified four main types and colors of *duan* stones that came from both mountain caverns and riverbeds. The deep purple stones with smooth and tightly packed fine granules were considered to be the best; those having "stone eyes" of blue-green were the most attractive. These stone eyes are highly prized by connoisseurs of inkstones; *duan* inkstones with large numbers of these eyes are particularly sought after.

It should be noted that the Zhaoxian district of Guangdong developed into a rich area from the mining of its *duan* stone. With the stone's positive effect on the economy, folktales grew regarding the *duan* stone and its influence on the area.

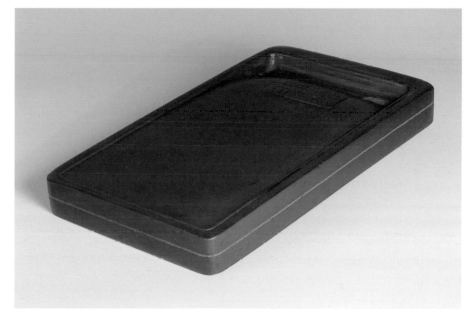

□ *Duan* inkstone.
Seventeenth/ eighteenth century.
Ji Zhen Zhai Collecction.

Duanwujie

Duanwujie, the Dragon Boat Festival, is celebrated on the fifth day of the fifth lunar month and symbolizes the overcoming of evil forces and poisonous creatures. This lunar festival is said to commemorate the drowning of Qu Yuan, the famed statesman who committed suicide by drowning in the Mi Lo River during the third century B.C.E. in protest of a corrupt government. Legendary folk stories recount that the townspeople attempted to save his life by boating to him while beating drums to frighten away the fish that would devour his body. The Dragon Boat Festival is said to honor Qu Yuan, the racing boats simulating the townspeople racing to rescue him. It is also the custom

to throw dumplings into the water to distract the fish. However, there are some scholars who believe that this lunar holiday actually predates the story of Qu Yuan.

It is also a custom to protect oneself during Duanwujie. This is done by posting pictures of Zhong Kui (the Demon Queller who slays evil forces), making charms of the Five Poisons (overcoming evil with evil) (*see* Five Poisons), and hanging bundles of the herbs moxa (said to resemble a tiger) and sweet flag (said to resemble the sword of Zhong Kui) on doors of the home.

□ Album painting of duck
for the Moghul market.
Nineteenth century.
Phil Wood Collection.

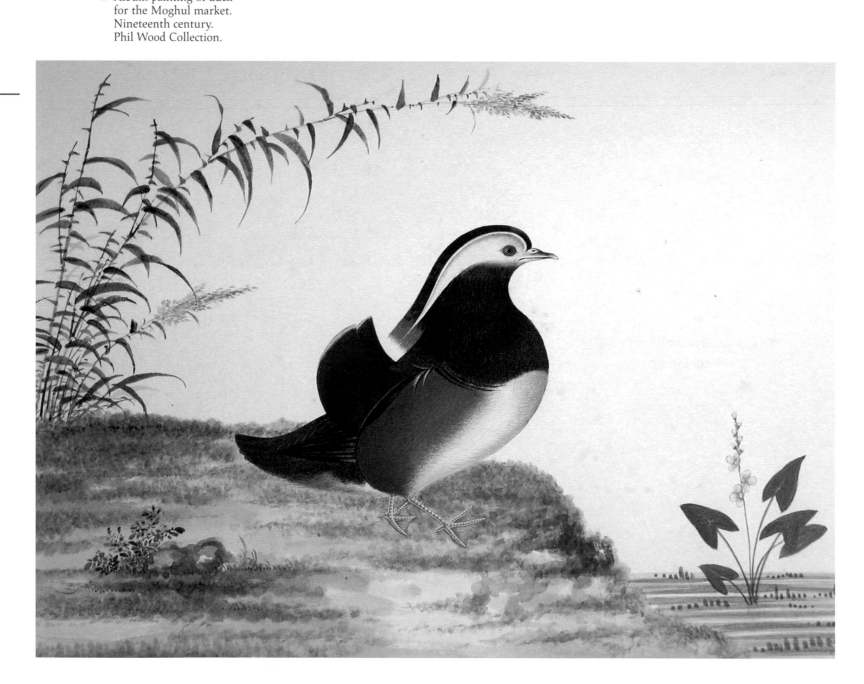

Duck (Mandarin Duck)

The duck, usually mandarin ducks in pairs, is a symbol of trust, affection, and marital bliss. With such an auspicious meaning, the mandarin duck is depicted in a variety of mediums, perhaps most famously on blue and white porcelains.

On textiles during the Ming dynasty, the wives of officials of the fifth rank wore badges with mandarin ducks. During the Qing dynasty, the mandarin duck was indicative of the civil official of the seventh rank. During the latter part of the nineteenth century, the wives of court officials no longer had the usual eight dragons on their court robes but had a lesser number with mandarin ducks taking up some of the formerly prescribed areas.

As a motif on porcelains and in paintings, mandarin ducks frequently appear in a lotus pond. This became a popular design in the early Yuan dynasty when the blue-and-white porcelains originated. The design continued to be used with great popularity and favor into the Ming and Qing dynasties. This depiction symbolizes marital devotion with purity and faithfulness and the ultimate bearing of many sons.

Yi jia yi ming is a rebus associated with the duck in the reeds, which means, "May you be number one in the first class of the court examination." The rebus is formed since the word for duck, *ya,* rhymes with *jia* and *yi jia* also has the meaning of first class. *Yi ming* means being number one.

Another rebus for a duck in the reeds is *yi jia lian ke,* which means, "May you do well in your examinations." *Lian ke* refers to the reeds, and has the same sound as passing the Civil Service Examinations all the way to the top.

Because of its symbolic meaning, duck is frequently served at marriages and New Year's banquets, thus expressing wishes for marital bliss and affection.

In earlier times, the word for duck, *ya,* went unspoken as it is the same word for penis and was synonymous with "homosexual." In later times, this folk meaning was lost but in contemporary China, it is a slang word meaning prostitute or the owner of a house of prostitution.

Dumplings

Dumplings, *jiaozi,* are said to resemble an ingot, a symbol for wealth. They are symbolic of good wishes for the family. Serving dumplings on specific holidays expresses good wishes as well as a wish for riches. At the time of the Dragon Boat Festival, they are thrown in the water to drive off the fish and to symbolically protect the historical figure Qu Yuan (*see* Duanwujie).

□ Belt buckle in the shape of two mandarin ducks. Jade, eighteenth century. Phil Wood Collection.

□ A Eagle clutching a snake.
Nephrite, Tang dynasty
(618–907 C.E.).
Ji Zhen Zhai Collection.

□ B Woodblock depicting an egret.
Ji Zhen Zhai Collection.

Eagle

The eagle is a symbol of power and strength. The Chinese word for eagle is *ying* and in its pictogram, it represents a bird grasping another bird below. Many ancient chieftains and nobles raised and trained eagles as companions for their outdoor hunting. Folk superstitions indicate that the feathers from eagle tails have magical power to heal diseases and ward off evils. The God of Thunder (Lei gong) in the Daoist pantheon is half eagle, with wings and a sharp beak, and half human. The eagle is a strong male, yang symbol.

The word for eagle in Chinese has the same sound as for the word hero, *ying*, and therefore likening one to an eagle or giving a gift with an eagle depicted is seen as calling one a hero, a great honor. A depiction of an eagle perched on a rock is symbolic of a warrior ready to do battle. When the eagle is perched on a pine tree, a longevity symbol, it conveys a wish that one will be in power or will be powerful for a long period of time. An eagle on a rock in the sea expresses a visual symbol of a hero who fights a long battle by himself.

A depiction of the eagle with the bear, *xiong*, forms the pun on their names, *ying xiong*, which means hero. During the Ming dynasty and Republic period, the eagle is frequently depicted with a dog and also means hero.[21]

Egg

The egg, *dan*, symbolizes fertility. It is a folk custom for parents to serve hard-boiled eggs when a baby is born. Traditionally called a "red egg and ginger party," the egg announces the birth while the color red signifies happiness as well as the driving away of evil. An even number of eggs served signifies a birth of a female child while an odd number signifies the birth of a male child.

Eggs, in the form of egg rolls, are served at the New Year, indicating a wish for all who partake to have prosperity in the coming year.

Egret

The egret with its beautiful pure-white feathers is a symbol for both purity and longevity. When the egret or heron is pictured in muddy waters, it is a metaphor for an official who is not corrupted by his surroundings. A gift with this depiction, sometimes seen painted on porcelains, is very honorable and pays great tribute.

The word for egret, *lu*, is also a homonym for the word for road, *lu*. When an egret is depicted, it has the meaning of "one road to prosperity" or "prosperity from start to finish."

Eight Buddhist Symbols

In 1759, the Emperor Qianlong issued specific regulations for dragon robes, the robes that were required court dress. He specified that in addition to dragons, "eight precious things" known as *ba bao* could be depicted (*see* Eight Precious Things). As time passed, these original *ba bao* extended to include two other groups of eight, Eight Buddhist Symbols and the Eight Symbols of the Daoist Immortals. As time passed, the Eight Buddhist Symbols gradually lost their original sacred meaning. By the end of the Qing dynasty in 1911, both sets of eight symbols had become decorative and lucky symbols. The original religious meaning of these objects had been lost completely.

The Eight Buddhist Symbols, *ba jixiang:*

- **Bell or canopy:** *Zhong* or *Gai.* Its sound chases away evil spirits and is a symbol of respect.

- **Conch shell:** *Luo.* A symbol of dignity and high rank, it also signifies the lungs of the Buddha.

- **Endless knot:** *Chang.* A symbol of the entrails of Buddha, infinity, and eternity as well as longevity. It symbolizes the endless and permanent awareness of the Buddha.

- **Lotus:** *Hua.* A symbol for faithfulness and purity.

- **Paired fish:** *Yu.* The symbol of marriage, conjugal harmony, and fertility.

- **Umbrella:** *San.* Symbol of spiritual authority and charity.

- **Wheel of the Law:** *Lun.* A symbol of Buddha's teaching that crushes all delusions and superstitions. It symbolizes Buddha himself as well as his teachings and the rays of sacred light that come from him.

- **Vase:** *Ping.* A ceremonial jar for relics as well as symbol of perpetual harmony and a triumph over birth and death.

- Sutra cover depicting Eight Buddhist Symbols. Kesi silk tapestry. Ming Dynasty (1368–1644). Clague Collection.

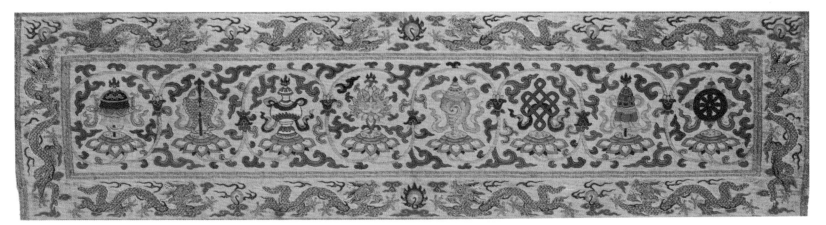

A

B

◻ A The Daoist Immortal Cao Guo
jiu. Detail from lacquer screen
with semiprecious stone inlay,
eighteenth century.
Collection Anunt Hengtrakul.

◻ B The Daoist Immortal Han
Xiang zi playing the flute.
Ivory, Ming dynasty
(1368–1644).
Gerard Hawthorn, Ltd.

The bell, conch shell, vase, and umbrella are emblems associated with Buddha himself while the endless knot, lotus, twin fish, and Wheel of the Law are symbols of Buddhist belief.

Images of the Eight Buddhist Symbols were placed on altars in Lamaist temples (*see* Lamaism). Seldom were all eight items displayed at one particular time; normally they were shown in pairs.

Eight Daoist Immortals

The Eight Daoist Immortals are legendary figures, residents of the Penglai Islands, the Islands of the Blessed or Immortality, who have attained immortality through their knowledge and study of the secrets of nature. Together they symbolize joy, happiness, and Daoism itself, and most important, they have become symbols of immortality. They reached their height of popularity during the Yuan dynasty, as people believed that they had the power to convey immortality to others. They were deified and temples were erected and dedicated to them.

Cao Guo jiu: Cao Guo (930–999 C.E.) was the son of a military official and uncle of the emperor. Legends tell how he was disturbed by the ill behavior of his brother. As a result, he sought solace in the mountains where he retreated to study Daoism. He loved secret things, spurned honors and riches after being influenced by Lu Dong bin and Han Xiang zi, and ultimately joined the society of celestial beings.

Considered the patron saint of the theater, he is distinguished by his dress in official robes and court headdress. His emblem, the castanets, may have its origins in official tablets.

Han Xiang zi: Han Xiang zi was a nephew of the great scholar and poet Han Yu of the Tang dynasty. He was the seventh of the Daoist Immortals to obtain immortality and became known as the patron saint of musicians.

Folktales present Hang Xiang zi as the favorite of his teacher Lu Dong bin, who took him to the magic peach tree where the immortal peaches grew. Han Xiang zi fell from the tree while picking peaches and became immortal. He had the ability to make flowers flourish and grow instantaneously. Once in early winter, he made the peonies blossom in different colors, and in each of the blossoms was a poem. This amazed Han Yu who was startled by his ability. But Han Ziang zi was also a wanderer who played his flute, attracting all with his music.

When depicted in art, the distinguishing feature of Han Xiang zi is his emblem the flute, which he is holding or playing.

He Xian Gu: He Xian Gu was born in the seventh century. According to Daoist folk writings, Lu Dong bin taught He Xian Gu alchemy and gave to her the peach of immortality to eat, which gave her eternal life. With her immortality, she journeyed to pay her respects to Xi Wang mu who took her to her new home, the Garden of Boundless Space.

Throughout her life, He Xian Gu nourished herself by feeding on the dew of the heavens, mother-of-pearl, and moonbeams. She spent much of her time flying from one mountain to another, meeting other immortals and collecting healing herbs for the needy. When summoned to court by the Empress Wu, she disappeared from the earth but appeared to oppressed and distressed innocent beings.

She is as pure and brilliant as her symbol, the lotus, which she frequently holds in her hand. She is often depicted standing on a leaf with a fly whisk, or sometimes mounted on the deer of longevity. She represents self-sacrifice and is the patroness of the home.

Li Tieguai: Li Tieguai, commonly known as Iron Crutch Li the magician, was one of the first of the Eight Immortals to attain immortality and become a Daoist god. A favorite folk hero god, he is a symbol of passion and mercy for the sick and unfortunate. As a god who possesses medical knowledge, he is always portrayed with an iron crutch and carrying a gourd container, *hulu,* which holds his medicinal potions. The *hulu* is also a symbol of the joining of heaven and earth in his own body.

Legends indicate that the real name of Li Tieguai was Li Xuan, who lived in the eighth century during the Tang dynasty. It is recorded that he was a tall, handsome hermit-scholar who was invited to visit Penglai, the Islands of the Blessed or Immortality, by Laozi (Lao-tzu), the founder of the Daoist philosophy and religion. Thus he took an out-of-body trip. Before he left, he instructed his disciple Yang Zi to keep vigil over his body and that on the seventh day, his soul would return to his body. Should he not return on the seventh day, his body was to be cremated. Yang Zi followed his instructions until the sixth day when he was suddenly summoned to attend his dying mother. Frustrated and feeling that Li Xuan was not going to return, he cremated Master Li's body one day ahead of the assigned time. But Li's soul returned on the seventh day. Without a body to inhabit, he entered the dead body of a lame roadside beggar who held an iron crutch that he had found lying in the street.[22] He has since been known as Li Tieguai who walks with an iron crutch, carries his medical *hulu,* and unselfishly performs kind deeds by helping the troubled and sick. The story of Li Tieguai teaches that a person's real mission on earth should not be inhibited by tragedy and impatience. Li Tieguai is one of the most popularly depicted Daoist Immortals.

A

B

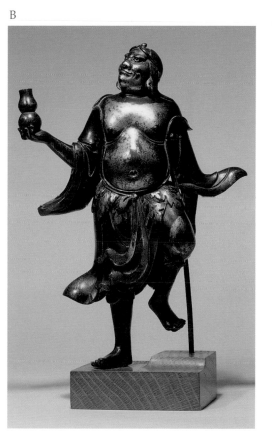

◻ A Porcelain vase depicting the Eight Daoist Immortals. Jiaqing period (1522–66), 20 inches high. Courtesy of J. J. Lally & Co.; photo by Maggie Nimkin.

◻ B The Daoist Immortal Li Tieguai. Gilt bronze, seventeenth century. Ji Zhen Zhai Collection.

Lu Dong bin: After Zhang Guolao, Lu Dong bin is considered to be the second-most important of the Daoist Immortals. Called the patron saint of the Quanzhen sect, he is also known as the patron saint of barbers. He was worshiped as the patron saint of ink makers, scholars, and pharmacists. His signs are the fly whisk and the sword. He is worshiped by the ill and is the destroyer of all things evil.

Lu Dong bin is said to have lived in the late Tang dynasty, but gained his greatest popularity during the Song dynasty. Folktales relate how Lu Dong bin survived ten temptations and wandered the world destroying evil with his sword, which became his most popular emblem. While known as a swordsman, poet, and calligrapher, he is usually depicted in the long flowing white robes of a scholar, but he holds a sword in lieu of one of the treasures of the scholar. This unusual combination of a scholar and a sword usually identifies him in artwork.

There are countless stories written of Lu Dong bin, most also involving Zhong Li quan. One states that he first came into contact with Zhong Li quan in the mountains, at which time he wanted to become a hermit. He was instructed in alchemy, as was Zhong Li quan. He became an immortal at the age of fifty, at which time he wanted to convert others to his faith. He passed the ten trials of temptation and was invested with the magical sword that Zhong Li quan used to slay all things evil.

Nan Cai he: First mentioned in *The Celestial Being's Biographies: The Sequel* by Shen Fen of the Tang dynasty, Nan Cai he is the patron saint of florists and gardeners. Her emblems are a flower basket and a flute or cymbals.

A symbol of elusive pleasure, she is said to wander the streets as a beggar in worn clothing and with one foot bare, denouncing the elusive pleasures of this fleeting life. Folktales describe her as being semi-crazed and appearing drunk, but she nonetheless held the secret to the fountain of youth, which was envied by the other immortals. She represents innocence and happiness.

Zhang Guolao: This immortal, believed to have lived in the seventh/eighth century, is said to have held the secrets of immortality. Legends tell that he was transformed into a human from a bat. He was a recluse who attained supernatural power and had abilities to perform magic. Both a sage and a hermit who carried a bamboo drum and sometimes a phoenix feather together with a pear of longevity, he was a wanderer who rode a mule, characteristically sitting backward. When depicted in art, Zhang Guolao is usually attired as an elderly but wise gentleman who holds an ancient musical instrument called a fish drum, which is made from a hollow vertical bamboo cylinder that is played by striking it with one's fingers.

Folktales describe his ability to become invisible and to travel great distances in a matter of seconds to aid the suffering. His mule had the strange ability to be

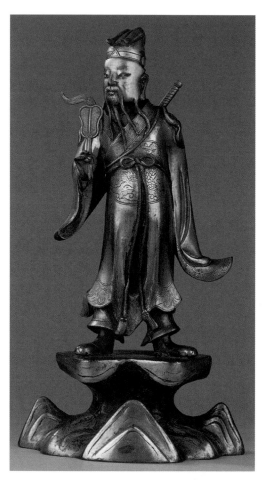

□ The Daoist Immortal
Lu Dong bin. Gilt bronze,
seventeenth century.
Gerard Hawthorn, Ltd.

folded as a piece of paper and placed in his pocket when it was not needed. When it was needed, Zhang Guolao would sprinkle the mule with water and he would come to life again. Hearing of his feats of magic, both the Empress Wu and Emperor Xuanzong summoned him. In both instances, he feigned death, refusing their calls. Eventually Xuanzong's persuasiveness and persistence succeeded. Summoned to court, Zhang Guolao was continually tested by Xuanzong, who was greatly impressed with his magic. But Zhang Guolao could not stop his desire to wander, and ultimately he disappeared and entered into immortality.

Zhong Li quan: Chief of the Eight Immortals, Zhong Li quan was also the teacher of Lu Dong bin. Exactly when he lived is not known, but according to most scholars and writings, he is believed to have lived during the Han dynasty. An alchemist, he found the elixir of life and he symbolizes longevity. He is said to have turned mercury and lead into yellow and white silver.

Zhong Li quan is sometimes depicted with a bared belly. He walks on water and carries a peach and a fan that he uses to restore the souls of the dead. These attributes are related to this story: Wandering in deep meditation, Zhong Li quan came upon a woman who was mourning at the grave of her husband while fanning the soil that covered the grave. Before her husband's death, she had promised him that she would not remarry until the soil of his grave was dry. When Zhong Li quan asked her why she fanned the soil of the grave, she said that she had recently found an admirer and wanted the soil to dry quickly so that she could remarry. Zhong Li quan offered to help her. He took her fan and as he fanned, the soil on the grave quickly dried. So excited was the thankful lady that she walked away, leaving her fan. But when Zhong Li quan's wife saw the fan, she asked to whom it belonged. When she heard the tale, she was extremely displeased. Zhong Li quan decided to test the veracity of the widow and transformed himself, taking on the appearance of the handsome young man that the widow wanted to marry. They made love, but then Zhong Li quan told the widow that he needed the brain of her deceased husband to make a potion before he could marry her. She quickly went to her husband's grave and dug up the casket. When she opened the casket, her husband came to life and the suitor disappeared. In her shame, she hung herself. Zhong Li quan set the widow's house on fire and left, taking only the fan and sacred book *Daode Jing* with him.

□ The Daoist Immortal Zhong Li quan. Detail of lacquer screen with semiprecious stone inlay, eighteenth century. Collection Anunt Hengtrakul.

Eight Precious Things

The first group of Eight Precious Things, *ba bao,* were symbols of wealth, originally consisting of pearls, gold circular and rectangular ornaments, a wishing jewel, *ruyi* (*see* Ruyi), rhinoceros horns, ivory tusks, sticks of coral, and rolls of tribute silk.

Sometimes an ingot or shoe of precious metal replaced one of the others. This early motif of eight symbols was not merely a decorative pattern that occurred on textiles and various objects of lacquer, wood, porcelain, and other media, but originally had a symbolic importance reflecting aspirations for status, wealth, and position as well as philosophic allegiance.

As time passed, the original meanings of the *ba bao* began to deteriorate. Rather than having symbolic importance, with an increase in the number of objects, they came to be used merely as decoration. This increase in number led to the so-called "hundred antiques" pattern.

By the time the *ba bao* appeared on Qing robes in the late eighteenth century, their number and variety had increased, giving more than sixteen alternatives that could be interchanged to make up various combinations of the Eight Precious Things. Pearls were now known shown as flaming jewels. Circular and square *sheng* jewels were elaborate decoration or sometimes interlocking pairs. Sometimes a pierced coin, or square *sheng,* was coupled with a swastika. *Ruyi* were now shown as a *ruyi* scepter, silk as scroll paintings or sutra and made into patterns with the artemesia leaf, rhino horn, and folk textiles. Particularly in the nineteenth century, the Eight Precious Objects were frequently called the Eight Ordinary Symbols. The Eight Ordinary Symbols often included objects that were not in the original Eight Precious Objects as the symbols became less associated with Buddhism and more of a decorative motif.

Representations of the early Eight Precious Things were usually as follows, with one sometimes being excluded and one added:

- Cash/coin: wealth
- Rhinoceros horn cups: happiness
- Artemesia leaf: felicity and healing
- Lozenges: ornaments for a headdress
- Double lozenges (Fan Sheng): victory
- Books/scrolls: learning, warding off evil
- Painting: symbol of the scholar, culture
- Mirror: reflecting away evil and continual marital happiness
- Jade gong or musical gong: felicity and ministerial associations

Eight Rules of Right

The Eight Rules of Right are rules of conduct: politeness, filial piety, sense of shame, fraternal duty, loyalty, fidelity, decorum, and integrity.

Eight Symbols of the Daoist Immortals

The Eight Symbols of the Daoist Immortals evolved from the original *ba bao,* or Eight Precious Things. These eight objects represent the attributes of the Eight Daoist Immortals.

- Magic fan: delicacy of feeling
- Bamboo rattle: longevity
- Lotus: purity
- Castanets: music
- Sword: triumph over evil
- Gourd and crutch: medicine
- Flute: knowledge, music
- Flower basket: innocence and happiness

- Enamel box with design of Eight Symbols of the Daoist Immortals. Yongzheng mark and period (1723–35). Ji Zhen Zhai Collection.

Eight Symbols of the Scholar

The scholar represented knowledge, purity, justice, and status. Since the earliest times, the scholar was held in high esteem. During the Sui dynasty, an educational process was put into effect whereby only scholars who were able to pass the Civil Service Examination were able to hold position at court.

The eight symbols of the scholar are books (knowledge), painting (arts), pearl (wisdom), rhinoceros horn (happiness), rhombus (victory), coin (wealth), musical stone (discrimination), and artemisia leaf (felicity). They are very similar to the eight treasures of Confucius. However, in depictions they have been reduced to four (usually the Four Treasures of the Scholar) and increased to as many as fourteen in the late Qing dynasty. This increase is said to show the disintegration of the dynasty when positions of influence could be purchased and the scholar no longer represented true knowledge.

Eight Tetragrams

The eight tetragrams commonly refers to a pattern of symbols that is usually seen on rugs enclosed in an octagon. The tetragrams represent heaven, earth, wind, fire, water, mountain, thunder, and cloud.

Eight Trigrams

The eight trigrams, or eight symbols of divination, are known in Chinese as *pa gua*. They are patterns of lines based on the yin-yang symbol that are used to foretell the future. Yin and yang depict the balance between the interaction of opposites in the universe. The trigram patterns are made up of three horizontal lines based on the symbols associated with yin (lines broken in the middle) and yang (continuous lines) and together represent stages in the process of change as well as connections between past, present, and future. Combinations of the eight trigrams yielded sixty-four hexagrams that are identified in *The Book of Changes,* or *Yi Jing.* The concept of the eight trigrams is associated directly with Daoism, but oddly enough, it did not originate with Daoism. It was said to have been developed by the legendary Emperor Fu Xi, the first of the Five Legendary Emperors, from the markings that he originally saw on the back of a tortoise.

Stephen Little writes in *Taoism and the Arts of China,* "The Eight Trigrams played a vital role in the Taoist alchemical tradition. This was because chemical alchemy entailed manipulating the forces of yin and yang toward understanding and immortality. The trigrams and their associated hexagrams were subtle visual symbols of cosmic flux and were easily adopted by Taoists. To help explain cosmological principles of transformation. The earliest surviving visual evidence for the Eight Trigrams dates to the Western Han dynasty (206 B.C.E.–8 C.E.)"[23]

Elephant

Owing to its size and its use for transportation of people and items, the elephant is the symbol of strength and astuteness. Its lengthy life also makes it a symbol of triumph over death. No longer found in present-day China, it was at one time common to the southern provinces. The elephant plays an important role in the Buddhist religion and in arts associated with Buddhism, and is seen as a sacred, auspicious symbol since it brought the Buddha to the earth. Buddha is reported to have been able to throw an elephant over a wall, and a white elephant was also said to have entered his mother, Maya. Buddha himself is sometimes depicted riding an elephant. One of the Eighteen Lohans, Samantabhadra, is also commonly depicted mounted on an elephant.

Chinese symbolism for the elephant in part lies in the pronunciation of the word, *xiang,* which is a homonym for the word for happiness. A rebus is formed when an elephant is depicted with a rider, usually a child. This depiction is a wish for happiness *qi xiang* (on an elephant), *ji xiang* (happiness). Three-dimensional

images—usually carvings of ivory, jade, or wood—of a child riding an elephant were especially popular during the Ming and early Qing dynasties. The Chinese character for elephant is sometimes interchanged with the character for prime minister.

An elephant with a vase forms the rebus *tai ping you xiang* meaning "perfect peace in the universe." Sometimes the rebus is expanded by depicting a saddle cloth, *an* (also having the meaning of harmony), under the vase on its back, which means "perfect peace and harmony in the universe."

Endless Knot

The endless knot is a visual symbol representing Buddha's entrails or intestines, one of the Eight Precious Organs of Buddha. In Chinese thought, the intestines connect with the lungs, and are understood to receive and give abundance. They symbolize a long life uninterrupted by setbacks, eternity, and a never-ending connection among wisdom, compassion, longevity, and infinity. They further symbolize the duration of one's spiritual life as well as represent the Eight Buddhist Warnings: 1. Thou shall not kill. 2. Thou shall not steal. 3. Thou shall not commit lewdness. 4. Thou shall not bear false witness. 5. Thou shall not drink wine. 6. Old age. 7. Infirmities. 8. Death.[24] These are all symbolically represented as an endless knot pattern.

The endless knot is seen on porcelain, wood, lacquer, paintings, rugs, knottings on cords, jade and other semiprecious stones, and textiles. It is seen on Mandarin robes of the middle and later Qing dynasty and sometimes incorporated into stylized border designs.

□ Lotus shoes with endless knot design. Early twentieth century. Ji Zhen Zhai Collection.

Famille Rose

Famille rose refers to a palette of colors that includes the rose enamel derived from colloidal gold. The color is the same as the purple of Europe, which was invented by Andreas Cassius and then taken to China by Jesuit missionaries. It appears in Chinese art circa 1700 and was used in the fine painting of flowers on porcelains produced in the imperial kilns under the direction of the emperor. These flowers represented feminine beauty. It should be noted that the finest of the *famille rose* porcelains were done during the Yongzheng period (1723–35). At the end of the eighteenth century when export wares began to be produced in large quantities, the quality rapidly deteriorated. These porcelains were no longer produced in the imperial kilns and no longer were under the strict supervision of the court. As the quantity of wares increased in production for export, the quality declined, as evidenced from the porcelains that are dated to the end of the Qing dynasty.

Famille Verte

Famille verte refers to a palette of colors used to decorate porcelains primarily in the Qing dynasty, although the enamels were developed during the Ming dynasty. The primary colors were green, yellow, blue, black, and red. The palette was named *wucai,* meaning "five colors." The translucent enamels were applied during

secondary firings, and were highly decorative and appealing to Westerners. They therefore became highly popular on porcelains made for export. During the eighteenth century, the palette took on the French name, *famille verte*. The clear green glazes tended to flow during the firing and were the dominant colors. *Famille verte* wares were of extremely high quality during the eighteenth century, but deteriorated in the nineteenth century.

Fan

The fan, *shan zi*, has been known in China since the earliest times and was most often made of palm leaf or feathers. These fans were fashioned in a round shape. The folding fan, which appears much later and is so often associated with China, was invented in Korea. The fan can be a symbol of an official and of the power of his office. It also can be a symbol of goodness because the word for goodness, *shan*, is a pun on and has a similar sound to the word for fan, *shan zi*. Zhong Li quan, chief of the Daoist Immortals, has as his emblem the fan, with which he is said to revive the dead.

In sculpture, a male figure is sometimes depicted fanning an elderly man. The figure with a fan is most likely not an attendant but Huang Xiang, one of the paragons of filial piety. A folktale tells that his mother died at an early age, and Huang Xiang devoted himself to the care of his father. He fanned him on hot summer nights and first lay in his bed on cold winter nights to bring warmth to the bed so that his father would not be chilled. He indeed is a symbol of filial piety.

B

Festival of Departed Spirits (All Souls' Day)

All Souls' Day is a ghost festival akin to Halloween in the West. A Buddhist festival that is celebrated on the fifteenth day of the seventh moon, it coincides with the Daoist Ghost Festival; both honor the spirits of the departed. It is also called the Buddhist Festival of Departed Spirits, *Yu Lan P'en Hu*, which translates literally as "Feeding the Hungry Ghost Festival." On this festival day, it is the custom for prayers to be said for those who have departed away from home and therefore have no family members to honor them through ancestral worship.

The Chinese believe that the deceased become ghosts who linger between heaven and earth. By celebrating this day, those departed who are without families enjoy the warmth of those who pray for them as their families would have. It accentuates the importance of filial piety.

□ A Bamboo fan with appliqué and zitan handle. Nineteenth century. Ji Zhen Zhai Collection.

□ B Detail of kesi tapestry depicting a fan. Eighteenth century. Courtesy of Jocelyn Chatterton.

Fire

Fire, *huo,* has multiple symbolic meanings in China. It is one of the Five Elements, associated with the color red (meaning happiness and celebration) and bitter taste, and is one of the Twelve Symbols of the Emperor. Being a symbol on the imperial robes, it symbolizes brilliance while the twelve symbols collectively are a representation of the universe—the wearer of the robe with twelve symbols controlled and ruled the universe.

Its other symbolic meaning lies in the more colloquial representation of driving away evil spirits. Fire, *huo,* has the same sound as the word for living, *huo,* thereby being the basis for its use as a pun. This homonym is related to the custom of setting fires on New Year's Day to attract and honor the gods with the hope that they might look favorably on those who set the fires, and bestow long life and wealth. Burning representational objects was a way of transmitting objects to the nether world in its smoke, as with incense. The burning of these objects was a substitute for the sacrifices that were made in earlier periods.

In Chinese mythological narratives recorded during the Han dynasty, fire is said to have been discovered by the multifaceted god Fu Xi. However, there are earlier accounts that attribute the founding of fire and cooking to a mythological figure who is called the Fire Driller. In these accounts, this figure is neither a god nor a human; a bird taught him how to produce fire from a special tree. Yet another account records that fire was discovered and taught by the Yellow Emperor. All three accounts emphasize the importance of fire and its relationship to the providing of subsistence to all human creatures, which explains why fire came to be a symbol for the emperor.

□ Fire. Detail from a twelve-symbol imperial robe. Eighteenth century. Linda Wrigglesworth, Ltd.

Fish

Fish are important in the cultural world of the Chinese since they have been an important food source since early times. As with any item that held such primary importance, folk tales, legends, and symbolisms are devoted to fish. As an art motif, fish are portrayed in every medium and in every dynasty. During the Song dynasty, a common motif was two fish side by side in the center of porcelains, particularly celadon wares. This pattern carried over into successive dynasties and was not only done in porcelain but also in jade and metalwork. Some scholars believe that the paired fish actually has its genesis in primitive drawings of two fish copulating, while others believe that it may be a variation of the *taiji* diagram (*see* Taiji Diagram). "The vase form of two fish appears to have become popular during the ninth century, not only in celadon wares of Zhejiang province but also in *sancai* (three

color) lead glaze wares, plain lead glazed wares, and white wares."[25] The popularity of two-fish vases continued well into the Qing dynasty.

The symbolic meaning of fish lies in the fact that the word for fish, *yu,* is phonetically identical with the word meaning abundance, *yu.* Fish are an ancient symbol of rank and power. The carp symbolized the scholar, and only scholars could hold court positions (*see* Carp). In later periods, fish symbolize marital bliss since they swim in pairs. They further represent the joining of the male and female as well as reproduction. Paired fish are therefore a symbol of marriage and conjugal happiness, and the combination of fish and water is a metaphor for sexual pleasure. Fish are also a charm against all things evil. Moreover, paired fish are one of the Eight Buddhist Symbols (*see* Paired Fish). It should be noted that the paired fish vases that were made for export during the eighteenth and nineteenth centuries held no meaning for Europeans; the fish were seen merely as a decorative motif.

Even in contemporary China, fish as a food carries important symbolic meaning. The serving of a whole fish is symbolic of a wish for abundance and is an important part of banquet meals for a guest.

Fisherman

Fishing is one of the Four Basic Occupations (*see* Four Basic Occupations), and the philosophic and poetic ideal of the scholar fisherman has long been a subject of Chinese folklore and art. The scholar fisherman represented solace, contemplation, the simple life, and being at peace with oneself. The best known scholar fisherman was Jiang Zi ya, who dressed in simple clothes and fished with a straight hook on a string beside a creek. One day as the emperor prepared to wage a campaign against barbarians, his court magician told him that his prize on that day would be not an animal but a man who would be his counselor. The emperor came across Jiang Zi ya fishing at a brook, who told the emperor that catching fish was not important but rather what was important to him was his contemplation and being alone with his thoughts. His fishing was said to symbolize patience and wisdom. Impressed with such wisdom, the emperor requested his service. Jiang Zi ya loyally provided the emperor with wise counsel for a twenty-year period.

Another folktale tells of Jiang Zi ya returning home from court after his years of service to the emperor. He found a woman and man begging on the road. The woman looked at Jiang Zi ya and, recognizing him, begged his forgiveness as she was the wife who left him after he went to service. Jiang Zi ya filled a cup of water and tossed it on the ground saying that it was not possible for him to be reunited with her just as it was not possible to bring the water back to his cup after it had been spilt. History records that he died in 1120 B.C.E. at the age of ninety.

B

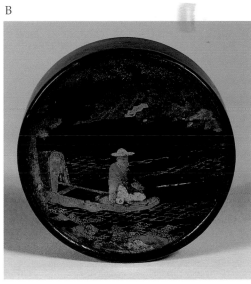

□ A Album leaf of fish by Qi Baishi (1864–1957). Private Collection.

□ B Lacquer box with mother of pearl inlay with fisherman design and seal of Qian li. Seventeenth century. Ji Zhen Zhai Collection.

Five Blessings

The five blessings of Chinese life are old age, wealth, health, virtue, and a natural death.

The five blessings are represented in a pattern of five bats, *wu fu,* fluttering around the character for *shou,* the longevity symbol. They are further represented in the saying *wu fu lin men,* or "May the five blessings approach the door."

Five Classics

The five classics of Chinese literature, *wu jing,* are *The Book of Documents (Shu Jing); The Book of Rites (Li Ji); The Book of Changes (Yi Jing); The Book of Ceremonies (Yi Li);* and *The Book of Odes (Shi Jing).*

□ Embroidered bag depicting a toad, one of the Five Poisons. Nineteenth century. Ji Zhen Zhai Collection.

Five Nourishing Fruits

The five nourishing fruits are sorghum, wheat, two types of millet, and beans. While one thinks of China as a country whose primary grain is rice, in Northern China, the primary grains are millet and wheat.

Five Poisons

The Five Poisons are the scorpion, lizard, centipede, snake, and toad. Together they are said to form an elixir that is a neutralizer of evil. The Five Poisons are widely depicted in folk art. It is a custom to make images of these creatures on red cloth and place them on the pockets of children's clothing that would be worn on the first five days of the fifth month. This was done to ward off sickness. On the day of the Dragon Boat Festival, amulets against the Five Poisons are displayed because it is believed that on this day the Five Poisons start to multiply.

The Five Poisons are rarely utilized as a design motif on rugs. The scorpion is the one exception; it is a favored design on eastern Turkestan rugs.

In traditional Chinese medicine, an elixir is made from the Five Poisons and is administered for upper respiratory infections as well as rheumatism.

Five Sacred Peaks of Daoism

China has nine senior sacred mountains, five of which are associated with Daoism and four of which are associated with Buddhism. Each has its own aura, but sacred mountains were places of retreat from the world, places of learning, and places of pilgrimage where one could coexist with nature, commune with gods and immortals, and pursue alchemy. To Daoists, the natural landscape and one's inner body were as one, reflecting one another.

The Five Sacred Peaks (wu yue)

- **Northern Peak, Heng Shan:** Associated with the element water and the color black.
- **Southern Peak, Heng Shan:** (not the same as the Northern Peak): Associated with the element fire and the color red.
- **Central Peak, Song Shan:** Associated with the element earth and the color yellow.
- **Eastern Peak, Tai Shan:** Associated with the element wood and the color green.
- **Western Peak, Hua Shan:** Associated with the element metal and the color white.

- Woodblock of a flower basket. Ji Zhen Zhai Collection.

Flower Basket

The flower basket, *hualan*, is one of the emblems (the other being cymbals, *jieban*) of the Daoist Immortal Nan Cai he and represents riches.

A flower-basket design is frequently seen in New Year's decorations; it conveys the wish for riches to come in the coming year. The basket is also the emblem of the Heavenly Twins (*see* He He). Here the meaning is related to the character *he,* meaning agreement.

Flowers of the Four Seasons

A flower or plant represents each of the seasons. These representations are most frequently seen in paintings or depictions on porcelains.

- **Winter:** plum blossom/bamboo
- **Spring:** grass orchid (resembling the miniature iris) or magnolia
- **Summer:** peony or lotus
- **Fall:** tree peony or chrysanthemum

Flowers of the Month

Each month is represented by a flower or plant in Chinese art. These representations are most frequently seen on sets of cups that were made in the imperial kilns during the reign of the Emperor Kangxi (1662–1722) under his strict supervision. Each exquisitely made porcelain item was potted and painted to perfection and then given the reign mark of the emperor.

- January: prunus or plum blossom
- February: peach blossom
- March: tree peony
- April: cherry blossom
- May: magnolia
- June: pomegranate blossom
- July: lotus
- August: quince blossom
- September: mallow
- October: chrysanthemum
- November: gardenia
- December: poppy

Flowing Water

Flowing water is an allusion that was developed in landscape painting to indicate sorrow. "It evolved from the literary phrase *chanyuan*, which originally indicated flowing water . . . 'teardrops flow down my cheeks in streams.' Borrowing flowing water to evoke copious tears demonstrated the depth of the poet's grief."[26] This representation was repeated from the Song through Qing dynasties.

Flowing waters from the high mountains, *shan gao shui chang,* is a visual rebus for eternity, never-ending abundance of time.

Flute

The flute, *xiao,* is the most ancient musical instrument in China and is the symbol for a scholar or learned person. Recent archeological excavations reveal that during the Late Stone Age in the Liangzhu culture (c.3300–2200 B.C.E.), flutes were made of tubular animal bones with bored holes.[27] Flutes of other periods were made of

such materials as metal, bamboo, jade, porcelain, wood, and horn. The Chinese believe that the sound of the flute is sacred and has the ability to connect the spiritual sound tunnel between earth, the heavens, and the netherworld. This is also seen in Chinese operas and plays where the appearances of ghosts are usually preceded by the sound of a flute.

During the Tang and Song times, there were numerous written references to flutes relating to scholars, particularly in poetry and paintings. Scholars and poets alike have played the flute to express their feelings of sadness and solitude, and it has often been said that the flute can simulate the melancholy sound of a weeping person. A person playing the flute has been the subject of paintings from ancient to contemporary times.

In religion, monks, priests, and shamans play flutes in ritual ceremonies. One of the Daoist Immortals, Han Xiang zi, the poet, scholar, and nephew of the great Tang poet Han Yu who lived during the eighth century, carried a flute as his emblem. It is one of the distinguishing features of this immortal in depictions.

Fly Whisk

Constructed of the long hairs of the deer, horse, or yak woven onto a long wand, the fly whisk, *fu chen* or *fu zi,* is a kind of wand that is held by Buddhist priests. By touching the head of a disciple with the whisk, the priest symbolically repels any obstacle of enlightenment. The fly whisk symbolizes authority but also signifies a tenet of Buddhism not to kill any living thing, even a fly. The origins of this symbolism are said by some scholars to lie with Buddha. At his birth, Buddha stood on a lotus. Over the lotus were a white parasol and a white fly whisk (white symbolized purity), which protected him. Traditionally, the fly whisk should be held in the right hand of all attendants of the Buddha. In paintings, Buddhist priests and lohans frequently are depicted with a fly whisk in one hand.

Flying Animals

Porcelain decorations of the Ming and Qing dynasties sometimes depict various animals—for example, horses, fish, rams, and elephants—with wings. These animals are presented over a wave background pattern. This symbolically represents the success of trade and diplomacy through the seas.[28] This unusual and unique pattern is found only during the Ming and Qing dynasties and is seen primarily on porcelains from the imperial kilns.

□ Fly whisk. Bamboo and horse hair, nineteenth century. Ji Zhen Zhai Collection.

Four

The number four is an ominous, inauspicious number to the Chinese. Four, *si,* is close in pronunciation to the word for death, *si* (same sound but with a different tone). Therefore, four is said to bear ill will and is to be avoided.

The Dowager Empress Cixi is said to have had forbidden the number four to be spoken in her presence, particularly when she was of advanced age and feared death. In contemporary China, there are many buildings that do not mark the fourth floor since to do so would be inauspicious.

Four Arts of the Scholar

By the time he passed his Civil Service Examination, the scholar was said to have the ability to excel in all things associated with the literati, including the arts. The four arts in which the scholar excelled are identified as the qin, chess, painting, and calligraphy (*see* Qin).

Four Basic Occupations

The four basic occupations in which all honorable men should seek accomplishment were that of the carpenter, scholar, peasant, and fisherman.

Four Directional Animals

The animals symbolizing the four directions are the green dragon, *Qinglong,* the east; the red bird, *Zhuqiao,* the south; the white tiger, *Baihu,* the west; and the turtle and snake, *Yuanwu,* the north. These are animals related to feng shui for auspicious interior and exterior environments.

Four Nobles (Four Noble Men)

The Four Nobles, *si junzi,* are represented by the prunus, bamboo, chrysanthemum, and orchid plants. These represent Confucian virtues. The plum, or prunus, symbolizes innocence and renewed vitality. Bamboo is associated with strength and scholarship. The chrysanthemum symbolizes pleasure and entertainment. The orchid symbolizes rarity, preciousness, and refinement.

Four Treasures of the Scholar

The scholar was highly revered because early in Chinese history, an educational system was put into effect whereby only those scholars who could pass the rigid Civil Service Examination could hold position at court. This involved memorization of scriptures, the *Analects of Confucius,* writing of famous scholars, and so on, in addition to doing calligraphy, painting, and playing the qin. Because of the time required to prepare for these examinations, only the rich could afford to devote themselves to these studies, which ultimately created a two-tiered society.

The Four Treasures of the Scholar are those articles that were important for literary skills—ink, paper, brush, and inkstone. These items were not only the tools required for scholarly work but also the symbols of the scholar. Ink was made of soot combined with sticky rice paste and other materials to ward off insects. The ink mixture was placed in molds and then dried. The molds were of various forms and many of them were only produced in imperial workshops.

A

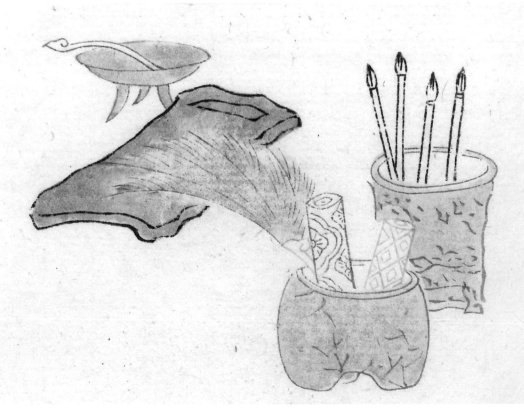

☐ A Woodblock depicting treasures of the scholar. Ji Zhen Zhai Collection.

☐ B Imperial ink. Qianlong mark and period (1736–95). Ji Zhen Zhai Collection.

The finest papers were originally made from the bark of trees and later rice straw, wood pulp, and reeds; some papers were made entirely of bamboo. However, the practice of using paper was not actually common until the Yuan dynasty. Prior to that, it was more common for painting and calligraphy to be done on silk. Paper became a substitute as it was less expensive than silk.

The brush is the most important tool in painting and calligraphy and is distinguished for use by length and size. It is the hair of the brush itself that is its most important characteristic. The fine hairs of the weasel, goat, deer, cat, wolf, and rabbit were greatly cherished. Simple brushes were made of bamboo and animal hairs whose texture would be appropriately matched for the type of writing or painting the brush would be used for. Other brushes were made of lacquer, jade and other semi-precious stones, and wood. Brushes were seen as an extension of the hand of the artist, therefore revealing of the character of the writer.

Inkstones, particularly those of an early date, were made of other materials than stone, but the most prized were the *duan* stones that came from the Guangdong Province. These stones had valuable properties that are said to produce fine ink—for example, moisture retention, grain, degree of hardness, and durability.

Fox

The fox, *hu li,* is associated with magic and sorcery. As it is plentiful in the wild and relies on its stealth to survive, folk stories are plentiful regarding its supernatural powers.

A popular folktale tells of the fox that comes to the scholar every evening in the guise of a seductive female, but then disappears each morning. He reappears night after night. As the scholar grows weaker from the nightly liaisons, a Daoist priest finally tells him that the figure of the female is really that of a fox who is taking his essence in order to have immortality.

In reality, the fox is most often seen coming from country graves, and it is from this that its lore is born. It is felt to be a carrier of the souls of the deceased. With its supernatural powers, it can transform into a human being and is seen to be demonic. The fox, an emblem of craftiness, is feared.

□ Fu symbol.
Detail from silk embroidery.
Qianlong period (1736–95).
Ji Zhen Zhai Collection.

Fu

One of the Twelve Symbols of the Emperor, it is the character *Ya* back to back. Fu symbolizes the power of the emperor to judge and rule.

Fu Dogs or Foo Dogs

Guardians of the Temple (*see* Lions).

Fu Xi

One of the Five Legendary Emperors, Fu Xi, sometimes called the creator god, was said to be the first emperor of China reigning from 2852 to 2737 B.C.E. A tale that gave fame to Fu Xi is recorded from the Han dynasty. It tells that his greatness was such that he had four faces, one for each of the four directions, which later historians and scholars interpreted to mean that he established four governmental ministers. He was said to have created the first written language and to have brought humankind fire, the knowledge of measuring distances, and musical instruments. In addition, he taught the domestication of animals and the benefits of hunting and fishing. Of seven classical records of Fu Xi of the Zhou dynasty, four list Fu Xi as the earliest god in the archaic pantheon.[29]

Tales of Fu Xi are often linked with Nu Wa, the mythical creator goddess, and these tales are associated with the creation of humanity, ancient warfare, and struggles against the elements. How these separate gods became linked is unknown or why their names are linked to the gourd or melon is equally unclear. To further add confusion, Fu Xi's name is known to have six variations. Seemingly contradictory to writings of his accomplishments, Fu Xi is seen as a relatively minor figure in folklore. His depictions are varied. He is sometimes shown with a human form with a head of a bull and a tiger's tail. He is also depicted as a seated elderly figure holding a disk with the yin and yang symbol in both hands.

Garlic

Garlic, *suan,* symbolizes good luck because it has been used in Chinese herbal medicine for hundreds of years to reduce poisons in the body. It also symbolizes a wish for wealth in one's offspring.

Glowworm

A beetle, the glowworm is of the family Lampyris. Only the adult wingless female "glows" to attract the male species, which has the ability to fly. The female has a very short adult life of only a few weeks, during which she is able to glow and subsequently lay her eggs.

The glowworm gains its notoriety in China primarily because of the folk story of Zhu Yin. Zhu Yin was a devoted scholar who was so poor that he could not afford to purchase oil for his lamp. He was so dedicated that he gathered glowworms and placed them in a container and studied by the light that they provided. This beetle has come to symbolize perseverance and dedication, revered qualities of a scholar.

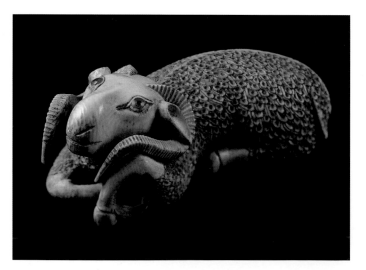

□ Goat. Carved ivory with amber eyes, eighteenth century. Ji Zhen Zhai Collection.

Goat

The goat, *shanyang,* is the emblem of retirement. It also symbolizes complacency and satisfaction. An animal of the zodiac, it represents the southeast. The goat was popularly carved during the Qing dynasty of jade and other hardstones, a gift frequently given to scholars.

God of Wealth

The popular God of Wealth, Cai Chen ye (or Lu), is one of the triad known as the Star Gods (*see* Star Gods).

The God of Wealth, a popular "people god," is not known before the Ming dynasty. He is distinguished in depictions by having a gold ingot in one hand and usually a *ruyi* scepter in the other (*see* Ruyi). It is customary for businesses to hold celebrations to receive the God of Wealth on the fifth day of the lunar year. By doing so, good business will bring wealth in the coming year.

Golden Age

The Golden Age is a symbolic term borrowed from Greek mythology that is used primarily in literature. In Chinese lore, it refers to the mythical Yao, Shun, and Yu periods of benevolent rule when there was great growth in culture. This time is known as the Golden Age of China, an ideal period.

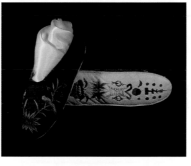

Golden Lotus

"Golden lotus" is a descriptive phrase that refers to the ideal size of the bound feet of women. The tiny bound feet were described as being beautiful as a lotus and the term "golden" meant the most prized or most valuable. The origins of the association with the ideal bound foot and the lotus is said to come from Xiao Baojian, "also known as the Duke of Dongbun, who ruled the southern kingdom of Qi from 499 to 501. He was said to have shaped gold leaves into lotus blossoms on the floor and had his favorite consort, Pan, tread on them. The enraptured duke exclaimed: 'Every step a lotus' twisting a Buddhist reference to the path of piety into an anti-Buddhist statement of wanton lust. . . . One year after the duke's death, his kingdom collapsed, and Consort Pan became a classic femme fatale in the history books. Centuries later, storytellers expounded on the lotus imagery, by then firmly identified with the bound foot, and made her into the first woman to bind her feet."[30]

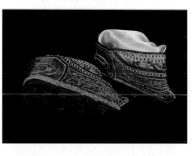

The custom of foot binding began in the late Tang dynasty and continued until banned by the Republican government in 1911. This custom, closely associated with the ethnic Chinese, the Han, did not extend to the Manchu women, who were forbidden to carry out this practice. Not limited to a particular class, the custom of foot binding was practiced by the wealthy as well as the poor peasants since it was seen as an attractive feature for women to have tiny feet. Most important, it was the mark of a woman who was a marriage prize.

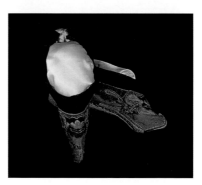

□ Lotus shoes.
Twentieth century.
Ji Zhen Zhai Collection.

Bronze lamp in the shape
of a goose holding a fish.
Han dynasty (206 B.C.E.–220 C.E.).
Ji Zhen Zhai Collection.

The actual binding of the feet began when the female child was five to seven years old. For the peasant class, binding began at a slightly later age so that the girls could perform daily work for a slightly longer period of time. Beginning the process at a later age gave these girls a slightly larger foot; it was done in a method called "loose binding." Thus, starting the process earlier for upper-class girls had visible results. Binding with bandages of long narrow strips, the four small toes were forced inward and under the sole while the great toe was left free. The binding forced the heel and toes together, thereby breaking the arch as the girl's foot grew, for there was no space for growth. The feet were kept bound day and night until the growth period passed. Both feet were then identical, with no difference between right or left, tiny and fitted with small decorative shoes. Stories abound of how painful this custom was.

The name, lotus shoe or golden lotus, is associated with the lotus flower, a symbol of purity as well as fertility. Moreover, the foot when properly bound grew into the shape likened to a small lotus bud. The prized ideal size of the "lotus bud" was three inches and called a golden lotus. However, the most common size of the bound foot was four to five inches.

The shoes were constructed of silk and cotton, and were made by the women of the family and ultimately the wearer herself. It was the custom of the bride to present her mother-in-law with a pair of lotus shoes. These shoes had decorations of embroidery and appliqué. Every imaginable technique was used to fashion designs that included symbols from folktales, good wishes, goddesses, gods, and expressions of luck, fortune, and so on. In many ways, these shoes and their designs represent one of the last great vestiges of symbolism in Chinese culture since many symbols were no longer used or had little meaning after the fall of the Qing dynasty.

Good Luck

Good luck is symbolized visually by five scholars, usually each with a bat hovering about, *wu fu*. Oftentimes good luck is depicted merely as five bats. The five are said to carry the qualities of good luck—wealth, longevity, health, welfare, and virtue.

Goose

The belief that the goose, *e*, travels in pairs and mates only once in its lifetime leads to it being used as a symbol of marriage, harmony, and fidelity. This symbolic usage began as early as the Zhou dynasty and lasted through the Qing dynasty.

The symbolism of the goose was expressed not only in each of the dynasties but also in all mediums. During the Han dynasty, lamps and pottery figures in the

form of the goose were placed in graves. This custom continued through the Tang dynasty. During the Qing dynasty, geese were depicted on porcelains manufactured in the imperial kilns as well as kilns that produced export wares, although Westerns saw the goose primarily as a decorative motif. On Mandarin squares of the Qing dynasty, the goose represented a fourth-rank civil official (*see* Mandarin Square).

An unusual folk figure who is sometimes depicted playing the *sheng* (Chinese mouth organ) while standing on the back of two flying geese is Wang Zi jiao, who lived from 571 to 544 B.C.E. Legend has it that Wang Zi jiao gave up his heritage and lived a life of wandering and living in the mountains. He sent a message to his family to meet him on the seventh day of the seventh month. On that day, as his parents arrived at the mountain site, he was seen waving to them from the back of two flying geese, which took him to an unknown place never to be seen again.

Gourd

The gourd, or bottle gourd, is a natural, durable product that when dried is used both as a tool and as a container to hold liquids. Gourds have been used in China for centuries. Given their importance in every aspect of life, folktales grew about them, such as that of the Gourd God, who controls the type and growth of gourds cultivated.

A

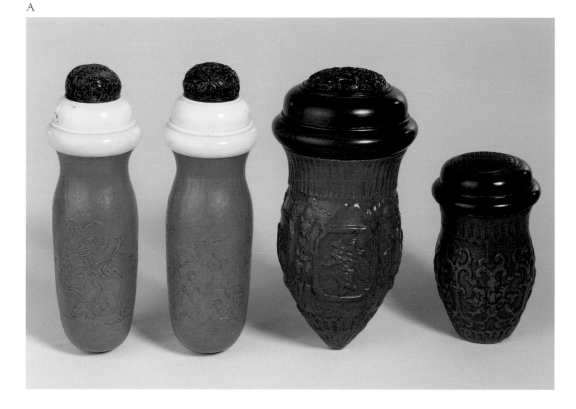

□ A Gourd cricket cages.
Nineteenth century.
Ji Zhen Zhai Collection.

□ B Double-gourd wine container embellished with silver and semiprecious stones.
Eighteenth century.
Ji Zhen Zhai Collection.

They also came to be associated with mystical qualities and religious figures, such as the Daoist Immortal Li Tieguai. They are even associated with the folk legend of the marriage of Nu Wa and Fu Xi, from whom humans are said to be descended.

Symbolically, the gourd came to represent longevity, medicine, magic, and science. The Daoists believed that the double gourd represented the unity between the heaven and the earth, the upper portion being the heaven and the lower half the earth. Some of the attributes it has been given are no doubt due to the fact that the gourd is the vessel that Li Tieguai carries (*see* Eight Daoist Immortals). When Li Tieguai is depicted, he always carries in his hand a double gourd containing a magic potion. Legend maintains that when the gourd is opened, a magical vapor is released to trap devils. Li Tieguai's vessel is also a symbol for medicine. The double gourd is a traditional symbol for numerous male progeny and long life. When a double gourd is depicted with bats (happiness) and the character *shou* (longevity), it forms a rebus expressing a wish for long life and many sons.

Gourd and vines with tendrils symbolize ten thousand generations. "The gourd was associated with fertility, and the words for vine, *wan,* and the stem that holds the gourd to the plant, *dai,* together make the phrase meaning 'ten thousand generations.'"[31]

Gourds not only have a symbolic meaning in Chinese art, but untold objects were fashioned from the gourd itself. Gourds with tortuous shapes that have been fashioned into vessels, particularly those that have age, are highly prized by scholars. Cages for crickets were fashioned from gourds that were placed in molds while growing, forcing them into shapes suitable not only in terms of design but for this particular use. Gourds were also made into brush washers and water droppers for use by scholars.

◻ Detail of porcelain dish depicting grapes and vines. Yongle period (1403–24). Private Collection.

Grapes and Vines

The fruit of the vine, grapes, *putao,* as well as the grapevine, *putaoshu,* symbolize a wish for abundance (wealth and sons), which hopefully would extend for many generations. Because of the many small fruits, grapes symbolized many sons while the vines symbolized the extension of many generations.

As a decorative motif, grapes and grapevines were utilized most famously on early Ming dynasty blue and white porcelains. The design continued to be used well into the Qing dynasty on porcelains and also on textiles.

Guan Di

Guan Di, the God of War, is said to be from Shanxi Province and is one of the three sworn brothers of Emperor Liu Bei of the Three Kingdoms period (220–265 C.E.) fighting in defense of the House of Han. His loyalty remained unbroken until his death. (He was beheaded by an enemy in 219 C.E.) In reality, he was a human hero who began to be worshiped shortly after his death. However, it wasn't until the Song dynasty that he was recognized as a Daoist god and granted the title of "marshal," or high official. He has had many aliases, *haos*, including Yun Chang (Long Cloud), Mei Ran Gong (Handsome Long Beard), as well as Guan Yu (Feather).[32] In the famous novel, *Romance of the Three Kingdoms,* he symbolizes absolute righteousness, dignity, and nobility and is seen as the God of War fighting against evil. He is the ultimate symbol for justice, honesty, and integrity.

A popular figure through the ages, he is frequently portrayed in Chinese opera in addition to being the subject of figurines placed in shrines, temples, homes, and police stations. He is the patron saint and protector of honest traders and businessmen, and encourages prosperity and growth. It is believed that no ghost, demon, or evil spirit would dare to come close to his temple or shrine, and no human being would dare to make a false statement at his altar as the punishment for such treachery would be to receive bad karma. Hence his name is Guan Di, Emperor, referring to his absolute justice and power. In folktales, he is not only a protector but also a diplomat, one who uses his strength to avoid war and conflicts. His qualities make him an ideal figure for all to worship.

There are many folk stories about Guan Di. One tells that he was a stubborn, rebellious child originally called Chang Sheng who was once confined to a room by his parents for being unruly. Having escaped the confines of his room and run to town, he overheard an elderly gentleman and woman lamenting that their daughter was to be taken by an official as a concubine in spite of the fact that she had already been promised to another. In anger, he took a sword and slew the official and fled. While washing in a brook, in the reflection of the water he saw that his features had changed and it was then that he took a new name Guan, which can mean "official."[33] The popular and theatrical stage features of Guan Di are a fierce red face, strong eyebrows, slanting phoenix eyes, long black beard, and a green robe.

Guan Di's birthday is on the thirteenth day of the fifth lunar month. The lighting of lanterns and eating of festive foods customarily mark this folk celebration.

Guan Di is a popular subject of painting and sculpture. During the Ming dynasty, bronze figures of him were particularly common, but he was also sculpted in wood and porcelain. He remained a popular figure for both paintings and sculpture in the Qing dynasty.

□ Guan Di. Boxwood carving, eighteenth century. Ji Zhen Zhai Collection.

Guanyin

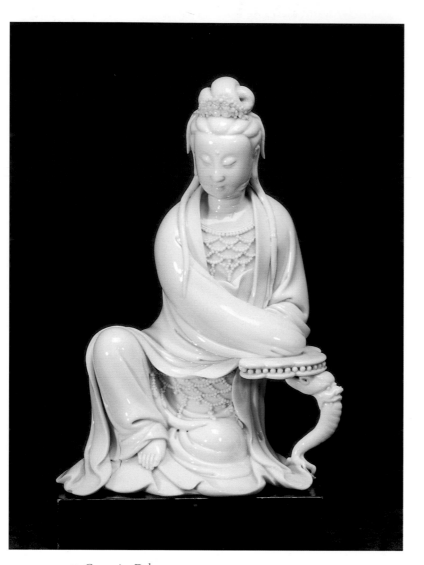

Guanyin. Dehua ware,
eighteenth century.
Collection Anunt Hengtrakul.

Guanyin, or Avalokiteshvara, originated in Buddhist India. Avalokiteshvara when translated into Chinese means "he who listens to the [world] sounds," or *Guanyin*. He was an ancient Indian male god, Buddha of the Past, and was referred to as such when Buddha was alive circa 550 B.C.E. Buddhism was introduced into China around the first to second century B.C.E., the Han dynasty. Centuries later, possibly during the late Tang or early Song dynasty, this male god of compassion and kindness was completely assimilated into Chinese culture and transformed into a female figure. This female transformation is seen only in Chinese Buddhism.

Guanyin came to embody the Chinese motherly virtues of compassion. This can be seen in the stone engraving of the Guanyin attributed to the famous Tang artist Wu Daozi (early to mid-eighth century), and the mural painting of the seated Shuiyue Guanyin, or Water and Moon Guanyin, in the Dunhuang caves of the early Song dynasty. Water and moon are female symbols in Chinese art. Guanyin is sometimes known by the name of *Nanhaizizhulin Quan yin dai shi*, the Great Lady from the Purple Bamboo Grove of the Southern Sea. This name refers to the sacred residence of her (his) ancient Indian origin. In a mythological Indian Ocean, there was a holy island with noble purple bamboo trees. Some believe it refers to the sacred Putuo Island off the coast of Zhejiang where a large temple was built during the Song dynasty and dedicated to Guanyin's worship.

Guanyin, the Goddess of Mercy, is depicted as a woman with white robes, shoeless, peering downward in an expression of purity and wisdom. The Chinese word *guan* means to see and the word *yin* means sound, referring to listening; the two words together translate to "she who always sees and pays attention to listening." She symbolizes purity and is worshiped for wealth, male offspring, and protection against all things that are evil.

Guanyin was the subject of paintings and sculptures from the Tang dynasty to the Qing dynasty. Because she represents purity, she was a particularly popular figure for the wares produced in the Dehua kilns of Fujian, the so-called blanc de chine porcelains that were pure white.

Guardian

Guardian figures were fashioned for both the living and dead to protect souls and spirits from evil. For the living, they were constructed of stone as well as other materials and placed in prominent places. For the deceased, it was commonplace during the Han and Tang dynasties for guardians to be constructed of pottery and to be placed in the graves to ward off evil spirits. In the early Han dynasty and periods preceding the Han, it was customary for servants of the wealthy deceased to be placed in the grave to accompany him to the netherworld, thereby protecting his spirit. In the Tang dynasty, pottery figures were used exclusively for this purpose.

Gui Dragon

The Gui dragon, *gui long*, has been described as having the body of a tortoise and head of a dragon. This mythical animal is sometimes referred to as one of the sons of the Dragon King and is recorded in Yuan literature.

Guihua

The flower of the eighth lunar month is the *guihua*. Highly fragrant and native to China, it is known in the West as "sweet olive." Its leaves are thick and not unlike those of the magnolia. The flowers of the *guihua* are highly prized and used as an additive for tea. The name of this flower is a homophone for the word for noble, thus *guihua* symbolizes nobility. In Chinese art, a male child frequently holds a branch of *guihua*, visually expressing the wish "May you have a son who achieves nobility."

"The *guihua* is also a symbol for literary success, for in ancient China, 'to pluck the *guihua* from the Moon Palace' was to pass the civil examination with honors."[34]

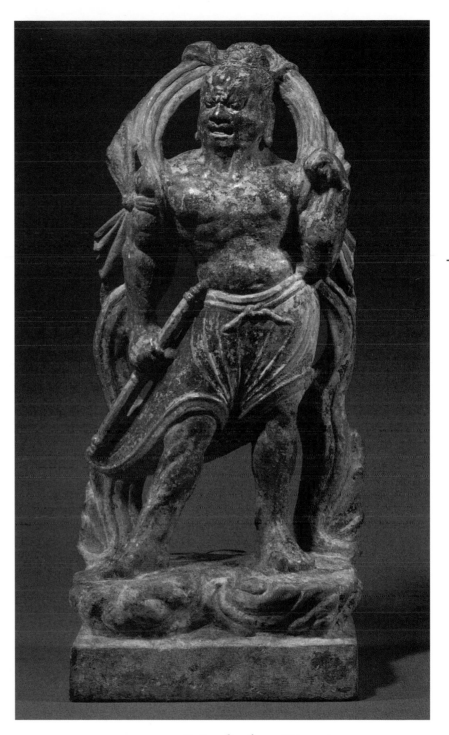

□ Guardian figure, Vajrapani. Carved stone, Tang dynasty (618–907 C.E.). Courtesy of Roger Keverne.

Halberd or Pole Axe

A specific type of axe weapon, an axe head on a long staff, is called a halberd, *ji*. This word forms a pun on the words meaning good luck, also *ji*, and rank, *ji*. Several rebuses are formed.

Three halberds and a vase form the rebus *ping sheng san ji,* which means "May I rise three degrees in official rank without opposition." *Ping* means "vase," *sheng* means "raise," and *san ji* means "three steps."

A halberd and musical stone together with a vase form the rebus *ji qing he ping,* or "good luck, good fortune, and tranquility" (*see* Musical Stone). *Ji* is the halberd; *qing* is a musical stone; and *ping* is a vase, which always implies peace, *he ping.*

Three halberds rising from an ingot with cassia flowers attached to halberd staffs form the rebus *yi ding sheng san gui ji,* or "May you rise three grades in the nobility."

Hat

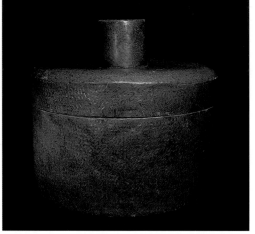

□ Hat box of rhinoceros lacquer.
Seventeenth century.
Ji Zhen Zhai Collection.

The word for hat, *guan,* is synonymous in sound with the word meaning official *guan.* Depictions of figures with hats give rise to many visual rebuses.

A father and son both wearing official hats expresses a visual wish that the son follow his father to an official position. It is also expressed in the rebus *dai zi shang chao.*

A common folk charm depicts a boy with a hat riding on the back of a dragon. This expresses a wish that the boy will someday achieve number one of the first class of the Civil Service Examination, *zhuang yuan.* It is also expressed by the saying *zhuang yuan ji di.*

To the Mandarin, the hat was an integral part of the court dress. From the eighth month of the lunar calendar, the prescribed hat was one with an upturned brim of black satin, sealskin, velvet, or mink with a padded crown that was covered with fringing. For the summers, beginning from the third month to the end of the seventh month of the lunar calendar, the prescribed hat was conical in shape, constructed of woven straw for the lower ranks and split bamboo for officials. Fringes of red silk or the hair of a goat or horse that was dyed red covered the hat from its apex to its edges. Topping the hat was a large bead affixed to a metal mount that held it to the hat. The bead was equivalent to the rank badge that was worn on the front and back of the surcoat (worn over the court robe), which identified the rank of the Mandarin.

- □ First rank: opaque red glass
- □ Second rank: coral or opaque red glass engraved with the character *shou*
- □ Third rank: sapphire or clear blue glass

- Fourth rank: lapis lazuli or opaque blue glass
- Fifth rank: crystal or clear glass
- Sixth rank: moonstone or opaque white glass
- Seventh rank: plain gold or gilt metal
- Eighth rank: gold or gilt metal engraved with the character *shou*
- Ninth rank: silver until 1800, then gold or gilt metal engraved with the character *shou*

He He

These two boys are commonly called the He He Twins, also known as the Heavenly Twins or the Two Saints of Harmony. Folktales maintain that the twin boys represent Han shan, the poet, and Shi de, a foster child of the Guo Qing monastery. The origins of their representations are not known. It is said that they represent marital harmony and gods of riches.

The He He Twins were a popular subject for paintings as well as sculptures. In spite of the fact that their meanings remained obscure, during the Kangxi period (1662–1722), they were a popular subject for export wares as Westerners merely saw them as figures of children.

Heron

The heron is an elegant white bird whose color signifies longevity as well as purity. With its beauty and symbolic meaning, it was a frequent subject for paintings.

The heron has a special meaning when pictured with a lotus. The Chinese word for heron is *lu*, being a homonym for the word for path or road. When combined with the lotus, *lian*, it forms the rebus "May your path take you higher [in status and position]."

- He He Twins. Dehua ware, nineteenth century. Private Collection.

A Pith painting depicting hibiscus. Nineteenth century. Collection Anunt Hengtrakul.

B Painting of horse by Xu Beihong (1895–1983). Private Collection.

Hibiscus

This beautiful showy flower is both a symbol of spring and of honor and riches in life. Hibiscus, *fu rong hua*, receives these attributions from its name, *fu* meaning riches and *rong* meaning fame. *Fu rong* is also often used to describe a beautiful lady's face.

Yi lu rong hua is a rebus that wishes one "a path to high status," *yi lu* meaning "one path" and *rong hua* meaning high status.

Honey

The word for honey, *mi,* refers not only to the product of bees, but also to sexual pleasure. Symbolically, they are one and the same. As such, dreams of honey were said to be a good omen.

It is a folk custom to place honey on the lips of pictures of the Kitchen God so that good will and fortune will be bestowed on the house (*see* Kitchen God). The center of the compass, the fifth point, is also the word *mi.*

Horse

The horse is native to Central Asia, but once imported to China, it was quickly incorporated into the culture. It is a symbol for speed, power, energy, and perseverance. Horses were subject matter for many famous Chinese painters and numerous stories, the most famous being "The Eight Steeds of Mu Wang." The story tells of Emperor Mu Wang. He longed to visit the Western Paradise at the center of the land of immortality, where, according to legend, trees, flowers, and fruits of pearls, jade, and coral grew. The Western Paradise contained the garden of Xi Wang mu (Queen Mother of the West and Queen of the Fairies) and her famed peach tree, which had the essence of immortality. Determined to visit this paradise, Mu Wang, his esteemed charioteer, Cao Fu, and his eight magnificent horses set out. The emperor, charioteer, and the magnificent horses were never heard of or seen again. It is assumed that they reached their destiny and once there, Mu Wang was rewarded one of the peaches of immortality and remained on the slopes of the mountain.

In Chinese medicine, all parts of the horse were utilized for specific ailments, which were listed in the *Bencao Fenjing* in the sixteenth century. As a motif in art, the classic Chinese painters who were famous for horse paintings were Han Gan, circa eighth century and Zhao Meng fu of the late Song dynasty. Xu Beihong (1895–1983) was the most famous painter of horses of the twentieth century.

Hu

A rectangular tablet, which was also called a hand board, jade board, or audience board, the *hu* was used in Daoist rituals and audiences with sovereigns. *The Book of Rites* specifies "to make Tablets, emperors use ball shaped jade, dukes use ivories, senior officials use fish scales and asparagus ferns, and scholar officials use bamboo roots and ivories." In Daoist rituals, the *hu* was a symbol of showing respect to spirits.

During the Ming dynasty, the *hu* were used by officials of the first to fifth rank and were made of ivory. *Hu* made of wood were used by officials of the sixth to eighth rank. During the Qing dynasty, *hu* were no longer a meaningful symbol and were no longer used at court. It is written that during the early Ming dynasty, there were strict regulations regarding the *hu* as it allowed one access to areas of the palace that were restricted.

Hu made of ivory are more common today than those made of wood, despite the fact that they represented a lower rank.

Hui Motif

The *hui* motif, or meander pattern, is used in decorative borders in Chinese art. It appears on Neolithic pottery and through the ages underwent stylistic changes, eventually evolving into a line motif. It bears resemblance to the character *hui*, meaning to return, or endless returning, everlasting. The swastika border pattern is thought to be related to one of the many forms of this pattern.

Human Figures

Human figures, *ren wu,* from *ren* meaning people and *wu* meaning events and matters, have been depicted in Chinese art since the pre-bronze periods of the Liangzhu and Hongshan cultures. Human figures made of red clay have been excavated that were rudimentary in form. Later figures were carved of stone, jade in particular. The excavated objects of jade were usually small and while they were primarily modeled after animals and ritual objects, there were also those of human forms. There is speculation that most of these early pieces were used for decorative purposes; however, other scholars speculate that they held religious significance.

During the Han dynasty, the human figure began to play a major role as an art form. With the entrance of Buddhism into China, cave and temple sculptures flourished. The magnificent cave sculptures along the Silk Road helped to spread the new religion throughout the land. At the same time, these sculptures inspired others to be made for temples. The sculptors and their assistants were supported

□ Hu. Ivory, seventeenth century. Gerard Hawthorn, Ltd.

by the wealthy. The sculptures they created inspired everyday people in the religious aspects of their lives. Tomb art also flourished, some of which depicted non-religious figures that were more representational of everyday life. These figures depicted people who were to accompany the deceased to the spirit world as well as figures that were designed to ward off evil spirits and to guard the dead.

With the development of folktales and tales of religious figures, craftsmen came to depict these gods, goddesses, and folk heroes in porcelain, painting, textiles, wood, and bamboo. It was during the Ming and Qing dynasties that figurative art forms other than stone carving were at their height in China. Figures conveyed messages of history, folklore, moral stories, mythology, and social customs as well as private entertainment. It should be noted that these figures also provided an educational focus for children and continuity in folk beliefs from generation to generation, until abruptly halted by the Cultural Revolution in 1949.

Hundred Antiques

□ Circular bronze box with design of the hundred antiques. Seventeenth century. Ji Zhen Zhai Collection.

The term hundred antiques, *bai gu,* refers to a group of antiques utilized in a decorative pattern. The pattern usually consists of combinations of a number of the following: the Seven Treasures of Buddhism, Eight Precious Things, Eight Symbols of the Daoist Immortals, Four Treasures of the Scholar, archaic bronzes, and musical instruments along with written and stylized characters as well as various animals.

This pattern was purely decorative and held no significance in terms of a projected meaning to the viewer. Some scholars believe that the evolution of the hundred-antiques pattern marks a development symbolizing the continuity of Chinese culture. Others, however, believe that this pattern is but visual evidence of the gradual deterioration of Chinese culture since it devolved to being simply decorative in nature; the pattern combinations no longer evoked the meaning they had held in the past.

Hydrangea

The hydrangea, *xiu qiu hua,* is an auspicious flower that is called "embroidered ball" by the Chinese. The size and beautiful color of the hydrangea flower relates it to the *Xiu Qiu.* In a folk custom, *Xiu Qiu,* a ball made of silk, is thrown by an unmarried woman toward a crowd of male admirers. The male suitor who catches the ball becomes her future husband. *Xiu Qiu* is also the embroidered toy ball of the Guardian Lion; sometimes it is depicted under the paw of the male Guardian Lion (*see* Lions).

A Painting of hydrangea.
Ink and color on silk,
thirteenth century.
Kaikodo Collection.

B Cracked ice pattern detail
from porcelain jar.
Kangxi period (1662–1722).
Collection Anunt Hengtrakul.

Ice

Ice is associated with piety and relates to a folk story of the Jin dynasty where Wang Xiang's mother is ill and longs for a carp to eat. Wang Xiang, showing his filial piety, goes to the lake to fish for a carp, but the waters are frozen. Determined to provide for his mother, he waits patiently until the ice melts and a carp jumps from the waters. What lies above the water is said to be yang (male) and what lies below the water is yin (female).

The term "broken ice" is a metaphor for the pleasures of marriage in old age. Ice is also a symbol of purity, and crystal is said to be pure ice.

The cracked ice pattern is frequently seen during the Kangxi period of the Qing dynasty. It represents the blossoms of the prunus tree that have fallen on the cracking ice, the overall pattern combining to represent spring. The pattern symbolizes is the rebirth of spring and continuation of life.

Incense

Incense, *xiang* (which has the meaning of being fragrant), has been important in religious rituals for centuries. Incense smoke is believed to resemble cloudlike energy that is sacred and to be a vehicle that travels to the spirit world. It is believed to purify religious areas.

The followers of Buddhism in India first burned strips of sandalwood during the summer to stave off fatigue and aid their concentration while listening to Sakyamuni, the founder of Buddhism. It then became a practice to burn sandalwood or other incense during discussions between teachers and disciples.

Incense was first brought to China from India along the Silk Road. The Silk Road was fraught with dangers, including robbers. Although incense was an expensive commodity, it was felt to hold mystical properties since it was used for religious ceremonies. Robbers feared that bad luck would be the result of stealing shipments of incense. For many decades, incense was shipped from India until the Chinese learned to produce it for themselves. Incense has remained an important part of rituals in Daoist and Buddhist temples.

□ A Miniature imperial workshop
 incense table. Boxwood,
 Qianlong period (1736–95).
 Ji Zhen Zhai Collection.

□ B *Duan* stone inkstone.
 Seventeenth century.
 Ji Zhen Zhai Collection.

A

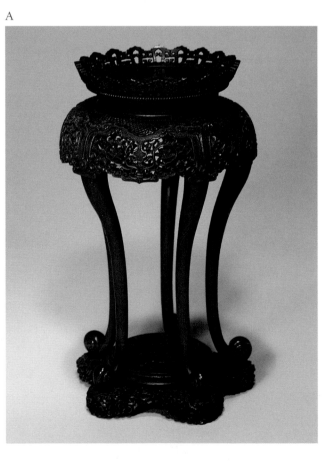

B

Inkstone

One of the Four Treasures of the Scholar, the inkstone is an indispensable tool. It provides the surface upon which the inkstick is ground and mixed with water to form an ink solution. The stone is selected for the texture of its grain as well as for the degree of friction created when the inkstick or ink cake is rubbed onto its surface. Some connoisseurs believe that in the process of grinding, a little bit of the stone is actually incorporated into the fluid, enhancing the color and durability of the ink. The stone also serves to retain the liquid ink for use; the quality of the stone influences the degree of absorption or evaporation of the ink. Although many types of stone were used for inkstones, the earliest were not made of stone at all but metal and pottery. The most famous type of stone was the *duan* stone from the Guangdong Province (*see* Duan Stone).

The inkstone is the emblem of Wang Xi zhi, the famed calligrapher who is said to have invented calligraphy in the kai shu style. When he is depicted in painting or sculpture, he holds an inkstone and wears the long robes of a scholar.

Iris

According to folk legend, the iris is repugnant to evil, therefore drives it away. It is a folk custom to hang an iris on one's door on the fifth day of the fifth month to drive away evil spirits. The iris has also been utilized in Chinese medicine as a rejuvenating herb.

Iron

Iron is the fifth of the five most important metals of China (the other four being gold, silver, copper, and tin) and corresponds to the color black. Iron symbolizes strength, integrity, and the ability to drive away evil. Hence, in the early days it was a folk custom to place figures of iron in rivers to drive away the evil sea monsters that would do harm to seafarers and their boats.

Unique items in Chinese art are the iron pictures of the four seasons that are frequently seen in the scholar's studio. The origin of these pictures is explained in a folktale of the Tang dynasty, where a poor artist falls ill and a blacksmith comes to his aid and nurses him back to health. In an effort to repay the blacksmith, the artist paints a picture and presents it to the blacksmith who hangs it near his forge. One day, the blacksmith copies the picture in scraps of iron and shows it to the artist. They then combine their skills to create these unique iron pictures.

□ Iron picture.
Eighteenth century.
Gerard Hawthorn, Ltd.

Ivory

Ivory, *xiang ya*, literally means "elephant tooth." It represents sacredness, compassion, completeness, and the Buddha. Its religious meaning came to China primarily with the entrance of Buddhism. It has been utilized as a medium for art for hundreds of years.

Jade

Since the earliest periods in Chinese history, the Chinese have prized jade (nephrite, not to be confused with jadite), *yu.* It was a symbol of the infinite and it was believed that jade had the power to conserve the body after death. As early as 3000 B.C.E., ritual and practical instruments were made of jade. Jade is not found throughout China, but only in the far western areas. Why it was chosen as such a prized substance is not known, but some scholars feel that it was due to its durability and the beautiful colorations that appear when the stone is polished. For whatever reason, it came to represent heaven in the form of a perforated disk, the *bi.* The character for jade in the Chinese written language was a pictogram of three pieces of jade connected with a string with a single stroke added to represent *wang,* meaning "prince." It took on the meaning of immortality. Suits of jade were made for royalty at the time of death, body openings were filled with jade plugs, and ritual symbols of jade were placed over one's body.

With the reverence of jade came symbolic meanings. Confucius likened the desired qualities of men to jade. According to the Confucian classic *The Book of Documents (Shu Jing),* jade was described as a source for strength and the core of the "ten thousand things" in the world. Jade was said to possess such human virtues as justice and wisdom. Therefore, carrying jade was not only an amulet for protection, but also it was said to have the power to prevent a rider from falling from his horse. Women were likened to the qualities of jade that symbolized purity and grace. Jade took on sexual connotations as well.

The word for jade, *yu,* is a homophone for the word meaning flesh, *yu.* Any evil influence one might encounter would mistakenly attack the jade, which is known for its durability. Hence the Chinese folk expression *zheng yi yu,* or "fulfill with jade," is derived from the custom of tying a piece of jade to oneself in order to bring luck and ensure safety.

□ Carved ivory teapot.
Tianqi mark, seventeenth/
eighteenth century.
Ji Zhen Zhai Collection.

Jade Emperor

The Jade Emperor, Yuhuang shi, is one of the three major Daoist gods. It is written that after the Supreme Sovereign of the Great Dao gave an infant to the Empress of Precious Moonlight, she bore a son. This son renounced the throne to cultivate fields and eventually attained immortality. He taught buddhas to understand the Great Vehicle (the way to approach the Dao) and eventually was named the Jade Emperor.

The ninth day of the first lunar month is the prescribed birthday for the Jade Emperor, which is celebrated by the burning of incense in the Daoist temple. He is welcomed on New Year's Eve, at which time he is said to reward those who do good or punish those who commit evil deeds. It is a custom for those who fear the Jade Emperor to place incense at their doors as well as offering of vegetarian food to welcome him.

Jasper Lady

The Jasper Lady, Yao chi, is a Daoist goddess who is said to have helped Yu, the legendary founder of the Xia dynasty, control the floods. Her name is said to have come from a jadelike substance that represents purity and refinement. It is written that she lived in the same area where the Queen Mother of the West, and she is associated with magic and the occult. She is further associated with the color of cinnabar and the attribute of immortality. As to how she might be identified is a difficult question, as it is recorded that when she is with humans she takes a human form; when she is with animals she takes an animal form. She is not limited to the shape of clouds or rain.

Ji Gong

Ji Gong is known as the "mad monk." Folktales indicate that he lived during the Song dynasty near Hangzhou. He rebelled against the Buddhist leaders by doing exactly what he was told not to do. Yet he was kind and helped the common folk, which made him a popular figure.

In sculpture, he is often confused with Li Bai, the drunken poet, since they both are portrayed being overintoxicated with wine. Ji Gong, however, is usually portrayed holding a fan or leaning against a tree, a portrayal uncharacteristic for Li Bai.

Jue

The *jue* is a bronze sacrificial wine vessel first seen in the Shang dynasty (1600–1050 B.C.E.) and replicated during later dynasties in many forms. Its cuplike body stands on three sharply pointed legs. Used in ancestral worship, symbolically it connotes rank and ancestral worship. Because of the symbolic meaning, it is frequently depicted in paintings, carvings, and designs on lacquer. Moreover, through the various dynasties, its original bronze form has been repeated in other media, including porcelain and bamboo.

A pair of *jue* on a tray, a design seen on late Qing dynasty Mandarin robes, forms the rebus *tai shang liang jue,* meaning "May I succeed to rise two ranks in nobility." *Tai shang* means "raise up," *liang* means "two," and *jue* means "rank of nobility."

When the two cups are green and supported by clouds, the rebus has the meaning *jue lu chong gao,* or "May my honors and riches be lofty."

□ Porcelain *jue* and stand. Qianlong mark and period (1736–95). Ji Zhen Zhai Collection.

Kapala (Skull Cap)

The kapala is a ritual cup in Lamaism (*see* Lamaism). Fashioned from the skull of a human, the kapala is placed on altars of deities and can be a direct object of worship. In other sects of Tibetan Buddhism, it is an offering vessel that is filled with juices of fruits, symbolizing wisdom and long life, which are the nectar of life. In tantric cults (offshoots of Buddhism), it can be filled with wine and semen. The symbolism of the skull is that of wisdom and self-sacrifice.

Kartrika

Kartrika is the Sanskrit word for what we know as a chopper or chisel. A ritual object in Lamaism (*see* Lamaism), it has a handle affixed in a perpendicular fashion to the middle of an S-shaped blade. The kartrika is usually held in the right hand of the Buddhist deity and symbolizes the ability to cut through and reduce all things to nothingness, which ultimately is transformed into wisdom.

Kingfisher

The kingfisher, *fei cui,* is the size of the swallow and is an inhabitant of Southern China. The brilliant emerald green color of the kingfisher feathers mimics the word for jadite, *fei cui,* Burmese jade that is highly prized by the Chinese.

This tiny bird is a symbol of beauty, and by legend was said to nest on the waves themselves and to quell the turbulent waters of the sea. It also symbolizes

the bringing of peace and quiet. Its feathers have been prized and utilized in artistic creations, for example, in screens and paintings, as well as for inlay in jewelry, particularly during the Qing dynasty. There are rare Qing court robes, obviously made for the wealthy, in which kingfisher feathers were incorporated into the weaving of the fabric.

Kitchen God

According to folklore, the Kitchen God, Zaowang, is the inventor of fire and the monitor and protector of the household. Either depicted as a folk god on brightly colored paper or represented by bold characters on red paper, he is placed on a wall in the kitchen to observe the family. A week before the New Year, the Kitchen God is said to make his report to the heavens. At this time, his depicted lips are smeared with honey—either to sweeten his report or to keep his mouth closed. The picture or saying is then burned and his spirit travels in the smoke to the Jade Emperor in heaven, to whom he will make his report.

Kui Dragon

The *Kui* dragon, *kui long,* is a primitive form of the dragon. This dragon lacks legs and is serpentlike in form. In the classical text *Shanhaijing, (The Book of Mountains and Seas),* the *kui* were described this way: "shaped like a cow, the animal has a grey body and one leg. It is without horns. When it enters or leaves the water, storms and rains occur. Its eyes are as bright as the sun and the moon. Its voice thunders. Its name is *k'uei.* When Huang-ti [the famed Emperor] captured it, he made a drum from its skin and beat it with an animal bone. The sound could be heard for 500 miles."

The *kui* were initially found cast on Shang dynasty bronzes. They were also used in complex interlacing patterns during the Eastern Zhou dynasty. During these two periods, at least fifteen different styles of *kui* have been identified. The most popular and frequently seen appeared as an animal with open mouth standing on one leg with a curved hooklike tail.

During all of the subsequent dynasties, these *kui long* continued to be seen as a design element. Popular during the Ming and Qing dynasties, as time progressed, the *kui* dragon took on a more stylized form and was popular as a secondary decoration in borders. The symbolic meaning of *kui long* was said to be that of a restraining influence on greed.

☐ Kingfisher embroidery by the famous Gu family of embroiderers. Ming dynasty (1368–1644). Chris Hall Collection Trust.

Kuixing

Kuixing, the star ghost, is an important figure who gives inspiration to Civil Service Examination candidates and sometimes is also called the God of Literature. The latter confuses him with Wenchang, the Daoist god who is also called the God of Literature. To complicate matters further, there is a painting in the British Museum that depicts Wenchang with Kuixing in the foreground where Kuixing is identified as Wenchang's acolyte.[35]

Kuixing is is unmistakable in depictions. He has a grotesque smiling face, large threatening eyes, and a square mouth to ward off demons and evil. He holds a brush in one hand and a scroll or tablet in his other hand, symbolizing writing or recording literature. Legends abound that the emperor, repulsed by the facial appearance of Kuixing, failed to award him the customary golden rose due to the candidate who passed first in the palace examinations. Humiliated, Kuixing threw himself into the river but was saved by a water monster. He then ascended to the northern part of the Great Bear and became the stellar patron of the literati. Kuixing is the name of one of the stars in the Great Bear constellation and their names are interchangeable.

The origin of the star ghost is the North Star (Polaris), located at the tip of the tail of the Little Dipper (Little Bear, or Ursa Minor). The two edge pointers of the Big Bear (Big Dipper, Ursa Major), point to the North Star. Navigators used this constellation for directional guidance as did those scholars seeking direction from Kuixing to the court of the emperor. In this case, Kuixing is portrayed bare footed with his left foot forming a right angle, pointing to the sky, representing the vertical bend of the side wall of a dipper or *dou*. In some examples, his raised foot bears a dipper that symbolizes the measuring and container of inspiration and wisdom. His bent foot points to the North Star, his trademark among all the Daoist heavenly gods. Chinese folklore maintains that if this ghost appears in the dream of a scholar the night before the Civil Service Examination, good tidings will follow.

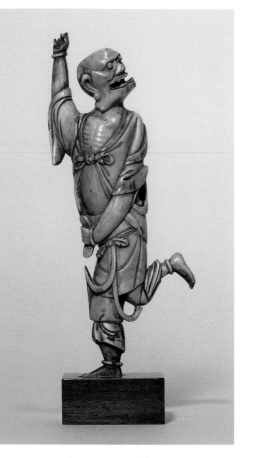

□ Ivory carving of Kuixing. Ming dynasty, sixteenth century. Ji Zhen Zhai Collection.

Lady Ma

Lady Ma, also known as Magu and Ma Gu Xian Shou, represents longevity. She is customarily and appropriately depicted in pictures displayed during birthday celebrations. In Chinese folklore, Lady Ma is a kind-hearted, happy Daoist goddess who always appears at the heavenly garden birthday party (which takes place but once every ten thousand years) of the Queen Mother of the West, Xi Wang mu. Lady Ma presents peaches and a basket of herbs and flowers to the heavenly

empress at the party, which is attended by all of the other gods. She can be identified by her basket of herbs and flowers, the peaches that she carries, and a deer that is sometimes at her side. The deer, *lu,* symbolizes accomplishment, reward, and wealth. The double peaches, *shoutao,* are the special peaches of longevity that convey a wish for the attainment of old age. The gift of the woven bamboo flower basket containing green herbs and peaches symbolizes the gift of health and vitality.

There are several versions of the legend of Lady Ma in Chinese folktales. One tells that she was from Shandong Province of the later Han dynasty. Her adopted brother was a Daoist immortal by the name of Wang Fang ping, and they met each other once every five hundred years to perform miracles. Another legend of Lady Ma tells of how she lived a hermit's life in the mountains among trees and herbs in order to escape her tyrannical, slave-owner father who tortured workers through hard labor. He later became blind, and Lady Ma returned in an act of filial piety and restored his sight with her special prescription made from mountain herbs and wine. Upon his healing, he did not repent but returned to his evil ways. Lady Ma herself attained immortality and flew to heaven on the back of a large bird. Hence, she is known for her compassion and magic herbs.[36]

Lady Ma is also sometimes portrayed in the saying of "being scratched by Magu." This arises from a folktale where the Emperor Xiao (147–158 C.E.) perseverated on the thought of how nice it would be to have his back scratched by the long nails of Lady Ma. For this unseemly thought, an invisible whip bridled him.

Lamaism

Lamaism is the primary religion of approximately three million Tibetan people as well as seven million Mongols. Considered a form of Buddhism—it is sometimes called Tibetan Buddhism—it is felt by some to be a form of spirit worship. The religious leader of Lamaism is the Dali Lama, who is said to be a reincarnation of Avalokiteshvara. Together with the Panchen Lama, a secondary leader, they are considered Living Buddhas—reincarnations of Buddha passing from one existence to another. When one dies, a successor is sought from boys born at the time of his death, since it is their belief that the soul of Buddha has but passed to another existence.

For those that practice Lamaism, objects with characteristics unique to this religion were manufactured in China.

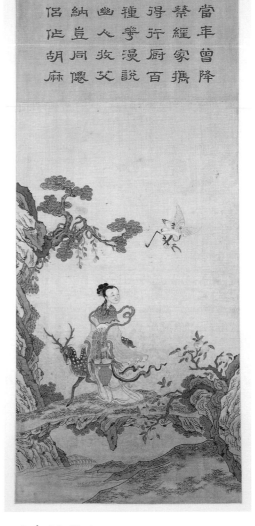

□ Lady Ma. Kesi tapestry, Yongzheng period (1723–35). Ji Zhen Zhai Collection.

Lance/Trident

The lance and trident are ancient weapons. They were adopted into Buddhism and became symbolic both of the essence of Buddha and of arms against evil. The trident has three points—the lance has one—and may have its origins in an early symbol for fire. The trident not only appears in early Buddhism in India but also appears in Daoism as an attribute of Daoist divinities. In Lamaistic Buddhism, the trident takes on the meaning of a magic wand that has power over demons. Guardian figures, common during the Tang dynasty, are sometimes depicted holding the trident, again symbolizing power over demons (*see* Guardian).

A fierce figure who holds a spear is Wang Yan-chang, a general of the sixth century. Known for his courage, honor, and strength, he was called "Wang of the Iron Spears." During a battle, he was captured and because of his fame and honor, his life would have been spared if he would pledge allegiance to the new king. But his convictions would not allow the change of allegiance; he refused and was killed.

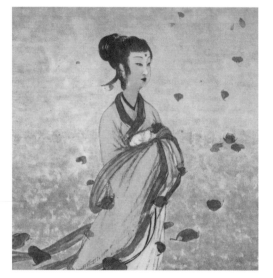

□ Detail of "Lady and the Leaves" by Fu Baoshi (1904–65). Private Collection.

Lantern

Lanterns are not only utilitarian objects but also have spiritual meaning. The lantern, *deng,* is said to provide light for the living and also for those who have departed. While in Buddhism light symbolized knowledge, to most Chinese light is an element of filial piety.

A design of lantern, *deng,* with wasps, *feng,* forms a rebus meaning "bumper crop," *feng deng,* since *feng* means "bumper crop" and *deng* has the same sound as "attain." This design was popular on bowls of the Qing dynasty for the Lantern Festival, the fifteenth day of the first lunar month. Folk legends maintain that during the Lantern Festival, lanterns provided a way of guiding the souls of one's ancestors to and from the netherworld. "The holiday was celebrated with lantern decorations, parades, and prayers for prosperity and health. The emperor wore special robes with the same pattern as the medallion bowls [porcelain bowls with framed pictorial areas]."[37]

Leaves Blowing in the Autumn Wind

The falling of leaves in the autumn wind is frequently depicted in Chinese paintings. "Leaves falling into Lake Dongting are a metaphor for petty men managing affairs and therefore worthy men being cast away *(Chu ci bu zhu)*."[38]

Paintings by the famous twentieth-century artist Fu Baoshi (1904–65) frequently reflected this metaphor or theme, particularly his paintings of Lady Hsiang.

Leopard

This beautiful, sleek, fierce animal of the cat family is native to China although it is relatively scarce. The leopard is one of the Four Animals of Power and Energy along with the elephant, lion, and tiger. It represents bravery and ferociousness.

Leopard, *bao,* has the same pronunciation as the word for "announcement." Leopard and magpie *(xi que)* become *bao xi,* or "announcement of happiness."

On the Mandarin square, the leopard is the emblem of a military official of the fourth rank during the early Qing dynasty. In the late Qing dynasty (after 1664), it became the emblem for the third rank. Mandarin squares depicting this rank are relatively scarce (*see* Mandarin Square).

Li Bai

Known as the drunken poet, Li Bai (699–762 C.E.) is one of the most celebrated of Chinese poets. His name comes from the planet Venus because it is said that his mother dreamed of Tai bai, Venus, while she was pregnant. He was named Li Tai bai, also called Li Bai.

Li Bai's talent emerged at a very young age, and as a result he was brought to court by the emperor. After giving him writing materials, the beautiful and celebrated concubine Yang Gui fei

□ Drunken poet Li Bai and attendant. Carved wood, seventeenth century. Ji Zhen Zhai Collection.

waited impatiently for his poems. He was inspired to write by drinking wine. However, Yang Gui fei thought his poetry was accusatory and interpreted them as alluding to her in a negative manner. She opposed any attempt to give him a royal position. Despondent, he then turned to a life of wandering and drinking wine. Folktales relate how his life ended. While boating, he saw the reflection of the moon on the water, fell in, and drowned.

Sometimes Li Bai's mentor, He Zhi zhang, is confused with Li Bai. He Zhi zhang was also known to have loved wine. A minister of Emperor Ming Huang, he was a lover of poetry and introduced Li Bai to the emperor. He is sometimes depicted reclining or leaning against a wine jar.

□ Imperial *zhaijie* (fasting
and purification) plaque depicting
a lichee. Carved ivory,
Yongzheng period (1723–35).
Ji Zhen Zhai Collection.

Lichee

The lichee, *li zhi,* is a late summer fruit that ripens when the cicada's sounds are at their loudest. This fruit symbolizes many things, including late summer, intensive heat, and a wish for many children. This last meaning gives rise to the custom of placing dried lichees under the marriage bed.

When the lichee is depicted with water chestnuts, together they form a visual rebus symbolizing intelligence.

It is said that summer is the season for the soothing comfort and luxury of afternoon tea or wine, which is taken with lichees. This was advocated by the famous Song dynasty poet and painter, Su Dong po (1037–1101 C.E.), who wrote the "Ballad of Lichee" in 1096.

> Beneath the Lo fu mountain all four seasons are Spring,
>
> Golden tangerines and yang prunes are continuously fresh.
>
> Daily Consuming, of lichees in the three hundred,
>
> Content without regrets, as a permanent resident,
>
> Of this Southern Province [Guangdong].[39]

In traditional Chinese medicine, the lichee is associated with "yang fire" and heavy consumption of lichees by the young is said to lead to summer fever.[40]

Lily

The lily, *bai he,* in classic Chinese was *xuan* and had the same sound as the word for bright or pleasant, *bai. Bai he* literally means "one hundred together" and is a symbol of harmony and friendship. Many auspicious emblems mimic the waterlily's tight overlapping folds. It is said to be a boy-favoring herb; the flower means "to bring one" sons. This led to the folk belief and custom of wearing a lily in one's belt to bring about the birth of a son. Given this symbolism, the lily became an appropriate present for a marriage or a woman's birthday.

Therese Tse Bartholomew of the Asian Art Museum in San Francisco describes porcelain objects in the museum collection that depict the lily combined with *lingzhi,* or *baihe lingzhi,* giving the meaning "a hundred things to your wish" and blossom of a lily with *lingzhi* and persimmons giving the meaning "a hundred things as you wish," *bai shi ruyi* [41] (*see* Lingzhi Fungus).

A folktale about the lily tells of the Qin dynasty (221–206 B.C.E.) emperor being so excited by the beauty of one of his concubines that he said, "Wherever she steps, a lily appears." Hence, some believe that the term "golden lily" refers to the most

beautiful tiny feet that had been bound. The custom of binding feet of women became widespread during the late Tang dynasty (*see* Golden Lotus).

Lin Hejing

A subject of paintings is Lin Hejing, also known as Lin Bu, a poet who lived from 967 to 1028 C.E. He was known as the "recluse of harmonious tranquillity."

Famous for never having committed any of his poems to writing, he chose not to record his poems because he did not want them handed down to posterity. He is usually pictured during the Ming dynasty with a cap and flowing robes standing alongside a blossoming plum tree and the cranes that he enjoyed. His lifestyle was known as *mei* (plum tree) *qi* (wife) *he* (crane) *zi* (son): a life of fulfillment, longevity, and pleasure.

Lingzhi Fungus

B

The *lingzhi* fungus is the sacred mushroom, fungus of immortality, that by legend could only be found by the stag or phoenix. *Lingzhi* literally means "sacred fungus." It grows in the mountains of Southern China, but according to Daoist beliefs it is found on the Three Islands of the Immortals, the Penglai Islands. Because qualities that give immortality or prolong life have been attributed to it, it has been utilized in Chinese medicine for centuries and remains a medicinal fungus today.

The *lingzhi* fungus is the subject matter in a variety of media, including painting, porcelain, tapestry, and carvings. Its depictions are usually stylized forms mimicking its woody, cloudlike appearance. The *lingzhi* expresses a wish for long life. It became an increasingly popular design in the Qing dynasty, when it came to be used in stylized borders and as a pattern to fill space. It can be a dating tool for Qing dynasty robes because it was not utilized until late in the dynasty. However, its meaning remained the same, that of eternal life. Sometimes it is seen in the mouths of bats and cranes, creating a visual rebus of longevity and happiness. Later this is simply seen as an embellishment.

Lingzhi in a vase represents a visual rebus for a wish for peace and security. It is also expressed by *ping an ruyi, ping an* meaning "peace" and *ruyi* meaning "as you wish."

□ A Detail of enamel design on porcelain saucer depicting lilacs and Wheel of the Law. Xianfeng mark and period (1851–1861). Ji Zhen Zhai Collection.

□ B Lingzhi fungus with inscription by court scholar Ruan Yuan. Qianlong period (1736–95). Ji Zhen Zhai Collection.

A

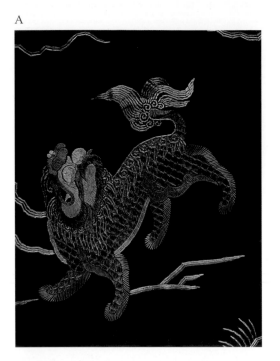

B

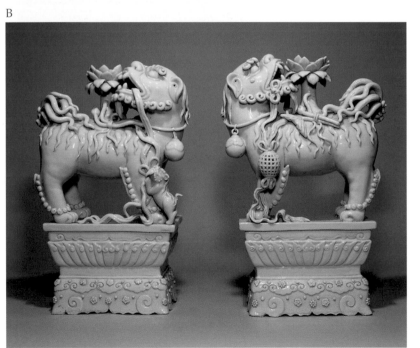

□ A Embroidery detail depicting a
baby lion. Nineteenth century.
Ji Zhen Zhai Collection.

□ B Fu dogs.
Dehua ware, eighteenth century.
Ji Zhen Zhai Collection.

Lions

Lions are not native to China, although there is documentation that the emperors received them as gifts. Lions appear quite early in Chinese art in depictions associated with tombs of the Zhou and Han dynasties. A sacred animal in Buddhism, it is depicted as offering flowers to Buddha and as a mount for some Buddhist deities. In these instances, the lions symbolize superhuman strength and protection of all things holy.

With the entrance of Buddhism into China, lions were gradually absorbed into the culture and symbolism of China. Most commonly, lions were seen outside of temples and important halls, symbolically protecting these structures and all who entered. These lions appeared primarily during the Tang dynasty, considerably later than the entrance of Buddhism during the Han dynasty. Sometimes called Dogs of Fu, they are emblems of valor and energy. As guardians of the temple of heaven, they symbolized courage and all things sacred. The male is seen with its paw over a sphere while the female has a cub under her paw. These depictions may have their origin in a legend where the male was said to produce milk for its young through its paw and the milk would pass into the sphere. Milk is not customarily imbibed in China, but mother's milk is said to impart sexual potency and long life. In some depictions, the male lion rests its paw on a wovenlike sphere that is said to represent an embroidered sphere (*see* Hydrangea). This depiction is usually seen in the late Qing dynasty.

The lion is the symbol of a first- and second-rank military official on Mandarin squares during the early Qing dynasty. However, during the later Qing dynasty, the lion was the symbol for only the second-rank military official (*see* Mandarin Squares).

Nine fu dogs symbolically mean "May nine generations live together." The rebus for this is *jiu shi tong ju.* Nine, *jiu,* is pronounced the same as the word for "long lasting," *jiu,* and generation and lion have the same pronunciation *"shi."* Nine lions, nine quails, and chrysanthemums have the same meaning: "May nine generations live together."

Two lions and *lingzhi,* or *shi shi ruyi,* has the meaning "everything goes the way one wishes." This same rebus is expressed by two persimmons and a *ruyi.* The word for persimmon has the same sound as the word for lion, *shi,* but is said in a different tone.

A lion with a cub, *tai shi shao shi,* is frequently depicted with the cub under the parent's paw. *Tai shi* is a high-ranking official. This rebus conveys a wish that the son may rise to the status of a high-ranking official as his father had done.

Liu Hai

Liu Hai is a popular youthful Daoist god. He is one of the most frequently depicted Daoist figures and is traditionally represented in two versions, one in which he carries a poisonous, ugly three-legged toad that he has tamed and the other where he carries a string of coins across his back. The former is said to symbolize protection from evil spirits, while the latter, seen from the end of the Ming dynasty, is said to represent good luck and wealth.

Who Liu Hai was and whether he was a real or a fictitious character is unclear. Some believe that Liu Hai was merely a character whose name was a play on the name of Liu Xuan-ying (hao, Hai-ch'an) the fifth patriarch of the Northern School of Daoism in the tenth century.[42] Some folk tales record that Liu Hai was a minister of state in the tenth century who attained immortality as a Daoist and forever remained young because he had access to the fountain of youth. Records do indicate that Liu Xuan-ying was an actual person who lived in the Feng-huang district and, in this same district, other records indicate that there was a person named Liu Hai who had the strange ability to call toads from wells. Nonetheless, Liu Hai is said to have had magical power, the ability to travel anywhere in the universe, and with his three-toed toad (his disciple and companion), he could fish money from the sea, which he dispersed to the poor and needy. It is also written that he distracted his toad from releasing poison by playing with coins, thereby preventing people from being harmed. The subtle message of this imagery would appear to be that there is a delicate balance between money and poison and that money can lure men to ruin. He was said to have gained magical powers from the teachings of Lu Dong bin and sometimes he is included as one of the Eight Daoist Immortals.

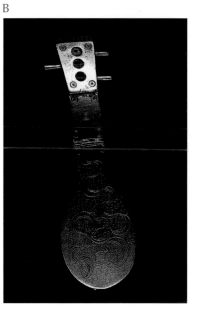

Lock

The lock is a symbolic amulet against evil. Owing to this belief, it was and is a folk custom, particularly fashionable in the nineteenth century, for a small lock to be fastened about a baby's neck to symbolically lock him to life away from the evil spirits. These small locks were usually fashioned from silver and contained characters on them with wishes for good luck.

▫ A Liu Hai.
Ivory, Ming dynasty,
sixteenth century.
Ji Zhen Zhai Collection.

▫ B Lock in the shape of a qin.
Pewter, nineteenth century.
Ji Zhen Zhai Collection.

A

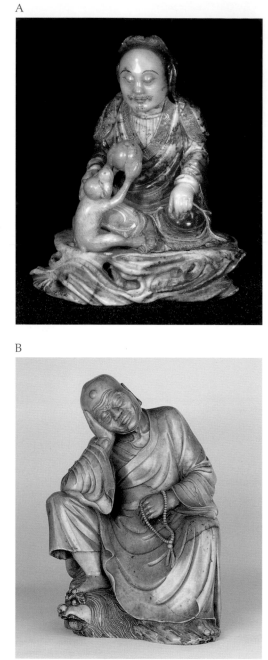

B

□ A Lohan.
 Soapstone, seventeenth century.
 Ji Zhen Zhai Collection.

□ B Lohan.
 Soapstone, eighteenth century.
 Ji Zhen Zhai Collection.

Lohan

A lohan, *arhat* in Sanskrit, is a holy Buddhist monk who has attained sainthood through diligent study and good deeds. Lohans originated as the sixteen (sometimes eighteen) most loyal disciples of the Buddha who were sent out as missionaries to carry the faith abroad. Usually depicted of Indian origin and features—large eyes, large noses, and ears pierced with circular earrings—they were high-class Hindu Brahmans before they became followers of Buddha. They made a vow to the world that they would delay entering nirvana (enlightenment) and would remain on earth indefinitely to save those who suffered and those who were needy. This story was translated from an eighth century Buddhist sutra (scriptural text) of the Tang dynasty by Xuan Zhuang (c.600–664 C.E.)[43] called "The Great Arhat Lantimiduolo Discourse Fazhu Record."[44]

Each of the lohans can be pictured with specific attributes that have symbolic meaning. The usual series of lohans includes:

1. **Ka-no-ka-Fa-tso, Kanaka the Vatsa.** Appointed to Kashmir with a retinue of five hundred other arhats. He was originally a disciple of Buddha, and it was said that he understood all systems, good and bad.

2. **Pin-t'ou-lu-O-lo-sui-shih, a second Pindola, or Elder.** Sometimes called Ko-no-ka-Po-li-to-she or Kanaka the Bharandvaja. His station is the Purva-Videha region and he has six hundred arhats under his authority. Like Esau of the Hebrew Scriptures, he was a hairy man.

3. **Nan-t'i-mi-to-lo-Ch'ing-yu, Nandimitra.** Sometimes known as Su-p'in-t'o or Subhinda. He governed the Kuru country and had a retinue of eight hundred arhats. He sits with an alms bowl and an incense vase beside him, holding a sacred book in his left hand, while with the right he snaps his fingers as an indication of the rapidity with which he attained spiritual insight.

4. **Pa-no-ka, Vakula or Nakula.** Sometimes known as Pa-ku-la or P-u-chu-lo. His sphere of influence is Jambudvipa, or India, and he has a retinue of eight hundred arhats. He was one of Buddha's great disciples, and led a solitary life free from bodily ailments. He converted to Buddhism at the age of one hundred twenty, whereupon he became young and happy. His name means "Mongoose-bearer," and he is said to have kept a mongoose as a pet. He is represented as meditating or teaching with a little boy by his side, and he holds a rosary of one hundred eight beads.

5. **Tan-mo-lo-Po-t'o, Tamra, Bhadra.** Appointed to Tamradvipa, or Ceylon, and provided with a retinue of nine hundred other arhats. He was a cousin of the Buddha and one of his great disciples. He is represented in an attitude of worship with his prayer beads.

6. **Ka-li-ha, Kalika or Kala.** He rules over Seng-ka-ch'a, or Sinha the Lion region, supposed to be Ceylon, but probably some other territory, and has a retinue of one thousand arhats. He is identified with Lion King Kala, who attained

arhatship and was honored by King Bimbiasra. He sits in meditation and has extremely long eyebrows that he holds up from the ground.

7. **Fa-she-na-fu-to, Vajraputra.** He rules over the Po-la-na division of the world, probably Parana-dvipa, and has a retinue of eleven hundred arhats. He is represented as very hairy and lean with his ribs showing.

8. **Chieh-po-ka, Gobaka the Protector.** Stationed on the Gandhamadana Mountain with a retinue of nine hundred arhats. He is represented in contemplation with a fan in his hand.

9. **Pan-t'o-ka, Panthaka or Pantha the Elder.** His sphere is in the Trayastrimsat Heaven, and he is attended by thirteen hundred arhats. Elder brother of Chota Panthaka (lohan number 15). His name signifies "born on the road" and was given to the two brothers because their births occurred while their mother was making journeys. The name is also explained as meaning "continuing the way"—propagating the Buddhist doctrine. He was one of the greatest of Buddha's disciples, who by thought aimed at excellence. He possessed magical power to pass through solids, to reproduce fire and water at will, and to reduce his dimensions little by little until he vanished entirely. He is represented sitting on a rock and reading from a scroll.

10. **Lo-hu-lo, Rahula, the son of Buddha.** Assigned to the Priyangu-dvipa, a land of chestnuts and aromatic herbs, with a suite of a thousand arhats. He was a diligent student of the canons and strict adherent to the laws of Buddhism. It is his fate to die and return to the world as Buddha's son several times. He is represented with a large "umbrella-shaped" or domed head, bushy eyebrows, and a hooked nose.

11. **Na-ka-his-na, Nagasena.** Appointed to the Pan-tu-p'o or Pandava Mountain in Magadha, with a retinue of twelve hundred arhats. An expert in propounding the essentials of Buddhism, he had a commanding presence and a ready wit.

12. **Yin-chieh-t'o, Angida.** Stationed on the mountain called Kuang-hsieh or Broad side, Vipulaparsva, with a retinue of thirteen hundred arhats. He is represented as a lean old monk with a wooden staff and a book containing Indian writing.

13. **Fa-na-p'o-ssu, Vanavasa.** Stationed on the K'o-chu or Habitable Mountain, with a retinue of fourteen hundred arhats. He is represented sitting in a cave meditating with closed eyes and hands folded over his knees.

14. **A-shih-to, Asita, or Ajita.** Appointed to reside on Gridhrakuta Mountain or Vulture Peak, with a retinue of fifteen hundred nine arhats. He is represented as an old seer with very long eyebrows, nursing his right knee, and absorbed in meditation.

15. **Chu-ch'a-Pan-t'o-ka, Chota Panthaka, or Pantha the Younger.** Appointed to Ishadhara Mountain in the Sumeru range with a retinue of sixteen hundred arhats. Younger brother of Pantha the Elder (lohan number 9). Though dull and stupid at first and despised by the other disciples, with the assistance of Buddha, he developed his intellectual faculties to an exceptional degree, and in course of time attained arhatship with the miraculous powers of flying through the air and of assuming any form at will. He is represented as an old

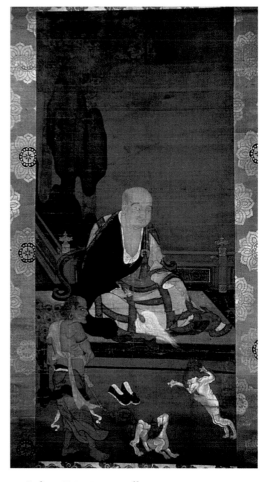

□ Lohan. Painting on silk.
Late Song dynasty (960–1279 C.E.).
Ji Zhen Zhai Collection.

man sitting under and leaning against a dead tree, one hand holding a fan and the other held up in an attitude of teaching.

16. **A-tzu-ta, Ajita.** Said to be an incarnation of Maitreya Buddha, though this is not logical, as according to all accounts, the bodhisattva remains in the Tushita Paradise until the time comes for him to be reincarnated, while the lohans as guardians of Sakyamuni Buddha's religious system are stationed on earth until Maitreya's coming again. He is represented as an old man seated on a rock grasping a bamboo staff.

17. **Po-lo-t'o-she.** Probably another form of Pindola the Bharandvaja (see lohan number 2). He rides upon a tiger, thus showing his power over wild animals, and "exemplifying his strength to overcome evil."[45]

□ Pith painting of loquat.
Nineteenth century.
Collection Anunt Hengtrakul.

Lokapala

The lokapala are four Buddhist heavenly kings who guard Mount Sumeru: Dhritarashtra, King of the East; Virupaksha, King of the West; Vaishravana, King of the North; and Virukhaka, King of the South. The lokapala were also protectors of the laws of Buddhism and of the four cardinal directions. They are frequently found as pottery sculptures guarding the tombs of the rich from the Tang dynasty, and also guarding the entrances to temples and monasteries. Typically, their garb includes very ornate armor and their faces depict marked fierceness. Each king has his respective attribute: Dhritarashtra, a lute; Virupaksha, a stupa and a serpent; Vaishravana, a banner of victory and a mongoose; and Virukhaka, a sword.

Loquat

The loquat, *pi pa,* symbolizes fertility and the birth of many children (sons) because these round fruit grow prolifically in clusters on branches. Hence, the loquat is also a symbol of luck and a welcome gift. It is a particularly common symbol in the south since the fruit grows in the region. The *pi pa* receives its name from the musical instrument of the same name, a moon-shaped stringed instrument that is played like the Western guitar.

Depictions of the loquat were particularly popular during the late Qing dynasty and also during the twentieth century.

Lotus

The lotus, *lian hua, he hua,* symbolizes much in Chinese art. "Although introduced into Chinese art by Buddhism it had, by the Song Dynasty, become fully assimilated and could be described in those terms drawing attention to those aspects of it which made it a symbol of the Confucian gentleman."[46] It is a symbol of beauty and purity since it rises from the mud, as Buddha was born from this earth but rose above. The lotus is a symbol of Buddha himself and at times Buddha is seen sitting on a lotus throne.

The lotus is also the emblem of summer as its flowers bloom to their fullest during warm days. Because its pods have many seeds, it is also the symbol of fruitfulness, plenty, and many offspring. This beautiful flower also is a symbol in Daoism, where it is the emblem of He Xian Gu, one of the Eight Daoist Immortals.

Because the symbolism of the lotus is so all encompassing, so it is depicted in many forms and in all media. It is incorporated into many rebuses.

When the lotus is depicted with a fish, it is an expression for abundance year after year, *nian nian you yu, nian* meaning "continuous," *nian* meaning "year," *you* meaning "have," and *yu* meaning "fish/abundance."

Lian zi, the lotus seed, forms a rebus meaning having many sons, *zi* meaning "sons."

When the lotus is pictured in combination with the egret and a withered lotus leaf, *yi lu lian ke,* it has the meaning of a wish for success in passing the official examination, *yi lu* meaning "one road" and *lian ke* meaning "continuous/passing."

Lotus flowers, *he,* and arrowhead leaves (*sagittaria*) create another rebus; lotus stands for harmony and the arrowhead plant, *ci,* sounds like the word for benevolence, *ci he.*[47]

A child holding a lotus seedpod, *lian,* creates the rebus "May one rise further and further *[lian]* in rank."

A lotus leaf with crabs forms the design *erjia chuanlu,* which has the meaning of passing the Civil Service Examination without difficulty.

The rebus *yin he de ou* expresses a wish that one's marriage in harmony will have many sons.

In painting, a scholar is sometimes depicted on the shore or in a boat peering into a lotus pond while contemplating. This figure is known as Chow Dun Yi, the Philosopher Chow who lived during the Song dynasty. He was a great scholar and became the tutor to the two greatest scholars of the Song dynasty. His being depicted contemplating the lotus is an allusion to his poems on the purity of the lotus whose roots are in the mud of darkness.

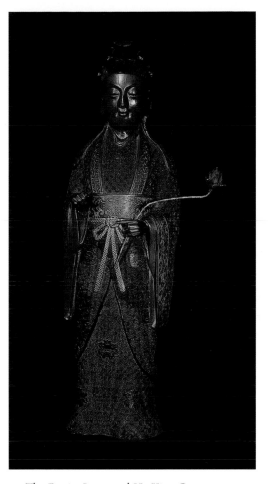

□ The Daoist Immortal He Xian Gu holding a lotus.
Lacquer, eighteenth century.
Private collection.

Lozenge

The lozenge is a design pattern of triangles. There are scholars who believe that the lozenge had its origins in drawings of fish, which represented female fertility. These symbols can be seen as early as the Shang and Han dynasties of China, but they also appear in Central Asia as well as Russia. Fertility was indeed important since many descendants were required for the tribe or people to survive. In Chinese representational art, with the passage of time, the lozenge became increasingly stylized and not only was utilized in central designs but also in design borders.

A double lozenge is a symbol for victory, *fan sheng.* A double lozenge also represents a musical instrument.

Luck

Ji is the Chinese character for luck. It is utilized in many stylized forms and always expresses the wish of its character. Auspicious, the character has been utilized as a design in and of itself. The *ji* for luck is not the same tone for rooster; however, when one calls out the word for rooster, *da ji,* it sounds like good fortune or big luck, which no one can resist.

Magnolia

□ Magnolia. Silk embroidery, eighteenth century. Gerard Hawthorn, Ltd.

The magnolia, *yu lan,* is said to symbolize femininity and the beauty of woman as its petals were likened to a maiden's lips. In China, *yu lan* literally means "jade orchid"; both jade and the orchid are prized auspicious objects. This flower was the favorite of the Dowager Empress Cixi, and she commissioned many robes decorated with it.

The magnolia also symbolizes fertility and when pictured with a butterfly, the visual picture connotes a young male in pursuit of his love.

Magnolia, crab apple, and peony, *yu tang fu gui,* forms the rebus "May you enjoy wealth and honors in the hall of jade." *Yu* means "jade," *tang* means "hall," *fu* means "wealth," and *gui* means "noble status."

Magpie

The magpie is a bird of happiness, a messenger who carries good news that brings happiness. As the harbinger of spring, a folk legend tells that any who live where the magpies have nested will have joy in their life. To the scholar who will take his Civil

Service Examination, to hear the chatter of a magpie is a omen of success, and certainly a dream of the magpie before one's examination is a prediction of achievement.

To the Manchu, this bird has great significance. A folk story tells that one of the three celestial maidens who lived in the north was bathing when a sacred magpie dropped a red berry on her robe. She ate the berry and gave birth to a son who had magical qualities, one of which was the ability to speak from the moment of his birth. He was seen as a gift from heaven sent by the gods to bring peace. After his mother died, he went down the river in a boat and was found by three chiefs who were engaged in war. When they heard of his attributes and his birth, they proclaimed that he was a saint and chose him as their prince and named his kingdom Manchu. Thus he was said to be the founder of the Manchu tribe. Due to this birth story as well as the fact that the magpie is a messenger of joy, the magpie has been a frequent subject in paintings, particularly in the late Qing dynasty as well as in contemporary times.

Magpie, *xi que*, forms part of its symbolism of good luck from the word, *xi*, happiness. Bamboo with a plum or pair of magpies symbolizes marital bliss, while a single magpie with bamboo and plum blossom is said to be a sign of friendship and happiness, *zhu mei shuang xi*. *Zhu* means "bamboo," *mei* is the plum, and *shuang* means "double." The magpie, a bird symbolizing great joy, can appear in these forms:

The rebus of a magpie with prunus, *xi zai mei shao*, has the meaning "happiness up to one's eyebrows." *Zai* means "to" and *mei shao* means "eyebrows."

The magpie, a bird symbolizing great joy, together with a badger, *xi huan*, expresses this wish: "May you have great joy and happiness in your future." *Xi* and *huan* both mean "happiness."

When the magpie is depicted with the pomegranate, *shi*, the message is "joy is having many sons."

Two magpies, *shuang xi*, symbolize the wish that you find each other in joy.

A magpie depicted at the top of a branch has the meaning of "happiness before your face," or *xi shang mei shao*.

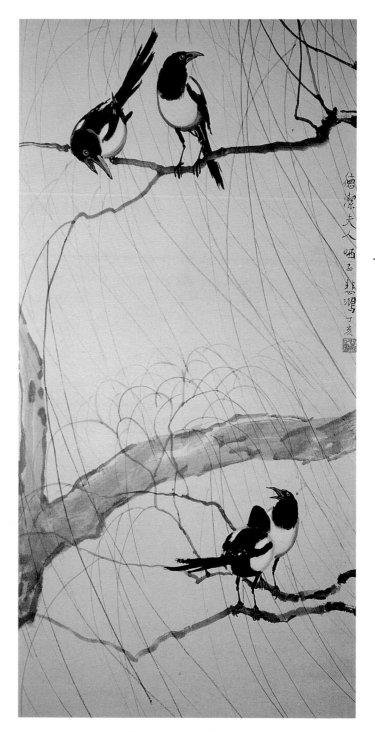

□ Painting of magpies by Xu Beihong (1895–1983). Private Collection.

Mallow

The mallow, *jin quei,* along with other flowers in this group (for example, hibiscus and hollyhock) symbolizes long life. The mallow is the flower of the ninth month. Its shape was utilized in pottery and porcelains and conveyed a wish for a long life to those who used the ware.

Mandarin Square

Sumptuary laws of the Ming dynasty (1368–1644), issued in the year 1391 defined regulations for the Mandarin badge of rank, or what is more commonly called the Mandarin square. These laws were reissued in 1527, during the reign of the Ming Emperor Hong wu, again setting forth regulations for *bu-zi,* badges of rank. And in 1652 during the Qing dynasty (1644–1911), after the overthrow of the Mongols, a decree was issued by the emperor by which all civil and military officials were required to wear badges that were designed to show their hierarchy as well as position within the court.

□ A Censor badge.
 Ming dynasty (1368–1644).
 Chris Hall Collection Trust.

□ B Ming badge.
 Wanli period (1573–1619).
 Chris Hall Collection Trust.

A

B

These large badges of the Ming dynasty were rectangular in shape, brocaded or embroidered of silk, and woven into the front and back of official court robes. The badges were manufactured under strict supervision of the court in specifically designated workshops. On the badges, birds represented civil officials while mythological animals and beasts represented military officials. While there is no documentation available that specifically identifies why these symbols were chosen, it is only logical to assume that the fierceness of animals and beasts was appropriate for the military, as opposed to birds, which were seen to be harbingers of messages and lacking in aggressive qualities.

When the Manchu conquered China in 1644, it was required of all Chinese serving in the government to wear Manchu official dress. It was not until 1652, some eight years after the Manchu takeover, that the Ming style badges of rank, the Mandarin squares, were formally adopted to be worn in the front and on the back of the informal three-quarter-length jackets called *bu fu*, meaning "patch coat." The Qing dynasty badges underwent a transformation from the Ming badges. They now were smaller and more square in shape as opposed to the Ming badges that were larger and more rectangular.

□ A Kangxi Mandarin square
(1662–1722).
Chris Hall Collection Trust.

□ B Qianlong military
Mandarin square (1736–95).
Chris Hall Collection Trust.

A

B

□ A Dragon roundel.
Nineteenth century.
Ji Zhen Zhai Collection.

□ B Mandarin square with
coral and seed pearls.
Nineteenth century.
Phil Wood Collection.

And rather than being an integral part of the coat as during the Ming dynasty, the Qing badges were made separate from the coat and affixed to it by sewing; the back badge was made of one piece while the front badge was of two equal parts, split in the center, to allow for the opening of the robe. Defined by a book of laws, *Huangchao liqi tushi* of 1759, the surcoat of the emperor carried a dragon roundel. Although the *bu fu* was worn over the semiformal court robes during the early Qing reigns, it wasn't until 1759 in the Qianlong reign (1736–95) that wearing the *bu fu* became a requirement. Not only did court officials wear the required *bu fu* with appropriate Mandarin squares, but wives of the officials also wore badges on surcoats, formal vests, and insignia jackets.

The Mandarin badges, particularly those of the Qing dynasty, in terms of symbolism are a micro-version of the symbolism that is found on the semiformal court robes. The overall pattern is a representation of the universe that the emperor rules. At the base are the swirls representing the waves of the sea, beneath which are the *lishui* or "upright water," which is frequently depicted in contrasting colors. At the center of the wavy lines of water is a mountain that represents the earth. It is on this rock that the bird or animal representing the position of rank of the wearer was situated. Above the central mountain and swirling water is the larger expanse of the badge, which represents the sky that houses the clouds, which are important as they hold the rain to nourish the earth and produce food. The complete pattern represented the cosmos—heaven and earth—over which the emperor ruled.

The earliest badges of the Qing dynasty, as previously identified, followed the conventions of the Ming badges. If one views the earliest Ming badges, for instance the censor badge (an officer who scrutinizes communications) of the sixteenth century and the early twentieth century Qing badge, the stylistic changes that took place during the ensuing years are striking. The *lishui* stripes undergo a series of changes from the earliest Qing dynasty in 1644 to the end of the dynasty in 1911. In general, the *lishui* lines evolve from a short section of thick, wavy lines to the straight, longer section of thin lines of the late nineteenth and early twentieth century. The sky section representing the heavens that are filled with clouds changes in proportions from four-fifths in early badges to roughly two-thirds in later badges. The clouds themselves also underwent a series of changes from being highly representative on Ming badges and robes to being stylized, and in some instances absent, in the late nineteenth- and early twentieth-century badges. In the later instances, the space was taken over by insertion of precious objects, which were mere decoration. These changes are best described in general terms as

becoming more stylized, cramped, decorative, and garish. Some scholars maintain that the garishness represented the decay of the dynasty.

It should be noted that the badges of the early Qing dynasty were produced under supervision of the court at textile centers in Suzhou and Nanjing. This supervision was reflected in their fine quality. With disintegration both economically and culturally in the mid-nineteenth century and later, these textile centers were not the only areas where badges were produced but villagers began their own businesses of production. Quality was no longer overseen. Badges and what they signified also became items for sale through bribery and influence rather than literary prowess. As the wearers were responsible personally for the purchase of their badges, expense also became a factor in the village production. All of these elements contributed heavily to the decline of the Mandarin square.

Qing Dynasty Mandarin Squares for Civil Officials

RANK	SYMBOL
First	Crane
Second	Golden Pheasant
Third	Peacock
Fourth	Goose
Fifth	Silver Pheasant
Sixth	Egret
Seventh	Mandarin Duck
Eighth	Quail
Ninth	Paradise Flycatcher

Qing Dynasty Mandarin Squares for Military Officials

RANK	EARLY QING (1652–)	LATER QING (–1911)
First	Lion	Qilin (after 1662)
Second	Lion	Lion
Third	Tiger	Leopard (after 1664)
Fourth	Leopard	Tiger (after 1664)
Fifth	Bear	Bear
Sixth	Panther	Panther
Seventh	Panther	Rhinoceros (after 1759)
Eighth	Rhinoceros	Rhinoceros
Ninth	Sea Horse	Sea Horse

Considerable research and authoritative material on Mandarin squares was done by the late Schuyler Cammann, who authored many scholarly books, one of which was *China's Dragon Robes.* In 1947, while discussing the various birds that were depicted representing civil officials of the Qing dynasty with the noted late collector/dealer Alice Boney, he produced this never before published drawing that explains the differences of the various birds more clearly than can be put to words.

Manjusri

Manjusri is a bodhissatva who is the God of Wisdom in China. A particularly popular figure to Chinese Buddhists and a popular subject for sculptors, his Sanskrit name has the meaning of luck. He is usually depicted seated on the back of a lion, and in Buddhist temples of China usually is at the side of Sakyamuni Buddha with Pu Xian being on the opposite side. His attributes are a sword in one hand and a lotus in the other.

Maple Tree

The maple tree, *feng,* exists in various species in China, and its name has the same sound as the word meaning "to bestow upon," *feng.*

The maple tree forms part of a rebus that consists of a monkey in the tree reaching for or holding a box wrapped in red *(feng hou).* The box represents the seal of court and the red represents happiness; the rebus expresses "May you achieve rank in court," *feng hou gua yin.* This depiction is most auspicious.

The quail, *an,* chrysanthemum, *jiu,* maple tree, and falling leaves, *le ye* gives the rebus *an jiu le ye* conveying the wish for harmonious life and work.

Marigold

The marigold symbolizes longevity. Its symbolism comes from its name, *wan shou chu,* which means "flower of ten thousand years."

Despite the fact that it is a symbol of longevity, the marigold is not frequently depicted on porcelains, paintings, or carvings, nor is it a particularly popular flower. The scholar who did a great deal of study on Chinese textiles, Schuyler Cammann, writes that "it is seen as a background motif on Mandarin Robes of the Qian Long period"; however, even these robes are scarce.

Melon

Melons, *gua,* symbolize fertility and a wish for many sons. This symbolism arises from the melon's shape, that of the abdomen of a woman with child, and the fact that melons are filled in the center with many seeds, which represent both fertility and children.

Melons are depicted in a variety of the arts of China. Perhaps none is more famous nor more valuable than the blue-and-white imperial porcelains of the early Ming dynasty, when melons on vines were a central motif. Melons in paintings were a favorite subject of the late Qing painters as well as contemporary painters.

Mi Le fo, Maitreya Buddha

The Maitreya Buddha, or the Coming Buddha, is known in Chinese Buddhism as Mi Le fo. Mi Le fo is said to be derived from the Sanskrit term meaning compassion. Mi Le fo is a later incarnation of Buddha Maitreya that is seen uniquely in Chinese and Japanese Buddhism. It is Mi Le fo who is always depicted as a hefty, laughing, balding Buddha with his chest and fat belly exposed.

The big belly of Mi Le fo symbolizes his compassion and capacity to contain the difficult events of the world, and his smile is to welcome all of society. He is sometimes portrayed carrying a big cloth bag that contains good blessings for all. According to one legend, he once lived in China (in approximately the ninth or tenth century) and disguised himself as a short, obese Buddhist monk who begged on the streets of Zhejiang Province. Eccentric and comical, he always carried a large bag that contained the food and things given to him as he begged. He later dispersed these to the needy, particularly children who slept on the streets because they were too poor to find a home. He was said to have the power to predict events, including impending disasters, and he preached and demonstrated the wisdom of Buddhism through real practice to the people. Only at the moment that he departed from this world did he reveal to the public that he was the reincarnation of Mi Le fo.[48]

The meanings conveyed by Mi Le fo are wealth, happiness in life, fertility, and continuity. He is one of the trinity representing the past, present, and future in the Buddhist pantheon. His image is seen in all Buddhist temples and shrines near the main entrance, welcoming and inspiring those who enter for he is a buddha "yet to come," representing the happy time of future enlightenment or buddhahood that is the final goal of all Buddhists.

Middle

The Chinese character for middle, *zhong*, arises from a pictogram of an arrow striking the center of a target. The concept of "middle" is a symbolism that is most important to China. The emperor saw himself as the center, or middle, between heaven and earth; he saw himself as seated in a position facing south so that he could watch the sun from dawn to evening while positioned in the center. He depicted China *(Zhongguo),* the middle kingdom, to be the center of all kingdoms. Those outside of the middle were considered barbarous.

Mille Fleurs

Mille fleurs in French literally means "a thousand flowers." This design pattern was infrequently used in the eighteenth century portion of the Qing dynasty and then commonly used at the end of the Qing dynasty. When export porcelains became desirable, the overcrowded, highly colored pattern of a multitude of flowers became popular in the West as they were inexpensive and decorative.

For the Chinese, flowers were symbolic of the beauty of the female; however, to the Europeans the mille fleurs pattern simply was a colorful decorative design incorporating a multitude of flowers.

Millet

Two types of millet are included in the Five Nourishing Fruits and it is one of the Twelve Symbols of the Emperor symbolizing grain, fertility, and prosperity (*see* Five Nourishing Fruits).

Millet represents a life-sustaining entity as well as an important grain in Chinese culture. Hou Ji was known as the Lord of Millet and God of Agriculture. The folktale of Hou Ji tells that when he was a child, he was named Ji, or the "abandoned one." Although he was described as large and imposing as a child, rather than play games with the other children, he liked to plant and the products of his plantings were so fine that others talked of his talent. He later became skilled at farming and assessing the lands for their suitability for growing of grains. Soon all followed his direction and imitated him. Emperor Yao, hearing of his talents, appointed him as the minister of agriculture. When the famines came, Emperor Shun instructed him to plant seedlings, and legends maintain that it was Hou Ji's knowledge and talents that saved the "black-haired people" from starvation. Emperor Shun thus rewarded him and gave him the title of Lord of Millet.

□ Ivory carving in the shape of a Tang dynasty mirror. Nineteenth century. Ji Zhen Zhai Collection.

Mirror

Mirrors, *jing*, have existed in China since the earliest times. Made of a bronze alloy, they were fashioned in a circular shape with one side being entirely plain and highly polished while the other side was decorated with various patterns. In the center of the decorated side, a nipple was placed through which a cord passed, forming a handle of sorts. During the Han and Tang dynasties, mirrors were finely cast with elaborate patterns, some of which were covered with thin sheets of silver and gold as well as inlays.

In daily household practice, the ancient Chinese used a mirror for a very special symbolic and mystical reason. The ancient phrase *hong yun gao zhao* means to elevate good fortune by reflecting or shining one's image into a mirror. Hence, if one looked into the mirror in the early morning, one was not only looking to see if one was presentable but was also elevating one's daily chances for good fortune and protection. Mirrors not only protected the living but also the dead. Mirrors were used as burial objects to protect and ward off evil spirits in the afterlife while helping to illuminate the path to the netherworld.

The mirror is also an attribute in Buddhism and is sometimes carried by Avalokiteshvara. "The mirror symbolizes the image of void, for it reflects all the factors of the phenomenal word, but deprives them of substance. . . . Everything is no more than the subjective idea one has of it."[49]

Today, the mirror is still seen as an important feng shui tool to ward off bad influences in a space. The mirror is also a symbol of marital happiness.

Symbolically, a gift of a mirror with a pair of shoes is a most honorable marriage gift. Mirror, *tong jing,* and shoes, *xie,* are combined to form the rebus, *tong xie,* or "together." A broken mirror is a colloquial term for the death of a husband or wife.

According to a folktale when a husband and wife are to be separated for a lengthy period, the husband breaks a mirror in half (mirrors are round in shape in China) and gives the wife one half and keeps the other for himself. It was believed that if one partner was unfaithful, that half would turn into a magpie and fly away, symbolizing the end of happiness; but should they be reunited, even after a lengthy period where they would not recognize one another, the two halves of the mirror would fit together forming a roundel and it would be confirmed that they belonged to one another.

Money Tree

The so-called money tree is a type of ritual burial object found in the tombs of the Han dynasty. The term "money tree" is misleading. The object is composed of a stone or pottery sculptural mountain base that is frequently carved with figures of deities, heavenly animals, and the like. It is surmounted by a bronze "tree" with a central pole that fits into the mountain base and branches that extend from the central pole. The branches are bedecked with coins, which appear as leaves cast with images.

The object symbolizes a path or route for the spirit or soul of the deceased to travel to the world of immortals.

□ Lotus shoes for mourning with mongoose design. Early twentieth century. Glenn Roberts Collection.

Mongoose

The mongoose is a rodentlike, sharp-snouted animal of approximately sixteen inches in length that feeds on termites and the like. This animal, a Buddhist symbol, is said to be the keeper of the jewels who sews up all riches when pinched by the God of Wealth.[50] It is only infrequently depicted in art.

Monkey

The monkey, *hou,* is the ninth animal in the zodiac. Hanuman, the monkey god, is worshiped in India; in Chinese lore, gods sometimes take the form of the monkey or ape. However, the symbolism of the monkey can be both positive and negative.

On the one hand, the monkey is seen as cunning and ugly. On the other hand, legends maintain that the monkey has the ability to drive away evil spirits. Because of this, the monkey has long been used in Chinese traditional medicine.

The monkey is depicted in a series of positive rebuses.

A monkey depicted on the back of a horse, *ma shang feng hou,* has the meaning "May you be immediately *(ma shang)* elevated to the rank of a count *(feng hou).*"

When the monkey is depicted holding a peach, it expresses the wish that the owner or wearer's descendants might cherish long life. It comes from the phrase *feng hou bao shou,* meaning "May you embrace immortality." *Feng* means "confer upon," *hou* is the monkey, *bao* means "hold," and *shou* means "longevity." By sound, the monkey signifies position/rank and the peach signifies longevity.

Two monkeys depicted together, *bei bei feng hou,* one on the back (*bei,* meaning generation) of another represents the visual rebus "May you rank as count from generation to generation."

A monkey together with a bee, *feng,* forms a visual pun, *feng hou,* meaning "preferment to noble rank."[51] *Feng* means "confer upon," while *hou* means both "monkey" and the title "marquise."

Moon

The moon, representing heaven, is one of the Twelve Symbols of the Emperor. It is the passive yin to the sun's yang. On the emperor's robe, an embroidered disk represents the moon, on which the hare is depicted pounding the herbs of immortality. The hare is the companion of the Queen Mother, Chang E, and they both reside on the moon and have immortality.

□ A Soapstone figure of a monkey. Tang dynasty (618–906 C.E.). Courtesy of Roger Keverne.

□ B Hare pounding the herbs of immortality on the moon. Detail of a twelve-symbol imperial robe, eighteenth century. Linda Wrigglesworth, Ltd.

Morning Glory

The morning glory is a member of the Convolvulus family, all of which are prolific growers in China. All members of this family are utilized in Chinese herbal medicine for a variety of ailments, the most common of which is stomach disorders. The flower is a symbol of harmony between a male and female. Its depiction in Chinese art is more frequent in the late Qing dynasty.

Mountains

Mountains have always been important to the Chinese, both in history and lore. From the very beginning, the Chinese regarded the existence of its five mountains as representing directions and related to the cosmos. Tai Shan, the East; Heng Shan, the south; Song Shan, the center; Hua Shan, the west; and Heng Shan (different character than the Heng representing the south) the north. These mountains were said to be inhabited by gods, and sacrifices were made to them.

□ A Album painting for the Moghul market depicting morning glory and beets. Nineteenth century. Phil Wood Collection.

□ B "Fantastic Mountain" by Kao Feng-han (1683–1748). Cheney Cowles Collection.

□ C Album leaf of summer mountains. Seventeenth century. Ji Zhen Zhai Collection.

A
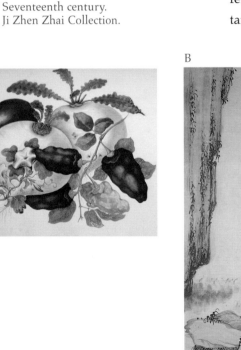

B
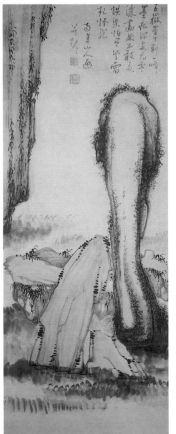

C
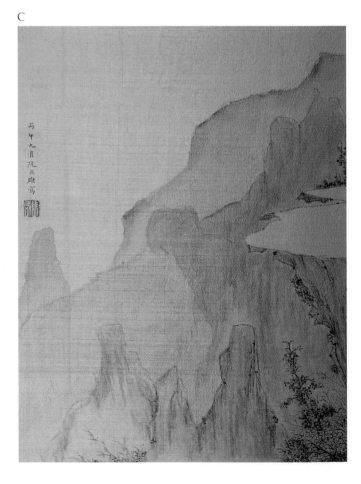

Mountains were felt to create the clouds that produced rain, certainly an important element in the growing of rice and other grains necessary for subsistence. The mountains when combined together with water or sea represent not only the earth but also China itself. In Buddhism and Daoism, the mountains also play an important role.

A folktale of old played an important role in the symbolism of the Cultural Revolution, as told frequently by Chairman Mao. His reference to the tale of Lie zi, entitled *"Yu Gong Yi Shan,"* was used to spur the common folk to "move mountains." Lie zi's tale told of an old male of ninety who throughout his life went around a mountain in order to get to the next village. One day he made a decision that he could no longer take this long road and began to dig his way through the mountain. People pointed out to him that his task was futile at his old age, but he pointed out that his children and grandchildren would help him finish. But the mountain and sea gods took pity on him and completed the task for him and his goal was reached—the moral of the story being that no task is insurmountable.

Mountains are one of the Twelve Symbols of the Emperor, symbolizing the earth and stability. In Chinese symbolism, mountains and water (waterfalls or rivers) together relate to the idiom of *shan chang shui yuan,* meaning the length of mountain ranges and the distance of water that connotes time and eternity. Together they express a wish for a long life and good fortune. Not only are they frequent subjects of paintings, but they are also seen on Mandarin court robes as well as rugs and lacquer ware.

Mouth Organ

The Chinese mouth organ, *sheng,* is a musical instrument that represents the gathering together of people. It is pictured primarily in folk art, and symbolizes a wish for one to rise to an important civil service position. This symbolism comes from the homonym of the word for "to rise," *sheng,* which has the same sound as the word for this instrument. The instrument is constructed of seventeen bamboo tubes fitted into a gourd with a mouthpiece at the lower end. The seventeen bamboo tubes are said to appear as the tail of a bird and hence are a positive symbol. While this instrument was once utilized in various ceremonies, it is rarely used in contemporary society.

Mudra

Symbolic hand gestures of Buddhism, the word *mudra* coming from the Sanskrit word meaning "mark." Mudras are used in Buddhist paintings and sculptures and identify the attitude of the figure portrayed.

- **Abhaya mudra:** Symbolizes protection. Palm held facing forward with fingers outstretched.
- **Anjali mudra:** Symbolizes reverence. Hands together with palms touching and fingers outstretched.
- **Bhumisparsha mudra:** Earth touching sign. Right hand extends over the right knee touching the earth with palm facing inward and fingers outstretched.
- **Bodhyagri mudra:** The lotus fist. Left thumb in the right hand, which Buddha holds in a diamond fist.
- **Dharmacakrapravartana mudra:** Turning of the wheel gesture. Left hand is placed near the heart facing inward with the thumb and index finger touching. Right hand faces outward with thumb and index finger touching.
- **Dhyani mudra:** With both hands resting on the lap in a meditating posture with the right palm over the left palm.
- **Vajrahumkara mudra:** Two forearms crossed at the wrists before the chest, usually holding vajra (the thunderbolt) and ghanta (a ritual bell).
- **Varada mudra:** Boon granting gesture. Palm faces outward with fingers facing downward.
- **Vyakhyana mudra:** Position of argument. Right hand held at the chest with thumb and index fingers touching.

- Musical stone.
 Detail of kesi tapestry.
 Eighteenth century.
 Jocelyn Chatterton Collection.

Mulberry

The mulberry tree is extremely important as its leaves are a food source for silkworms. It is emblematic for industry. It is also a punning word for mourning as the word for mulberry, *sang,* has the same sound as the word for mourning, *sang.*

In some areas of China, it is customary to carry a staff made of mulberry upon the death of one's mother as a sign of mourning. The combination of bamboo and mulberry is a symbol of filial piety.

Musical Stone

The hanging sonorous stone, usually of jade, *qing,* is an emblem of a just and upright life and also a symbol of prosperity. The word for musical stone, *qing,* is a symbol of happiness. Its sound when struck is synonymous with the word for felicity, making the stone a punning symbol. The musical stone is one of the Eight

Symbols of the Scholar. Its auspicious meaning made the stone a popular item to display in the home, particularly during the nineteenth century. While many of these were exported to the West during this period of time, few Westerners were aware of their meaning and saw them purely as decorative objects.

A jade musical stone, a halberd behind it, and a *ruyi* is the rebus "May I, the wearer, have as much good luck and good fortune as I desire," *ji qing ruyi. Ji* means "auspicious," *qing* means "celebrate," and *ruyi* means "as you wish."

A bat with a musical stone in its mouth forms the wish *fu qing,* meaning "happiness and good fortune" since both bat and happiness have the same word, *fu.* This symbol was often found on porcelains, lacquers, and Mandarin robes of the eighteenth century.

Mutton Fat

This term is used to describe pure white jade, which is like the whiteness of sheep fat. Pure white jade is highly sought after by the Chinese. It is a symbol of purity—the qualities of a person were frequently likened to the qualities of jade. The highest quality, white jade (nephrite) was found in the western area of China in present-day Xinjiang Province. The fact that this area was a substantial distance from the jade working centers that surrounded Xian and Beijing only increased the value of the finest mutton fat jade objects. Transporting the jade from this faraway province was extremely difficult because of bandits, taxation, and the physical difficulties of transporting during this period of time.

□ Nandina. Detail of kesi tapestry.
Nineteenth century.
Phil Wood Collection.

Nan Cai he

Nan Cai he is one of the Eight Daoist Immortals. Her emblem is a basket of fruit or flowers (*see* Eight Daoist Immortals).

Nandina

Nandina, *tianzhu* or "heaven's bamboo," in the fall and winter has slender stems with clumps of bright red berries. Its symbolic meaning is that of happiness and goodness owing to its color and profuse berries. It has also been used in Chinese herbal medicine and is thought to have special powers.

The combination of *lingzhi,* rock, narcissus, and nandina forms the rebus "fungus fairy bestows birthday greetings."[52] All four of these elements symbolize longevity. However, nandina as a decorative motif is seen in combinations with any number of other flowers.

Narcissus

The narcissus, *shui xian hua,* literally means "water fairy flower." While it is frequently depicted in Chinese art, it is not native to China but is said to have come from Byzantium during the ninth century, another import from travel along the Silk Road. It became extremely popular, particularly during the Yuan dynasty. It has come to symbolize a married couple.

A depiction of narcissus *(xian),* rock *(yan),* and bamboo *(zhu),* forms the rebus that symbolizes the "immortals *(xian)* wish *(zhu)* long life to the owner," *qun xian zhu shou.*

The narcissus is frequently depicted in New Year's paintings and wishes. Shown with orchids and fruits, it is a visual rebus for the immortals to give one harmony in marriage, many sons (seeds of the fruit), and virtue. Its depiction in New Year's paintings is related to the fact that its bulbs are frequently forced into bloom each New Year.

The narcissus is also combined with nandina, lingzhi, and rock forming a birthday greeting (*see* Nandina).

A famous painting by the thirteenth-century artist Zhao Meng fu depicted the narcissus bowed down by frost, and it was said to be a symbol of the devastation of China after the Mongol invasion.

Nature

Nature plays an important role in almost every aspect of Chinese culture. It permeates China's religion, arts, poetry, history, folklore, and so on. Rocks, scholar rocks in particular, are symbols of nature that are quite unique to Chinese culture (*see* Scholar Rocks).

The differences in views of nature as expressed in the West and in Asian art and religion are substantial. In the West, biblical writings assert, "Thou madest him to have dominion over the works of thy hands and has cast out all things under his feet." In contrast, Daoists, for instance, speak of harmony and being at one with nature, not dominating nature and its creations. This is expressed particularly in Chinese painting where paintings (*shanshui,* mountain/water) of mountain landscapes are the predominant subject matter, scenes that humans contemplate seeking to understand our place *with* nature.

▫ Detail of narcissus, nandina, and rock. Porcelain saucer, Yongzheng period (1723–35). Ji Zhen Zhai Collection.

Nine

Nine, *jiu,* is considered to be a yang number par excellence, and therefore takes on considerable significance in Chinese culture. Nine, which is the largest of the single digits, is taken to mean the "most masculine" and therefore symbolizes the supreme sovereignty of the emperor. Nine is an extremely important number in the palace architecture. It takes on great significance in any "ultimate" feature. For instance, the famous Song encyclopedia of natural history describes the dragon as having "nine resemblances"—horns like a stag, head like a camel, eyes like a demon, neck like a snake, belly of a sea monster, scales like a carp, claws of an eagle, pads of a tiger, and ears like an ox. Dragons were described as having eighty-one scales—nine times nine. It is said that the dragon had nine sons. They are Baxia (his image is carved on bridges as it is said that he was a good swimmer); Yazi (his image is carved on weapons); Pulao (his image is carved on bells as he likes to roar); Jiaotu (his image is carved on doors as he keeps to himself); Haoxian (his images are carved on rafters of the palace as he was daring); Chiwen (his image is carved on items of great height as he enjoyed views from afar); Qiuniu (his image is carved on musical instruments as he loves music); Bixi (he is a carrier and is his image is frequently on parcels); and Suanmi (his image is carved on cauldrons as he likes fire).

During the Qing dynasty, the number nine carried imperial significance still further as robes and objects carrying nine dragons were designated solely for imperial usage.

Architecturally, there are interesting features involving the number nine. At the palace gates, the studs are arranged in rows of nine. Such an arrangement is also seen at the Guan Yu Temple in Loyang as Guan was posthumously honored as an emperor. In the Forbidden City, each of the towers of the four corners has nine beams, the three major screens each have nine dragons, the great hall on Tianamen Square has nine bays, and the upper terrace of the Altar of Heaven is made of nine concentric rings.

However, as early as the fourth century B.C.E., there are folktales involving Yu, the legendary founder of the Xia dynasty, that are recorded in the *Chronicle of Tso:* "The divine wisdom of Yu is teaching humans how to distinguish between harmful and benign gods, the symbolic value of representing images of gods on the nine cauldrons, the number nine, which reflects the celestial sphere, and the moral value of the cauldrons in gauging the rise or decline of sovereign power."[53]

The nine cauldrons became a symbol of legitimate dynastic rule, being symbols of wealth, ritual, and the control of metal.

Jiu, is also a homonym for the word for long, and *jiu jiu* means "for a long time." This homonym makes it a visual punning symbol.

Noodles

Noodles, *miantiao,* are symbolic of longevity because they are long. They are a food of the people and served traditionally at birthday celebrations wishing long life. Therefore, to cut a strand of noodles is unlucky.

Nu Wa

Nu Wa is a mythical Chinese empress who is said to have lived during the prehistoric period. She is recorded in some texts as being the sister to the god Fu Xi. When Nu Wa and Fu Xi are pictured together during the Han dynasty, they symbolize marriage, which they are said to have invented. On Han murals, a compass and a knotted cord symbolize Nu Wa. Sometimes she is depicted as a human figure with the lower portion of her body as a serpent intertwined with that of Fu Xi. How and when Fu Xi and Nu Wa became intertwined is not known nor understood.

In early Chinese literature, there are questions raised as to who made Nu Wa. This clearly means that she is not the creator of humankind. However, there are written stories that say that Nu Wa created man from clay and her cord, which she dragged through the mud. The cord motif in Han pottery is said to symbolize the making of man.

Oleander

The oleander is an evergreen bush with both red and white flowers that symbolize feminine beauty. Although the leaves of the plant are poisonous, all other parts of the plant have been utilized in traditional Chinese medicine.

Onion

Onions are a symbol for cleverness and were a subject for painting in the late nineteenth and twentieth century. The same-sounding Chinese word, *cong,* means both "clever" and "onion," which results in a visual pun. Giving someone a painting of an onion is to imply that the person is clever.

Orange

The orange is a symbol of good luck. Orange, *ju zi,* has the sound of the word to wish good fortune, *zhu fu,* from which it garners its symbolic meaning. The orange is frequently depicted in New Year's pictures and also is a fruit given as a gift at New

Year's celebrations and for the newly married. The orange has many seeds, symbolizing a wish for many children.

The orange is connected with the folk story of Luh Su, one of the paragons of filial piety. As the story goes, Luh Su was invited to the home of a rich neighbor who offered him oranges to eat. Rather than eat them, Luh Su put them in his clothes to give to his mother, whom he highly cherished. When leaving, upon saying good-bye to his host, the oranges fell from under his clothing, which led his host to think that he had been greedy. But when Luh Su explained that he had saved his gift for his mother, his host was impressed with his filial piety. Luh Su later became an official.

Orchid

The rich symbolism of the orchid is built upon its natural qualities. It grows in secluded woodland sites, its natural habitat being akin to Confucian and Daoist ideals, ideals that also relate to the life of the scholar, and the intrinsic beauty of the orchid lends itself to depictions in painting. Its fragrance is haunting. Depicting orchid and *lingzhi* together forms a visual rebus expressing a wish for a long life of success as a scholar-official.

There is a Chinese saying that in order for one to excel at calligraphy, which is considered to be the highest art form, one should be able to utilize the brush in such a manner as to execute equally well paintings of the bamboo and orchid. Excellent calligraphy is considered to contain the "fragrance" of orchids and to have brush strokes with the gracefulness of a dancing orchid. The fragrant orchid is a symbol of the neglected scholar.

□ Painting of orchid by Qi Baishi (1864–1957). Horacio Fabrega Jr. Collection.

Orchids are frequently depicted in a vase, which connotes "concord." This meaning stems from a saying in the *Yi Jing*, "When people are in concord, their sharpness is broken. Words of concord are as fragrant as orchids."[54]

The orchid also symbolizes moral virtue. This symbolism arises from the tale of the poet-statesman Qu Yuan (340–278 B.C.E.), who criticized those in power who were corrupt. In his well-known poem "Li Sao," or "Encountering Sorrow," he likens himself and other righteous ministers to fragrant flowers that only bloom under a wise king. He personally had been slandered and lost the favor of his monarch; while waiting for reconciliation, he tended his orchids and other flowers and wove them into garlands to be worn as a girdle. Eventually he committed suicide by drowning, preferring to remain righteous rather than to give in to corruptness.

□ A Porcelain bowl with
 Dayazhai pattern of the
 Dowager Empress.
 Late nineteenth century.
 Ji Zhen Zhai Collection.

□ B Painting of one of the Eight
 Eccentrics of Yangzhou by
 Huang Shen (1687–1768).
 Ji Zhen Zhai Collection.

Oriole

The oriole, *ying,* symbolizes friendship and joy. It is frequently depicted in paintings. When the oriole is depicted with the peony and prunus, it expresses a wish for joy to be had at the arrival of spring.

Owl

The owl, *xiao,* is not completely understood in terms of its symbolism. On the one hand, it is not looked favorably upon and, according to legend, is said to be a harbinger of evil. It is also seen as an animal that does not respect filial piety. The latter stems from a saying that a young owl does not fly on its own until it pecks out the eyes of its mother. Its screeching sound was said to mimic the sound of the calling of one's soul, thereby foretelling death. But on the other hand, during the Shang dynasty, bronze vessels were made in the shape of owls, and during the Ming dynasty, tiles with owl images on them were made for placement on roofs. Both of these items would indicate that the owl was seen as a positive omen.

Pagoda or Pavilion

Although these structures are associated with China, they are actually of Indian origin. Pagodas were first built in China during the third century. Of an unusual shape and seven or nine floors, they are usually built to commemorate a favorable deed of a person or an act of devotion. Symbolically, they usually convey goodness. The pagoda is also a receptacle for relics.

An unusual depiction of the pagoda is found on later Qing robes where it is frequently seen emanating from the dragon (or *shen* monster) that is rising from the waves. "It represents a mirage created by the mythical monster shen over the Eastern Sea and is a symbolic pun on *sheng shi* meaning "successful affairs.""[55]

Painting

One of the Four Arts of the Scholar, painting is an emblem of culture and art. To Westerners, it is surprising that calligraphy is held in greater esteem than painting. However, to the Chinese, there is realization of the greater skill needed in calligraphy as opposed to painting. Nonetheless, there are fundamental differences in Western and Eastern painting, both in concept and technique. In terms of technique, Chinese painting is frequently confused with Western watercolor painting.

The techniques of the two are markedly different. In simplistic terms, Chinese painting relies on the movement of the brush and its strokes, which is said to be an extension of the arm of the painter.

Paired Fish

One of the Eight Buddhist Symbols, the paired fish signify harmony. The fish in water knows no restraint as one in the Buddhist state knows no restraint. Paired fish are also a symbol of conjugal harmony. The design of paired fish was seen during the early dynasties particularly the Tang, Song, and Ming. It also was a frequently used design for the so-called "marriage bowls" of jade that were extremely popular during the eighteenth century.

Palm Tree

The palm tree is a symbol of retirement and a carefree life. An elderly scholar who sits under a palm usually represents these meanings. The leaf of the palm is sometimes made into a fan and becomes a symbol of the retired scholar.

Pan Gu

A folktale attributes the founding of the Yao and Miao tribes (minority peoples) in Southern China to the union of a dog and human in the so-called Pan Gu dog myth. This legendary Chinese tale of the creation maintains that a deity called Pan Gu was the child of Yin and Yang, the two vital forces of the universe. Pan Gu grew inside an egg of enormous size and then was born. The clear parts of the egg rose to become the heavens while the yolk became the earth. Pan Gu stood and, by his own force, prevented the heavens and earth from coming together. As he grew, he separated the heavens and earth ten feet a day. This continued for over eighteen thousand years, after which time the earth and heavens held their positions. Weary, Pan Gu lay down and died. His breath became the wind and clouds, his eyes the sun and moon, his hair and whiskers the stars, and his beads of sweat the rain. His body elements became the mountains, metals, plants, and rocks that make up the earth as we know it. The Pan Gu story of creation is often symbolized by a doglike animal with the yin/yang symbols and the Eight Trigrams. It should be noted that Pan Gu still survives as an important figure for the minority peoples of China.

□ Celadon saucer depicting paired fish. Song dynasty (960–1279 C.E.). Ji Zhen Zhai Collection.

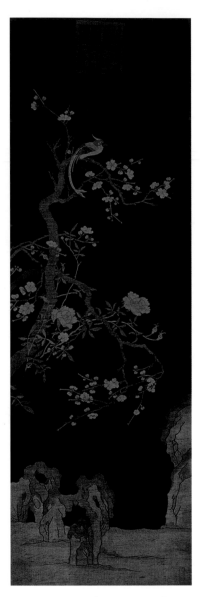

Kesi tapestry depicting paradise flycatcher. Ming Dynasty (1368–1644). Chris Hall Collection Trust.

Panda

In the modern day, the panda has become the animal symbol of China (*see* Bear).

Panther

The panther, *bao,* offers a contradictory symbolism in China. On the one hand, it is seen as a cruel, fierce animal and as a mark of its fierceness, its tail was frequently tied to chariots during battle. But on the other hand, when the panther is pictured with magpies, *xi,* the rebus *bao xi* is formed, meaning "announce joyful event" since *bao* also means "announce" and *xi* means "happiness."

On Mandarin squares, the panther is the emblem of the sixth-level military official. During the early Qing dynasty, it was the emblem of both sixth- and seventh-level officers but in the later Qing dynasty, it was only the emblem of the sixth-level officer (*see* Mandarin Square).

In the realm of folk symbolism, a woman, when called *hua bao,* is said to be beautiful but also headstrong and violent, an unsavory person. *Hua* means "flower" while *bao,* the panther, implies a strong animal.

Paradise Flycatcher

The paradise flycatcher, commonly called the ribbon bird, symbolizes long life. The name for this bird, *shou dai niao,* literally means "sash bird," likening the long tail feathers of the paradise flycatcher to the long sash worn by scholars. The character for longevity, *shou,* has obvious homophonic ties. The paradise flycatcher represents a ninth-grade civil official on Mandarin squares (*see* Mandarin Square).

Parrot

The parrot, *yingwu,* is the symbol of a prostitute. This originates from the folk story whereby an unfaithful wife's behavior was made known to her husband by a talking parrot.

During the Kangxi period, a depiction of a parrot in various colors was not an unusual pattern, but was apparently popular with Westerners because it utilized brilliant colors. It would appear that in this instance, the parrot did not symbolize a woman of loose morals but rather was simply a decoration chosen for its colorful feathers.

Pasa (Snare)

The pasa or snare is a ritual object used in Lamaism. Constructed of a chain with metal knobs at either end, it symbolizes the ability to bind evil opponents (*see* Lamaism).

Peach

The peach, also called "fairy fruit," originated in China and has been a symbol in Chinese art and history for centuries. To the Daoists, it is the elixir of life, an emblem of marriage, a symbol of spring, and the fruit that could, according to legend, bring immortality. Peach blossoms symbolize the female gender, referring to the pink cheeks of young girls. The peach tree of the gods was said to grow in the gardens of the palace of Xi Wang mu and to blossom but once every three thousand years. The fruit of eternal life took another three thousand years to ripen. The peach is associated with Shou Lao, the God of Longevity, and is frequently a symbol held in his hand. He himself is a symbol of long life. As such, a single peach tree represented a wish for longevity and was a common birthday depiction.

Not only is the peach fruit said to have powers, but the wood of the tree is also said to have powers of exorcism. This is supported by a folktale in which Feng Meng kills the famed archer Hou yi with a club made of peach wood. The symbolism of the peach wood lies in the homophone for the word for peach, *tao,* which is the same as the word to expel, *tao.*[56] Peach wood has an acrid smell when burned and therefore is said to drive away evil spirits. Peach stones or charms of peach wood also are said to have the power to drive away evil spirits. Sprigs of *tao hua,* peach blossoms, are customarily hung on doors as a folk custom to drive away evil that may come to one's home. Carved peach stones are frequently worn about the necks of children to keep them from harm in the same way silver locks are worn. Carved peach pits are also carried as good luck talismans.

The peach is seen as a motif in middle Qing dynasty robes and on porcelains, particularly of the Qianlong period.

A peach tree growing on a mountain together with a bat and waves, *fu ru dong hai, shou bi nan shan,* represents the traditional birthday greeting "May your happiness be as deep as the Eastern Sea and may you live to be as old as the southern Mountain."[57] *Fu* means "happiness," *ru* means "as," *dong hai* is the Eastern Sea, *bi* means "as," and *nan shan* is the Southern Mountain. This has been a birthday greeting since the Ming dynasty and continued well into the Qing dynasty as a pattern depicted on porcelain.

An elderly figure that holds the peach of longevity, although most often Shou Lao, may be the folk character Dungfang shuo. Legends abound about Dungfang

□ Painting of a parrot by Qi Baishi (1864–1957). Hanley Collection.

□ Album painting for the Moghul market depicting peaches. Nineteenth century. Phil Wood Collection.

shuo who was said to be conceived by immaculate conception and was an adviser to the famed Emperor Wu Di. A story tells that one day the emperor saw a green sparrow and inquired of Dungfang shuo if this was an omen. Dungfang shuo said it meant that the Goddess Xi Wang mu would come and bring the peaches of immortality, and indeed she arrived some days later. But while the goddess was conferring with Wu Di and eating one of her peaches, she spied Dungfang shuo peering through the window and said to the emperor, "That man stole my peaches, three of them, and is now three thousand years old." Dungfang shuo, as is Shou Lao, is depicted with the peach of immortality in his hand and is also sometimes accompanied by a stag and bat, all symbols of longevity. However, the distinguishing factor is that Dungfang shuo's forehead is not as large as Shou Lao's. Moreover, he is more of a folk hero and sometimes accompanied by the goddess or the emperor.

The peach, peach tree, and peach pit all have been utilized in Chinese medicine for centuries and remain herbal treatments for a variety of ailments including the common cough and lung diseases.

Peach Blossom

The blossoms of the peach tree are said to be a charm against evil. At New Year's, it is the custom for peach blossoms to be placed on the doors of homes to drive away the evil spirits and bring the inhabitants longevity. It is also the flower of the second month.

Peacock

The peacock was introduced into China from the south and since then has been absorbed into Chinese culture, prized and honored both because of its beauty as well as its size. It is a symbol of beauty and dignity and also of rank on Mandarin badges (*see* Mandarin Square). It first was used as a symbol to designate rank or social position in the court during the Ming dynasty, and was distinguished from other birds by its characteristic circular tail feather pattern. The peacock, both in the Ming and Qing dynasties, was indicative of a third-rank civil official. There are rare court robes, only known to exist during the early eighteenth century, where peacock feathers were actually woven into the robes and incorporated into the design. These robes were no doubt those of the very wealthy.

A folktale tells of the daughter of a prestigious military official who painted a peacock on a screen and stated that she would marry the first man who would twice pierce the peacock with an arrow while running. A Tang emperor not only pierced the peacock on two tries but pierced it right through the eyes. The saying, *"que ping zhong xuan,"* "selection by hitting the bird screen" came to express a wish for finding a husband.

Peanuts

The Chinese word for peanuts, *hua sheng,* literally means "flower of life," referring not only to its symbolism but also to its nutritional value. Peanuts symbolize a wish for many offspring. They also symbolize new growth and continuity.

In Southern China, Buddhist and Daoist monks and priests consume peanuts and give them as humble gifts to those who visit their temples and monasteries. In Chinese medicine, the peanut is an herbal food used for problems with eyesight and also as an ingredient for treating problems with the feet.

In shamanistic rituals, the shaman would say prayers over an ill person and then tie peanuts onto the person's garments. The shaman would then burn the garments as an offering to the gods. The secured peanuts were said to become the imprisoned bodies of the evil spirits to be purified by the power of fire from the gods.[58]

Pear

The pear tree is said to bear fruit for an infinitely long period of time. It is from this long period of productivity that the fruit derives its symbolism, that of longevity. It also symbolizes purity and the wise, benevolent administration of justice. This meaning arises from stories that tell how the Duke of Shao imparted justice under a pear true.

The word for pear, *li,* has the same sound as the word for separation, *li;* therefore, it is a negative symbol for lovers, who never partake of this fruit together. The pear should never be given as a gift because of the implications of its name.

□ A Brush rest in the shape of peanuts. Lacquered wood, nineteenth century. Ji Zhen Zhai Collection.

□ B Flaming pearl design. Detail of kesi tapestry, eighteenth century. Courtesy of Jocelyn Chatterton.

Pearl

The pearl, *zhenzhu,* is both a symbolic and decorative object in Chinese art. As a symbol, it conveys good fortune, brilliance, and feminine beauty.

With the entry of Buddhism into China during the Han dynasty, the pearl became one of the Seven Treasures of Buddhism. Later it was sometimes included as one of the Eight Ordinary Symbols; however, it also is known to appear in Daoist literature.

The pearl is perhaps best known as the representation of knowledge or wisdom that is pursued by the dragon, as depicted on imperial objects including robes, carvings, sculptures, and friezes. The pearl is also a representation of purity, the essence of the moon and beauty. Noting its symbolic meaning, it is said that the Dowager Empress was buried with a rare pearl of uncommonly large size in her mouth. Unfortunately, her grave was looted, and the whereabouts of this pearl is not known.

During the Qing dynasty, there are examples of court robes of the very wealthy that utilized pearls in the weaving process, and there are court accoutrements in which pearls were incorporated, such as toggles and necklaces.

Peng Niao (Peng Bird)

The Peng Niao is a mythical bird that predates the fourth century B.C.E. It is recorded that this mythical creature turned into a bird from the Kun fish. It was described as being so enormous in size that it could fly high into the heavens until it could see nothing beneath it but the blue waters of the sea. And yet the Peng Niao had the ability to swoop down to earth in an instant and see every miniscule object. This Daoist tale is a parody on concepts of reality, subjectivity, and objective reality in life.

Peng zu

According to folktales, Peng zu, the great grandson of an emperor, died in 1123 B.C.E. at the end of the Yin dynasty, at which time he was 767 years of age. As he lived such a long life, he himself symbolizes a wish for long life in sculptures and painting. He is frequently depicted as an elderly male who burns incense, an elderly male surrounded by children, or an elderly male who reclines on waves. The latter depiction comes from a folktale in which he was said to have the ability to sleep for a day on water. He is seen to be the Methuselah of Chinese folklore.

Penglai Islands

In Daoist mythology, the Immortal Islands of Penglai, called *Penglai xianshan,* are the home of the gods. The names of these three legendary islands are Penglai, Fangzhang, and Yingzhou.[59] According to legend, they are the far distant lands surrounded by waves off the eastern sea coast of China. They are inaccessible to all beings except immortals and the cranes, which are the vehicles for travel. Throughout the centuries, these three Penglai Islands are frequently mentioned as creative metaphors and spiritual retreats by scholars and poets in poems and literature.

□ Woodblock depicting the Penglai Islands. Ji Zhen Zhai Collection.

Peony

The Chinese refer to the peony (tree peony) as *mudan* (supposedly derived from words meaning male vermilion, *mu* meaning "male" and *dan* meaning "deep red" or "vermillon"), which is said to be the "flower of the emperor." The *Pen-ts-ao,* the classical book of Chinese medicine from the sixteenth century, intimates that the peony's name may mean "most beautiful." It further suggests that it was the custom to give the peony to friends who were going away, making it known as the flower of parting. It is documented in ancient books such as *The Book of Odes* that peonies were the gifts that lovers gave one another. The peony also symbolizes late spring or early summer and is the flower emblem of China. It is an omen of good fortune, but if the flowers and leaves suddenly wither and die away, it is then an omen of coming disaster for the owner. The many layers of densely packed petals symbolize affluence and prosperity.

There are tales that identify the tree peony as being so beautiful that only the emperor could own it. It is also known as the flower of flowers, the queen of flowers, the flower of riches, and the flower of honor. With these attributes, the peony came to symbolize beauty of the female, riches, wealth, and good fortune. Famous artists through the various dynasties have produced paintings of the peony utilizing this symbolism.

Other symbolic meanings arise when the peony is shown with other fruits or flowers. Depicted with the lotus, plum, and chrysanthemum, it stands for the four seasons. This is frequently seen as a design on imperial porcelains in which the flowers are tied with a ribbon.

The peony and peach symbolize a wish for "wealth and a long life."

The peony and hibiscus *(fu rong)* symbolizes flourishing *(rong)* with wealth.

The wild apple *(hai tang)* and peony expresses the wish "May your house *(tang)* be filled with riches."

□ Imperial enamel vase with peony design. Qianlong mark and period (1736–95). Ji Zhen Zhai Collection.

There are a group of porcelain dishes of the Yongzheng period whose rims are shaped to simulate the petals of a chrysanthemum, representing fall, while in the center of each dish a peony is depicted, representing spring. This design alludes to the yin and yang of life and the constant passing of the seasons.

Persimmon

This fruit is an emblem or symbol of joy because of its brilliant red color.

The coupling of the persimmon-shaped covered spittoon, used by the emperor and court scholars, with a *ruyi* scepter is the basis for a pun as the words for persimmon, *shi zi*, sound like *shi*, to serve or affairs, and *zhi*, to manage public safety or affairs. While *ruyi* literally means, "as you wish," together the two objects embody the wish that the emperor or court scholar might manage all affairs according to his will for the benefit of the nation.[60]

Another rebus depicts the persimmon with the tangerine. This rebus has the meaning "May you have good fortune in your affairs." Here the tangerine, *ju*, is phonetically close to the *ji*, meaning luck, while the persimmon, *shi*, phonetically stands for affairs.

□ Brushrest of rat eating persimmons. Kangxi period (1662–1722). Ji Zhen Zhai Collection.

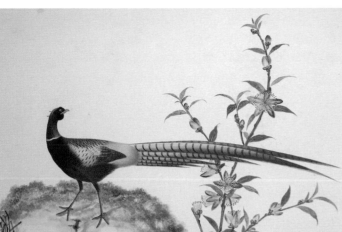

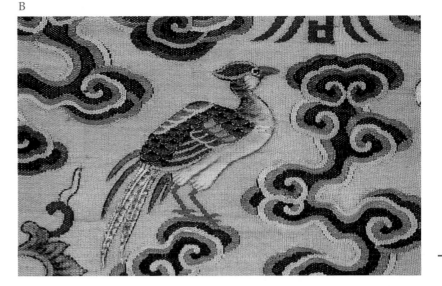

An appropriate painting, which is sometimes given as a gift for an opening of a new business, couples the persimmon *(shi)* in the form of a cake with a pine tree branch *(bo)* and an orange *(ju* suggesting *ji* for luck). This rebus conveys the wish "May you have luck in a hundred business matters." A similar meaning is conveyed by depicting the lichee *(li)* with the persimmon *(shi),* meaning "profit in business matters."

Pheasant

The pheasant, *yeji,* is an important symbol in China, as shown by its being one of the Twelve Symbols of the Emperor. In this case, the pheasant is an imperial symbol of authority. It represents the bird kingdom while the dragon represents the animal kingdom, so together they symbolize the entire natural world. But the pheasant further symbolizes literary refinement and official office. A golden pheasant is the symbol of a second-rank civil official while a silver pheasant represents the fifth-rank civil official. The pheasant is also an omen of good fortune.

Phoenix

The legendary phoenix, symbolizing the sun, good luck, abundance, and longevity, is said to be the most beautiful of all birds, the empress of all birds. "As resembling a wild swan before, and a unicorn behind, it has the throat of a swallow, the bill of a fowl, the neck of a snake, the tail of fish, the forehead of a crane, the crown of a mandarin drake, the stripes of a dragon and the vaulted back of a tortoise."[61] It is

□ A Album painting for the Moghul market depicting pheasant. Nineteenth century. Phil Wood Collection.

□ B Pheasant, detail of a twelve-symbol imperial robe. Eighteenth century. Linda Wrigglesworth, Ltd.

□ C Stembowl with phoenix design. Yongzheng mark and period (1723–1735). Ji Zhen Zhai Collection.

the emblem of the empress and of beauty, the messenger of the Daoist Immortals and, as the red bird of the south, one of the four directions. It is said to control the sun and only appears at the time of peace and prosperity. With strong yang attributes, it is also a symbol of fertility. It ranks second of the four great mythical animals—dragon being the first, qilin third, and tortoise fourth.

The phoenix symbolizes the human qualities of virtue, duty, correct behavior, humanity, and reliability. The male is called *feng* while the female is called *huang;* the gender is distinguished in images by its tail feathers.

In paintings and on porcelains, a beautiful, elaborately dressed woman who sits on the back of a flying feng bird is identified as Lao Yu. Legends describe her as the daughter of Emperor Mu Wang who accompanied her father to the world of Xi Wang mu.

In contemporary Chinese life, the phoenix is frequently seen on the robes of brides, who, according to tradition, are "empress for a day."

150

□ A Phoenix-headed ewer.
Song dynasty (960–1279 C.E.).
Ji Zhen Zhai Collection.

□ B Gold phoenixes.
Liao dynasty (907–1125 C.E.).
Gisèle Croës S.A.

A

B

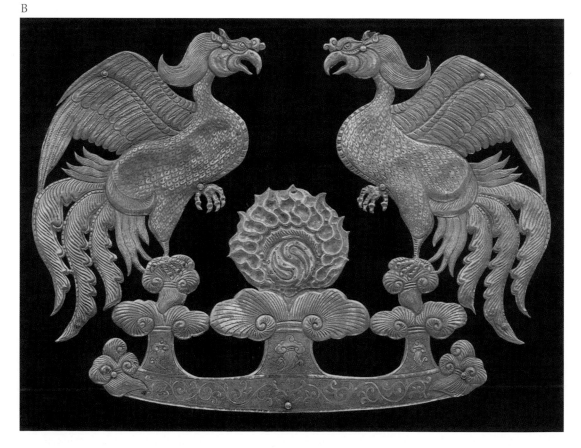

Pig (Wild Boar)

The pig is the last and the twelfth animal of the zodiac and symbolizes satisfaction, protection against evil spirits, and male virility (*see* Zodiac). The wild boar in the forest is a symbol of wealth. Wild boars are prominently seen in tomb figures of the Tang dynasty.

The Chinese word for pig, *zhu,* is a relatively common surname as it is said to fool the evil spirits into thinking that the child is only an unworthy pig and therefore should be overlooked. This is a pun that some might feel is insulting to the child; however it is clearly put into use as there are countless folk hats and shoes made in the shape of a pig.

Pine Tree

Longevity, steadfastness, and self discipline are symbolized by the pine tree, *songshu,* which is one of the most popular symbols in Chinese art. Since its needles remain green through the harsh winter, it is identified as one of the Three Friends of Winter, the other two being prunus and bamboo, symbolizing longevity and strength.

The pine tree and crane are among the most common longevity symbol combinations repeated through the centuries in paintings, carvings, textile weavings, and decorations on porcelains.

The detailed design of a pine tree with two squirrels, *song shu,* refers to their diligent autumn activities of collecting and storing food for winter. The symbolism of the pine tree coupled with the squirrels (or rats) means having the foresight to prepare for a lengthy life rather than wasting one's life in extravagance.

On dragon robes, the pine is seen in later Qing robes portraying Penglai, the Islands of the Blessed or Immortality. On Mandarin squares, it is only seen in later Qing dynasty squares expressing the same symbol of longevity.

At times, in paintings or carvings, a sage is depicted standing atop a pine tree with a crane at his side, or a sage is depicted riding a flying crane. This is Yu Tao Hua, a Daoist figure who, according to folk literature, had a reputation of acting as an emotionally disturbed individual. He frequently stood on steep rocks and other dangerous places and behaved irrationally. But one day, he was given a medication by the name of Tan after which he climbed to the top of a tree and flew off into the heavens on the back of a crane.

An unusual Daoist figure, Wu Chuan, is sometimes depicted in Chinese art. He can be identified by his disheveled appearance, his wearing of mugwort leaves, and his holding of pinecones. A folktale says that he knew the secret of longevity

and lived on pinecones while making an elixir of life. He offered his mixture to the emperor, who refused, but several others did partake of it and achieved immortality. The gift of an image of Wu Chuan bestows a wish for longevity.

Pipa

The *pipa* is a Chinese mandolin-type stringed instrument that is not seen in other countries. It bears the same name as the *pipa* fruit as it has a similar shape. It is played as a guitar is played and represents feminine purity and the delicate sentiments of women. A lady playing the *pipa* is a frequent subject of Chinese paintings.

Plantain

The plantain is popular primarily in Southern China and its symbolism seems to be limited to that region, perhaps as this fruit is not seen in the north. The plantain is said to symbolize the self-learning of the poor. This symbolism is related to the folk story of a poor youth who utilized the large plantain leaves to write on because he was too poor to afford paper.

Plum Blossom (Prunus)

The plum is rich with symbolism and history in Chinese culture. The plum tree is one of the Three Friends of Winter, the other two being the pine tree and bamboo. The beautiful, delicate blossoms of five petals appear before the leaves and are said to represent survival of hardships, endurance, and perseverance in the same way that the plum blossoms, *mei,* survive the hard winter. The plum blossom is itself a symbol of long life in that blossoms appear on lifeless-appearing branches of highly advanced age. The five petals of the blossom, a distinguishing factor in identifying the plum blossom on paintings, are also said to represent the Five Gods of Happiness. The flower represents the female youth and is the emblem of the first month of winter.

A visual rebus is formed by the plum tree with bamboo and the figures of an elderly man and woman. The meaning conveyed here, a wish for generations of children, is shown by the plum tree symbolizing happiness, the green bamboo *(sun)* symbolizing grandchildren (also *sun* but with a different tone), while the elderly figures represent generations. This visual rebus is sometimes shortened by showing the plum tree with bamboo.[62]

A depiction of a vase with plum and *ruyi* expresses a wish for peace and long life (*see* Ruyi).

□ Painting of lady playing the pipa by Hua Yan (1682–1756). Ji Zhen Zhai Collection.

Peach *(tao)* and plum *(lu)* together, *tao lu,* symbolize students. *Tao* also means "fruits of hard work" and *lu* can mean "seedlings."

The plum blossom is one of the two elements of the Hawthorn pattern, an enormously popular blue-and-white porcelain decorative pattern made famous during the Kangxi era. The Hawthorn pattern consists of a background cracked ice pattern of deep blue on which fallen plum blossoms appear and represents the falling blossoms on the cracked ice from the northern rivers, the coming of spring and new life.

The plum blossom *(mei hua)* also has erotic connotations, being synonymous with a virgin. A plum blossom bed refers to the bridal bed. In writings, when a plum tree is said to be in bloom for a second time, it suggests a second marriage.

The plum and its seed are utilized in Chinese medicine. "Willow plum sickness," *yang mei bing,* is the term for syphilis.

□ A Brushpot with prunus design by Wu Zhifan. Bamboo. Seventeenth century. Ji Zhen Zhai Collection.

□ B Album leaf of plum blossom. Ink on paper, by Yao Rou yi. Late Ming/early Qing dynasties. Horacio Fabrega Jr. Collection.

A

B

C

- A Porcelain Mei Ping vase
 with pomegranate design.
 Ming dynasty (1368–1644).
 Collection Anunt Hengtrakul.

- B Album painting for the Moghul
 market depicting pomegranates.
 Nineteenth century.
 Phil Wood Collection.

- C Detail of pomegranate design,
 porcelain flask.
 Qianlong period (1736–95).
 Private Collection.

Pomegranate

Commonly called the "Chinese apple" in the West, the pomegranate, *shi liu,* is not native to China but was brought there during the Han dynasty from Central Asia, where it remains an important food commodity. Once this fruit became known in China, it was quickly adopted into the culture, primarily as a symbolic object. The pomegranate symbolizes abundance and a wish for many sons. This symbolism comes from the many seeds of red fruit that lie under its brilliant red skin. The pomegranate has meanings to both Daoists and Buddhists. To Daoists, it has the same symbolism and meaning as the peach of immortality. To Buddhists, it is a symbol for good luck. It is most commonly depicted in objects during the Ming and Qing dynasties.

Depictions of an opened pomegranate exposing its seeds give the rebus *liu kai bai zi,* meaning "the pomegranate opens and [gives] a hundred sons." The same depiction can also give the rebus *shi liu kai xiao kou,* meaning "the open pomegranate [gives] laughter."

The pomegranate is a common design in the far western areas of China inhabited by minority peoples and on eastern Turkestan rugs.

Poppy

In spite of the fact that the poppy, *ying su,* with its paper-thin petals is one of the most beautiful flowers found in China, it is not a common motif in Chinese art. During the reign of Yongzheng (1723–35), it was seen on imperial porcelain bowls in *famille rose* enamels, but it never became a popular design motif. The poppy represents the twelfth month in Chinese art.

Prawns/Oysters

Prawns, *daxia,* and oysters, *muli,* are symbolic of liveliness, happiness, and goodness. Sometimes the oyster is symbolic of a younger brother. Both prawns and oysters are common subject matter of late Qing and contemporary artists, the most famous being Qi Baishi, arguably the most famous of the twentieth-century artists.

As both prawns and oysters are relatively expensive food items, they are served to important guests as symbols of honor combined with wishes of happiness.

Praying Mantis

This insect takes a characteristic pose with its forelegs being in a praying position, which gives it its name. Yet it is a voracious eater and preys on all insects with tenacity. It is perhaps best known for the female of the species eating its mate, a particularly egregious act to the Chinese, a society that favors males. Therefore, the praying mantis takes on only negative attributes, that of greed or retentiveness. In paintings, it is a relatively rare subject owing to its symbolism.

Pu Xian

In Sanskrit, Pu Xian is known as Samantabhadra. He is a bodhisattva who is very popular in China, particularly in Mount Omi of Szechuan and to a considerably lesser degree in India. To the Chinese, he is the God of Compassion; he is known to dispense knowledge and is usually depicted seated sideways on an elephant, perhaps holding a lotus. He was particularly popular as a sculptural subject during the Ming dynasty.

In the great hall of a Chinese Buddhist monastery or temple, unlike temples in India or other countries, the main altar is found with the image of Sakyamuni Buddha and his two foremost disciples or other buddhas of the past. The arrangement and choice of images selected may vary; however, to the right and left of the main altar one usually finds the two great bodhisattvas, Manjusri and Samantabhadra, also known as Pu Xian.

A

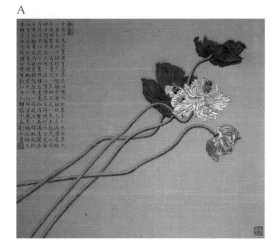

B

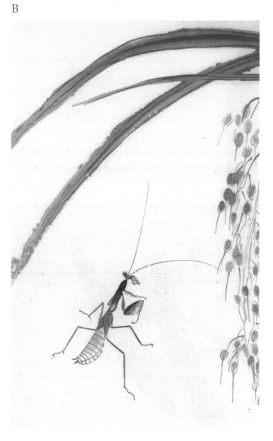

□ A Painting of poppies in ink and color by Liu Dan (b. 1953). Ji Zhen Zhai Collection.

□ B Woodblock depicting praying mantis. Ji Zhen Zhai Collection.

A

B

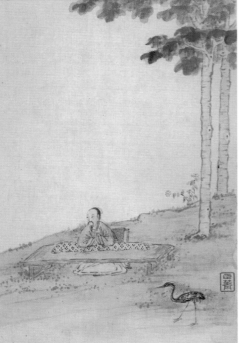

□ A Qilin. Cinnabar lacquer with
cat's-eye and turquoise inlay.
Eighteenth century.
Ji Zhen Zhai Collection.

□ B Scholar, with crane playing
qin. Album painting.
Seventeenth century.
Horacio Fabrega Jr. Collection.

Pumpkin

Pumpkin, *nan,* is a homonym for the word for boy. A boy child is most prized in
Chinese culture, as he continues the legacy of one's family; therefore, the pumpkin
is frequently depicted in Chinese art expressing a wish for a son.

There is a folk custom that on the fifteenth of August of the lunar year, women
grope in the dark where beans and melons have been planted. If one touches a
pumpkin, she will be blessed with a son and if she touches a bean, she will have a
girl. This is called "touching the autumn" (*see* Melon).

Qilin

The counterpart to the qilin of China is said to be the unicorn, a description that
some scholars dislike intensely as the body of the qilin figure has scales and two
horns, quite unlike the unicorn of the West. One of the four great mythical animals
of China, it is recorded that this animal's body resembles that of a deer with scales,
horns in the center of its head, a tail of an ox, a forehead of a wolf, hooves of a
horse, and backward antlers.

The qilin is a symbol for happiness, and legends maintain that it will bring
many sons to the family and those sons will become successful scholars. In the
later Qing dynasty, it was the symbol for a first-level military official. Among the
many things that the qilin stands for is a wise administration; folktales claim that
the qilin only appears during the reign of a wise and just ruler.

The qilin's appearance is not limited to textiles. It is also seen on porcelains,
carvings, stone sculptures, and lacquers. During the Yuan, Ming, and Qing dynasties,
it was particularly popular. Qilin appear as a decorative motif on later Qing robes and
is associated with the saying *"Qilin song zi,"* "the Qilin will send children." In some
Annamese robes, qilin replace some of the large dragons, but this is only seen in
designs that were made for the Dukes of Annam. (Annam is a former kingdom
in central Vietnam that was ruled by China from 111 B.C.E. to 939 C.E.)

During the very late Qing dynasty, women wore amulets of silver in the shape
of qilin, hoping to be favored with a son or sons.

Qin

The most prestigious and favored of musical instruments is the *qin,* a zitherlike
instrument that is uniquely Chinese. It is a symbol of the scholar and representa-
tive of the scholar himself. The Four Arts of the Scholar were defined as playing the
qin (qin), chess *(qi),* calligraphy *(shui),* and painting *(shu).*

The *qin* is a five-stringed instrument developed during the Zhou dynasty (c.1050–221 B.C.E.). Sometime between the reigns of Emperors Wen and Wu in the Han dynasty, two more strings were added to enrich the sound and tones of its musical scale. It was considered the soul of music in ancient China, and Confucius himself advised that learning the *qin* should be an essential and integral part of higher education.

The instrument itself is steeped in symbolism. The domed surface was said to represent the learned and the heavens while the flat bottom was said to represent the common man and the earth. Not only are these instruments collected, but through the centuries, the *qin* have been depicted in all forms of Chinese art.

The *qin* along with a crane forms the rebus "May you be a good official," *yi qin yi he. Qin* also means "official" and *he* means "crane." It is said that during the Song dynasty, a good official had a *qin* (the instrument) and befriended a crane.

Qu Yuan

Qu Yuan (340–278 B.C.E.) was a famed statesman and a highly skilled diplomat as well as chief poet in the *Songs of Chu*, an ancient anthology of Chinese poems. He is said to be the father of Chinese poetry. But he was the victim of jealousy. His fellow ministers slandered and plotted against him, causing him to lose the favor of his king. As a result, he was banished several times, only to be recalled time and again. The king failed to heed Qu Yuan's advice not to go into a conference with the king of Qin, where he was captured and died. Instead of avenging the death of his father, the new king was fooled and the kingdom was plundered and destroyed. Qu Yuan, an old man at the time the Qu capital was lost, drowned himself in despair. It is written that he died on the fifth day of the fifth month. The Dragon Boat Festival commemorates his drowning. There are many varying folktales of Qu Yuan, but in each one, Qu Yuan is said, above all, to symbolize loyalty.

Quail

The quail seems to have conflicting symbolisms. Quail, *an* (in shortened form), has the same sound as *an*, meaning peace. But in contrast to its homonym, the quail, *an chun*, is also an emblem of courage with its easily aroused anger. It has been used for fighting purposes in gambling because it is so easily brought to anger. This custom is said to have come to China from the Middle East, where it remains a popular pastime.

Yet the quail also symbolizes the scholar who struggles mightily to pass his examinations in the face of many obstacles. Many articles for the scholar's table are

A

B

fashioned with the quail emblem, accompanied by sheaves of wheat. The quail is a common motif in Chinese art and frequently appear in pairs.

A rebus is formed by depicting the quail with a chrysanthemum, which expresses the hope for one "to live in peace." Here the quail, *an,* represents peace and the chrysanthemum, *jiu,* means "to live."

Two quail, *shuang an,* form the symbol of harmony, *shuang* meaning "two" and *an* meaning "quail" or "peace."

In folk belief, the quail is a symbol for appropriateness, moderation, and good yin energy to keep the strong active yang in balance. Loved by women and children, it stands for *wenhe,* that which is warm and harmonious. In both traditional medicine and traditional Chinese cuisine, quail is an ingredient for cold weather. In Chinese folk medicine, quail are consumed for blood circulation and their small eggs are believed to aid the ill in recuperation.

Quince

The quince, *tiegeng haitang,* is the Chinese New Year flower. It therefore brings traditional greetings and wishes for wealth and happiness.

Rabbit or Hare

In Chinese legend, folklore, and religion, the rabbit, *tu,* is well represented. In Daoism, the rabbit is frequently depicted with the moon goddess, Chang E. It is written that they lived in the crystal palace on the moon and at night, the rabbit helped the goddess to prepare the sacred herbs for immortality by pounding the herbs with a mortar and pestle. The tale of Chang E is an ancient one and is recorded in the Western Han fairy-tale book called *Shanhaijing (The Book of Mountains and Seas).*[63] The story tells how the beautiful goddess Chang E stole the pill of immortality from her archer husband, Hou yi, who shot down twelve suns in the sky to save the crops and land from being scorched by the heat. On discovering the treachery of his wife, he chased her to regain the stolen pill. In desperation, she swallowed the pill and escaped to the moon. There she lives a lonely life forever in the company of her loyal companion, the rabbit, who does the herb pounding as well as safeguarding of her palace. This tale became very popular in the Tang and Song dynasties, and numerous poems were composed about the rabbit and the lonely exile of the moon goddess.

□ A Ivory box in the form
of a quail.
Qianlong period (1736–95).
Ji Zhen Zhai Collection.

□ B Celadon water dropper in the
form of the hare grinding the
herbs of immortality.
Song dynasty (960–1279 C.E.).
Ji Zhen Zhai Collection.

The rabbit also appears in Buddhist legend. In one story, a hare that sympathized with the starving Buddha threw itself onto a fire to provide food for Buddha and therefore became a symbol of self-sacrifice and faith. As a reward, the rabbit was sent to the moon to live for a thousand years.

The rabbit or hare is the fourth sign of the Twelve Terrestrial Branches, the symbol of longevity, and one of the symbols of the twelve-symbol imperial robes. The white rabbit or hare is said to be particularly auspicious as it only becomes white after living more than a thousand years.

The rabbit also represents femininity. This attribution relates to the fact that rabbits are very fertile and bear many young, something that Chinese women hope will be true in their lives as well.

At the time of the lunar festival, six children surrounding a figure with the head of a hare symbolizes a wish that the children in the family will be elevated to the rank of civil officials. *Liu,* the number six, also sounds like *liu,* meaning "swift." *Tu,* hare, sounds like *tou,* head, meaning "auspicious."

The rabbit depicted with lichee and *lingzhi* expresses this wish: "May you have many sons and long life." The rabbit represents fertility, the prolific lichee represents sons, and *lingzhi* here means "may you have."

□ Imperial brush washer with ram's head. Jade. Qianlong period (1736–95). Ji Zhen Zhai Collection.

Rain

Rain represents the product of the proper union of yin and yang. Because China is an agrarian society, rain is particularly important. From the earliest times, rain was seen in supernatural terms—controlled by the gods and beasts of the heavens.

Rainbow

The rainbow is said to represent the coming together of ying and yang and therefore is symbolic of marriage. But in contrast to this positive symbolism, the rainbow in folklore represents a husband who is more attractive than his wife and who is an adulterer. Therefore, the rainbow symbolizes fornication. Other folk traditions teach that pointing at the rainbow is disrespectful to anyone in your presence.

Ram

The ram is a symbol for kindness and patience. The city of Guangzhou, Canton, in Guangdong Province, is sometimes called the City of Rams. This is based on a folktale in which five magicians presented to the people of Guangzhou five rams, each of which had five stalks of grain in its mouth. Proclaiming that famine should

never come to Guangzhou, the magicians suddenly disappeared and the rams turned into stone.

Folk beliefs consider the meat of the ram (mutton), to be a yang energy source when prepared with appropriate Chinese herbs. It is said to promote good blood circulation that is especially beneficial in the elderly. The ram is also an astrological animal that occupies the eighth position in the Chinese Twelve Terrestrial Branches. It belongs to the earth element within the Daoist five element cosmological theory (earth, wood, metal, water, and fire). The astrological character of the ram is patience with an enduring and peaceful nature, and its essence is that of a new beginning and prosperity.

The ram, *yang,* has the same sound as *yang,* the word for the long lines of the trigram, and *san yang* symbolizes spring (*see* Eight Trigrams). When three rams appear together, *san yang,* along with the sun or the *taichi* symbol, this refers to an old idiomatic expression, *san yang kai tai,* meaning "three rams initiate a new beginning." "A new start with auspicious possibilities and chances for prosperity" is gleaned from this saying. Therefore the ram grants good wishes.

□ Porcelain water dropper of rat eating grapes. Kangxi period (1662–1722). Ji Zhen Zhai Collection.

Rat

The rat in Chinese astrology is in the first position of all of the animals of the Twelve Terrestrial Branches and is a symbol for both cleverness and timidity (*see* Zodiac). In Chinese folk legend, the rat is considered a peak *yin,* or female, creature that could live to an age of three hundred years. As it ages, it is felt to be endowed with divination powers and an ability to make predictions for humanity. It could forecast events ten thousand miles away, and when tyranny or injustice occurs, the divine white rat will manifest itself to save the oppressed.[64]

As a member of the zodiac family it represents the north. It also symbolizes thriftiness and prosperity as it hoards its food. It is sometimes depicted pulling a bunch of grapes (a squirrel sometimes substitutes for the rat) or eating a bunch of grapes, forming the rebus "rise to the top of the imperial court."

Raven

The raven in ancient China was a three-legged bird that lived in the sun. According to legend, there were once ten ravens (the number varies from one source to another) on the sun that cast such heat that life was endangered. The famed archer Hou yi shot down nine of them, leaving one on the sun with three legs. The three-legged raven is said to be the messenger of the goddess Xi Wang mu. The sounds of the raven are said to be a harbinger of death, except when heard before ten o'clock at night.

Red Bird

The red bird is the symbol of the south and emblem of the Yin people who established the Shang dynasty in 1500 B.C.E. by overcoming the Xia tribes. They were known for their skills in establishing a Bronze Age culture. Their main god was Shang di, but they worshiped and made sacrifices to the four cardinal directions, as well as the sun, moon, clouds, stars, mountains, and earth. One of their methods of attempting to communicate with spirits was through oracle bones. Bones and shells of the tortoise were scorched in fires and the cracks that appeared were interpreted to be communications from the spirits.

Rhinoceros

The unusual magical power of neutralizing poison, a quality attributed to rhinoceros horn, may have origins in Bronze Age China. Records dating back to the earliest times, also known as the Spring and Autumn periods, make reference to a "poison bird, a *zhen* bird" where the rhinoceros lived. The bird was described as goose or eagle-like but the size of an owl. This deep-purple bird had a red beak and its feathers were poisoned from its diet of poisonous snakes. Legends maintain that when the bird ate these poisonous snakes, its droppings were so potent that they dissolved stones; moreover, if the feathers were mixed with wine, a poison was produced that was neutralized only by rhinoceros horn. The horn from the rhinoceros, *xi niu* (literally meaning "western cow" but also called "sacred cow") was utilized in Chinese medicine for centuries and was said to cure a variety of ailments, including sexual impotency.

□ Rhinoceros horn cup.
Seventeenth/eighteenth century.
Ji Zhen Zhai Collection.

The associations with rhinoceros horn have no doubt led to the animal being extinct in China, as it was said not only to neutralize poison but also to have aphrodisiac qualities. Utilized for centuries in Chinese herbal medicine, the ground horn of the rhinoceros is highly sought after, even to the point of grinding and destroying antique objects made from rhinoceros horn. There are scholars who believe that the rhinoceros horn symbol evolved into the artemisia leaf because of unclear representations, but the rhinoceros horn appears on Mandarin robes in the Qing dynasty. The horn has been used to fashion libation cups as well as simulations of archaic bronzes. A pair of rhinoceros horn cups represents happiness and is one of the Eight Precious Things.

For military officials, the rhinoceros, *xi niu,* was the symbol of the eighth level on Mandarin squares during the early Qing dynasty. In the later Qing dynasty, it was the symbol for seventh- and eighth-level military officials (*see* Mandarin Square).

Rhombus

The rhombus is one of the Eight Symbols of the Scholar and it is somtimes included as one of the Eight Precious Things. It is said to symbolize stability in ruling and victory.

Rooster

The rooster is the tenth animal of the zodiac. As a zodiac figure, he is courageous and is seen as the life of the universe. Symbolically, the rooster frightens off evil spirits, and a red rooster is said to protect one against fire. The word for rooster, *ji,* is a homonym for auspicious and is symbolic of a successful career as an official.

The rebus *guan shang jia guan* conveys the meaning for one to keep climbing up on one's civil official path, *guan* being the word for the comb of a cock and for official, *shang* meaning "rise," and *jia* meaning "add."

When the rooster is depicted flying in the rain, it is a symbol that spring has arrived and the planting of rice is to begin.

The rooster forms a homonym when crowing *gong* (rooster) *ming* (crowing) having the meaning "merit and fame."

A visual rebus is formed by depicting a cock with the cockscomb flower. The comb of the cock has a likeness to the cockscomb flower. The cock comb and the hat of an official form a homophonous pun, *guan,* which means both "cock" and "official." This depiction is a wish for success in a civil service official position.

A rooster surrounded by chicks is symbolic of the patriarch caring for his sons. A rebus *jiao wu zi* is depicted by a cock crowing with five chicks and has the meaning that a father has the wish that his five sons will all become court officials, *jiao* meaning "teaching" and *wu zi* meaning "five sons."

On Mandarin robes with the Twelve Symbols of the Emperor, one of the symbols is a three-legged bird on a sun disk. This bird, originally thought to be a crow during earlier periods, perhaps evolved into a rooster since during the Qing dynasty it is depicted as a rooster (*see* Twelve Symbols of the Emperor).

Roosters are also seen as a motif on the prized, so-called "chicken cups" of the Ming (Chenghua period) and early Qing dynasties (*see* Chicken).

Three-legged rooster. Detail from a twelve-symbol imperial robe. Eighteenth century. Linda Wrigglesworth, Ltd.

Rope

The rope is an attribute in Buddhism and is sometimes seen in the hand of Avalokiteshvara. The rope signifies "the love of the Buddha and Bodhisattva for all Sentient Beings, whom they catch and lead to salvation with the help of the rope."[65] This attribute is rarely seen in Chinese Buddhism, however.

Rosary

The rosary, *mala* in Sanskrit, is worn by Buddhist priests for religious purposes. The origin of the rosary is unknown, but there is one account that places it in the seventh century. At that time, Sakyamuni Buddha "paid a visit to King Vaidurya and made him a convert. To aid the King in his new found faith, Sakyamuni directed him to thread 108 seeds of the Bodhi tree on a string, and while passing seed by seed between the fingers to repeat a certain formula meaning: 'Hail to Buddha, The Law and the Congregation' at least two thousand times a day."[66] The short rosary of eighteen beads symbolizes the eighteen arhat (*see* Lohan) and is encountered less frequently than the ordinary chaplet of 108 beads.

The Chinese rosary consists of 108 beads: twelve for the months of the year, twenty-four for the solar periods of the year, and seventy-two for the lesser terms of five days into which the year was subdivided. There are two extra strings of ten beads each that were counters, beads used to keep track of the number of recitations made.

The court necklace, a rosary with some alterations, was part of the ceremonial regalia required to be worn with the Mandarin robe for the nine ranks of officials during the Qing dynasty. Between every twenty-seven beads there is a *fo tou* (Buddha's head) bead and at the very top of the necklace there is a *fo tou* and *fo tou ta* bead. A long cloth strand extends from the *fo tou* bead down the wearer's back to end at a *bei yun* (back) pendant, which acts as a counterweight. There are three strands, each ending in a pendant attached to the main necklace. Each strand is composed of *ji nian*, memory beads, each with ten beads ending in a pendant called a *pei yun.* The court necklaces were constructed of jade and other semiprecious stones as well as glass.

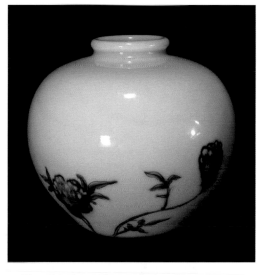

□ Porcelain jar with rose design. Kangxi mark and period (1662–1722). Ji Zhen Zhai Collection.

Rose

The rose, *meigui,* is the flower of everlasting springtime and symbolizes enduring youth. In contrast to Western symbolism, the rose has no connotation of love. Moreover, it is not a particularly popular flower of the Chinese.

The rose is most frequently seen as a motif on porcelains of the Qing dynasty, but it is not a common depiction, perhaps because perfection in the use of red

☐ *Ruyi* of silver inlaid iron.
Qianlong mark and
period (1736–95).
Ji Zhen Zhai Collection.

coloring did not occur until late in the dynasty. There are examples of rose decoration in early porcelains of the eighteenth century (Kangxi and Yongzheng periods) in which the roses were of a muddy brown color and not precisely painted.

Ruyi

The history of the *ruyi* scepter, frequently called *ruyi,* in Chinese culture has been both long and continuous. Whether the *ruyi* scepter was indigenous to China or a Buddhist importation is not clear. What is clear is that the *ruyi* became a prominent symbol in Chinese culture. The two earliest excavated examples came from Qufu, Shangdong, dating from sometime between the late Warring States period and the early Western Han dynasty (206 B.C.E.–8 C.E.).[67] One excavated example is made of carved bone in the shape of a back scratcher with a long thin handle. Hence some scholars believe that it originally had the function of relieving an itch. Another early-excavated example had an animal head at its end. According to an early Chinese archaeologist, Chao Xi ku of the thirteenth century C.E., the *ruyi* was made of iron and was utilized for pointing or self-defense. Still other scholars conjecture that it may have evolved from a symbol of phallic worship, later becoming a symbol of authority. Early pictorial documentation of the *ruyi* being a symbol of authority is found in numerous sources—carved Northern Wei tomb murals, Buddhist paintings, marble sculpture of the Tang dynasty from the Dunhuang Caves, and the well-known handscroll figure painting of the Thirteen Emperors by Yan Lipen (c.600–673 C.E.).

In documented Buddhist paintings and carvings, deities are seen with lotus blossoms and swords of varied shapes, and the *ruyi* bears a resemblance to a lotus stalk and flower. The Daoists laid claim to the belief that the *ruyi* evolved from the *lingzhi* fungus, the Daoist symbol of immortality. While the early Tang *ruyi* scepters have small oval knobs at the head, art historians are uncertain during which period the *lingzhi* cloud form evolved from the small knob head; however, the symbol of authority for the scepter remained intact.

The Chinese word *ru* means "accordingly," "similarly," or "something orderly without obstacles"; the word *yi* means "wishes" or "ideas." Together the word *ruyi* means "good, smooth prospects" and "wishes without obstacles." Phrases such as "May fortune and happiness fill your house" or "May you live as old as pine and cypress" are often inscribed or inlaid symbolically on the end of the *ruyi*, illustrating the belief that the *ruyi* was capable of granting mystical power. *Ruyi* literally means "as you wish," which may come from the story of a Daoist priest who promised that if he raised his scepter, one would be receive one's wish.[68]

It was during the Qing dynasty that *ruyi* scepters became favored gift objects in the royal court, and it is said that during feast days, the palace was inundated with

them. This was particularly true during the reign of Emperor Qianlong. Large numbers of *ruyi* were made and imperial workshops were established to keep up with the demand.[69]

In the scholar's studio, *ruyi* scepters were frequently placed in vases, resulting in the rebus *ping an ruyi,* which conveys good wishes and a hope for peace. *Ping,* the vase, signifies peace; *an* means "peace" and "tranquility"; and the *ruyi* means "may you have." Pictorially, this rebus is frequently seen in paintings, particularly those of the Qing dynasty.

Ruyi were designed with many symbols to convey different wishes. A depiction of a *ruyi* scepter with the *lingzhi* fungus expressed that one might have their wish for immortality. *Lingzhi* is the immortality fungus, and *ruyi* means "may you have." A *ruyi* decorated with persimmons *(shi), shi shi ruyi,* conveyed a wish that all matters *(shi)* should go according to one's wishes.

It should be noted that although the complete *ruyi* was utilized as a design motif, the head of the *ruyi* was perhaps even more extensively used. This was particularly popular during the Ming and Qing dynasties as a border design on porcelains and carvings.

On Chinese rugs, the *ruyi* is extremely stylized and most frequently seen as a short cloud with a tail.

Sacred Lily of China

The sacred lily of China, *wan nian qing,* literally translates to "ten thousand years green." A plant not commonly known in the West, the sacred lily is an evergreen with leaves not unlike those of the narcissus. Hence, its leaves in paintings frequently lead Westerners to identify the sacred lily as a narcissus, but its flowering stalk covered with red berries is unmistakable. Its name makes it a favorite for New Year's and holiday depictions. It is also frequently given as a gift on holidays or at the opening of new businesses, as it expresses a good wish for ten thousand years. It should be noted that the philodendron plant, common in the West in many species, in China carries the same name *wan nian qing.* As the sacred lily has become less common, the philodendron has taken on the symbolism previously held by the sacred lily.

When the sacred lily is depicted along with the *lingzhi* fungus, it expresses a hope that your wish will be granted for ten thousand years. The lily is also called *bai he, bai* meaning "hundred" and *he* meaning harmony. The *lingzhi* fungus symbolizes immortality.

Sage Emperors

In Chinese history, the time period from 2852 to 2205 B.C.E. was also known as the period of the Sage Emperors. It is written in legends that mythical emperors ruled for approximately two hundred years and are credited with many feats, including the founding of agriculture and medicine and the development of silk and construction.

The first legendary emperor of this period was Yao, who also was known as Tang Yao and Fangrun. He named the kingdom Tang and its capital Pingyang. With a background that bordered on poverty, he lived in a small house and existed on simple foods. His clothes were made of animal skins and he was known for his humility. He blamed himself when people suffered, and he also believed in a democratic system. Yao had ten sons and in spite of his having offspring who could succeed him, he appointed Shun to be his successor and banished his eldest son to be a minor ruler. Yao tested Shun by placing him in a forest during a storm. Shun was able to find his way back in spite of wolves and tigers that lived and hunted in the forest.

Shun, the second legendary ruler, named his kingdom Yu. He had great affection for people in the south and died on a journey there when he was of considerable age. It is said that during his reign, there was a great flood of the Yellow River. A man by the name of Yu achieved greatness by solving the problem of the great floods by diverting the flow of the river. Yu became Shun's successor.

Yu was known as the controller of water and had great influence on his people although he was stern. He chose as his successor Bo-Yi, a man not of his lineage. But after Yu's death, his son Qi killed Bo-Yi and the passing of the throne to a member of the family was then established.

□ Woodblock depicting a sash. Ji Zhen Zhai Collection.

San Da Shi (Three Great Beings)

The three bodhisattvas known as San Da Shi, or Three Great Beings, are Manjusri, Pu Xian, and Guanyin. In Chinese Buddhist temples, they are particularly popular figures (*see* Manjusri; Pu Xian; Guanyin).

Sash

As robes were standard dress for scholars and merchants and had no pockets, sashes were used to hold the looped cords of small purses or containers. The sash, *dai,* also is a homonym for "to carry." Scholars or court officials were frequently depicted with sashes flowing in the wind walking with a son, giving a visual rebus of a wish for an official to "carry" his son to an official office or a son to "carry on" the honor of being an official for another generation.

Scholar

The scholar represented the paragon of social and cultural success. By decree in the Sui dynasty, only those scholars who could pass the Civil Service Examination would be eligible for positions in the court. These examinations required rote memorization of scores of classical writings and were highly rigid. Only the wealthy had the time and financial freedom to prepare for the exam. Hence, the scholar not only was viewed as a knowledgeable, learned person but also one who welcomed riches and fame. Many would rotate through provincial posts of greater or lesser importance, while others would become members of the vast Confucian bureaucracy at the capital. A lucky few might become powerful ministers at the imperial court, ultimately gaining the ear of the emperor. While this life seemed romantic because it entitled one to a life of status and rank, it also exposed one to the constant infighting for favor at the court.

If one failed to pass the examinations, his was seen as a life of failure. There are countless documented stories of those who committed suicide rather than face the shame of failure, both for the lack of knowledge as well as the poor reflection on their families. They were consumed with feelings of doom.

In the scholar's studio, the scholar studied the Confucian classics, wrote poetry, played music, practiced calligraphy, and painted. The image of the scholar is seen through many dynasties in paintings, porcelain, and scholar objects. The ideal scholar is always depicted as a honest and upright man, dedicated to knowledge and the pursuit of scholarship. One example is the the Daoist worthy Zhu Yin, who was so poor that he could not afford to buy candles for his nightly studies so he gathered glowworms and placed them in a bag that he hung on a post for night light.

The ideals of the scholar are further exemplified by the story of Sun Kang, the so-called Sage of Luo Yang. It is written that as a youth he was so poor that he had no candles to burn for his studies at night. But he was so committed to his studies that when the moon shown brightly, he piled the white snow against his window so that the moon reflected its light against the snow, providing him with enough light to read.

In the nineteenth century, with incursions of foreigners in China, forced trade, internal conflicts, and the decline of empire, so too was there a decline in the values and morals of the scholars. Cheating on the scholar examinations became prominent as well as the bribing of officials who administered the examination. Even the symbols of the court, such as attire, were no longer produced at court-supervised workshops and what was produced became garish and lost its original meaning.

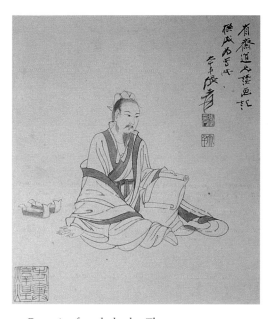

□ Portrait of a scholar by Zhang Daqian (1899–1983). Ji Zhen Zhai Collection.

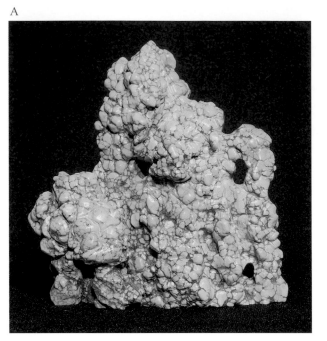

A

B

□ A Turquoise scholar rock.
 Qianlong period (1736–95).
 Ji Zhen Zhai Collection.

□ B Box in the form of three
 scrolls. Zitan wood with
 jade and boxwood,
 nineteenth century.
 Charles Tiee Collection.

Scholar Rocks

Scholar rocks, sometimes called *guai shi* (grotesque stones), are unique items in Chinese culture. Naturally eroded rocks were prized and documented as early as the Tang dynasty in poems and paintings. These rocks were collected from various areas and protected as natural treasures of the scholar. The requirements for a good-quality scholar rock were *xiu,* grace; *shou,* slimness; *ya,* refinement; and *tou,* penetration. A rock of quality should be graceful on all four sides, being slender and elegant in shape, having a good service with textures and wrinkles, and penetrating—having "eyes."

Scrolls

In Buddhism, the scrolls, sometimes depicted with a brush, represent the sacred text of the Buddha, or truth. This was a much more common depiction in China than in India and was a Chinese adaptation. As time passed, the Buddhist meaning was lost in part, and scrolls tied together were seen as one of the Eight Precious Things, symbolizing good fortune and learning. By the middle of the Qing dynasty, they were only a decorative motif.

To the scholar, scrolls symbolized calligraphy and painting, attributes of the scholar and knowledge. During the later Qing dynasty, scrolls became a frequent decorative motif, usually included in the Hundred Antiques (*see* Hundred Antiques).

Sea Horse

The sea horse is rarely depicted in Chinese art. For military officials, it was the symbol of the ninth level on Mandarin squares. Squares with this symbol are extremely rare (*see* Mandarin Square).

Seeds

Seed-filled fruits, vegetables, and flowers all have a common symbolism, that of a wish for many children and many progeny in the coming years.

The Chinese word for seeds, *zi,* has a sound similar to that of *zi,* meaning "fruit," "pit," "seed," and most important, "sons." During the Qing dynasty, it was not uncommon for the interiors of porcelains such as bowls to be painted with seeds of various forms, expressing a wish for children, particularly sons. Serving a guest tea in a tea bowl with a seed painted on its interior meant the host honored the guest by wishing him many sons in his future.

Seven Sages in the Bamboo Grove

A favorite subject of artists, the Seven Sages in the Bamboo Grove (Zhu Lin Qi Xian) represent a literati group circa 275 C.E. The seven sages were said to meet to relax and discuss music, the arts, and philosophical issues of the time. They symbolize the most positive qualities of the arts and knowledge. The seven sages were Ruan Ji, a scholar official who was a model of filial piety; Ruan Xian, the nephew of Ruan Ji, a philosopher whose emblem is a staff and fan; Xiang Xiu, whose emblem is a *chuan,* an unrolled scroll; Shan Tao, a statesman who carries a staff; Liu Ling, whose emblem is a book and who seeks pleasure; Wang Rong, a minister whose emblem is the plum; and Ji Kang, an official who carries a *pipa* instrument (*see* Pipa).

Seven Treasures of Buddhism

The Seven Treasures of Buddhism are precious metals and stones that it is thought that Buddha would surround himself with in paradise. There are several variations on what makes up this grouping: gold, silver, lapis lazuli, crystal, agate, pearl, and carnelian; gold, silver, lapis lazuli, crystal, red pearls, mother of pearl, and carnelian; and gold, silver, coral, gems, diamonds, pearls, and lapis lazuli. The Seven Treasures represent the seven spiritual treasures of Buddhism: perseverance and confidence in his teachings, moral shame, avoidance of doing evil, wisdom, generosity, education and mindfulness, and moral conduct.

A

B

Shaman

The shaman was a male or female medium who was said to have the ability to communicate with the gods and the netherworld. Han documentation lists the names of twenty-two shamans, *wu* identifying them as female and *xi* as male. Shamans who were on Kunlun Mountain are said to have performed ceremonies to keep the dead bodies from becoming corrupted by evil forces.

Sheep

Sheep, *yang,* is the eighth animal of the zodiac. Sheep symbolize filial piety since the young kneel when they nurse—they bow to the mother. The word for sheep has the same sound as *yang,* the male principle. Hence, sheep also symbolize *yang,* the strong male principle.

Three sheep, *san yang,* are often portrayed together, which represents the three months of spring when the male is dominant (*see* Ram).

Shoe

The shoe, *xie,* is a symbol of wealth since it has a similar shape to that of an ingot. The lotus *(lian)* shoes, which were worn by women with bound feet, symbolized a wish that a woman would bear many sons, one after another, *lian* (*see* Golden Lotus).

The visual rebus of a lotus shoe, *xie,* with a mirror of copper, *tong,* expressed the wish for a long marriage together *(tong xie).* The saying *"tong xie dao lao"* expresses a wish for one to have a long marriage until old age, *dao* meaning "arrive" and *lao* meaning "old."

The word for shoes also has a similar sound as the words for evil spirits. Therefore, shoes are frequently used as a symbol to drive away evil.

Shou

Shou in its many character forms is a symbol for longevity. It is linked both to Confucianism and Daoism. In Confucianism, it is the belief that wisdom comes with age. In Daoism, it is the eternal quest for immortality. In design, not only is the *shou* character seen in many forms but sometimes in a pattern called "one hundred *shou* characters," which expresses a wish for someone to live to one hundred years of age, a most auspicious wish. During the Jiajing period (1522–66), a rather unique pattern of the character *shou* emerged in the form of a bent, contorted tree, which is seldom seen in other periods.

Shou Lao

Shou Lao or Shou xing, known as the God of Longevity or Immortality is portrayed as a smiling, aged sage with a characteristic elongated, protruding forehead symbolizing cumulative wisdom and eternal health. This elongated forehead appears during the middle Ming dynasty, and can be seen in paintings, carvings, and textiles. He is a popular symbol for birthday celebrations and feasts, and is also one of the Daoist trinity gods of Fu, Lu, and Shou (happiness, affluence, and longevity) known collectively as the Star Gods.

Shou Lao is sometimes known as Nanjixianweng, the Old Immortal of the South Pole, referring to the constellation Little Bear (Little Dipper), which is said to provide direction, wisdom, and stability for people on earth.[70] He is also said to live in a palace at the South Pole and is a popular smiling god frequently portrayed with a crane, deer, and pine tree, or holding a walking staff with double peaches—all symbols of longevity and health.

Traditional Chinese culture is not youth oriented and believes that a person who lives to seventy or more years knows and has witnessed much of life and therefore deserves respect and wisdom. Shou Lao is the epitome of that belief. Even among the gods in the Daoist pantheon, this immortal holds such a unique position with high honor that even the Jade Emperor (*see* Jade Emperor) and the Queen Mother of the West (*see* Xi Wang Mu) enjoy his presence and advice. During the Tang dynasty, Emperor Xuanzong decreed that Shou Lao should be worshiped and established his altar at Chang an (Xian).

Various rebuses are formed with Shou Lao:

- Shou Lao and a crane expresses a wish for longevity since they both are symbols of longevity.
- Shou Lao depicted with a *ruyi* scepter expresses the rebus "May you be granted long life," the *ruyi* here meaning "may you be granted."
- Shou Lao with his companion, the deer with bat hovering above, creates the rebus *fu lu shou xi*, symbolizing "happiness, high office, longevity, and good fortune."

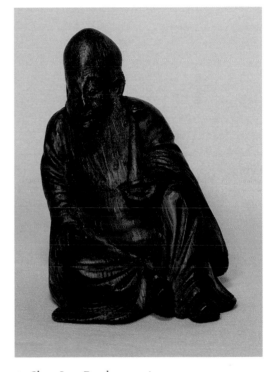

- Shou Lao. Bamboo carving. Seventeenth century. Ji Zhen Zhai Collection.

Shuangxi

Shuangxi is a character conveying a wish for double happiness. It is used as a motif symbolizing happiness and longevity, two wishes often proferred at celebrations.

Silkworm

By legend, silk is said to have been originated by Lady of Xiling, the consort of the Yellow Emperor, Huang Di, in 2698 B.C.E. Sericulture (silk cultivation) was practiced as early as the Neolithic times in China, and there is documentation of the discovery of a cocoon dating to 2600 to 2300 B.C.E. Shang-era woven silk has been recovered, and by the Zhou dynasty, we know that silk was readily produced.

Silk has played an important role in China's history and for its people, and therefore is the symbol of industry itself. It represents purity and virtue, and many folk stories are associated with it. Not only did the early Chinese develop the raw material, but also "loom design and weaving skills were also closely linked in early China. This means that one can hardly produce satisfactory results if one evaluates textile patterns solely according to criteria of style or fashion, for the weave patterns and their development were dictated by the technical possibilities of the looms."[71]

Qi Nu is known as the Heavenly Weaver and is associated with the weaving of silk. A famous folk story of the late Han dynasty tells of Dung Yung, one of the paragons of filial piety. After his father died, he was so poor he could not pay for the funeral. The only way he could obtain the money for the funeral, which he wanted out of respect for his father, was to borrow it from a moneylender who forced him to work as a menial servant. One day while returning home in a state of despondency, he came across a woman who asked him what was wrong. When he told her of his dilemma, she offered to marry him as she respected his integrity and did not look upon his being a servant as being lowly. After they married, she wove silk, and the silks were sufficient to pay off his loan. When the loans were repaid, she told him that she was, in fact, Qi Nu, the Heavenly Weaver and then she disappeared.

◻ Album painting of silkworms. Thirteenth/fourteenth century. Phil Wood Collection.

Silver

Silver, *yin*, during the Ming dynasty was formed into shoe-shaped ingots. Each ingot was a specific weight and held a specific value. Silver is a symbol of purity; the silver ingot is a symbol of power and riches.

During the nineteenth century, when trade with the West was at its height, silver utensils and objects in imitation of Western objects were made by Chinese artisans for export.

Sistrum

The sistrum, *xi chang,* is sometimes called an alarm staff or alarum staff and is a Buddhist attribute. At its apex, the staff has several rings that cause a tinkling or ringing when moved or shaken. The staff is carried by mendicant monks to warn off creatures that may be on the ground or in the path so they will not be trodden upon and killed in keeping with the Buddhist tenet of not taking the life of any creature or animal. As Buddhists monks also observe rules of silence, it is used to announce one's presence. Usually seen as an attribute of Jizo, the bodhisattva who guards the unborn, it was therefore thought to be Japanese in origin; however, discoveries by the eminent explorer Sir Aural Stein indicate that it originated in Central Asia. The sistrum is not usually seen in China and was rarely adapted into Chinese Buddhism.

Snake

The snake *(she)* is a symbol of fertility and flexibility, and represents the female gender. It is also said to represent the qualities of being cunning, evil, and having supernatural powers. In the Chinese zodiac, the snake is in the sixth position representing softness, flexibility, quietness, and strength in the yin female.

In early times, the snake was worshipped, and in Han tomb murals the Daoist Queen Mother of the West (*see* Xi Wang mu) was portrayed as being a half-woman and half-snake deity. The dragon in Chinese folklore is said to be a snake with wings that flew to heaven and became a dragon. However, in the later dynasties, the snake is not a popular design motif nor is it seen to be a symbolic figure.

In traditional Chinese medicine, the snake has been consumed for medicinal and fertility purposes for hundreds of years.

Snow

Snow symbolically refers to old age, prosperity, and good luck. Depicting snow as "silvery white" is a visual rebus for "real silver," a standard of currency in ancient China. The accumulation of silver symbolizes wealth.

Allusions to a cold snowy mountain in poetry and painting represent thoughts of eternity. With their association with age, eternity, and luck, snow scenes were a popular subject matter for painters in all eras.

Sphere

There are many meanings given to the sphere in China, and its representation may take many forms. Dragons facing one another are said to pursue the sphere, sometimes called the "pearl of wisdom," that may be shown with flames. Buddhist lions are shown in pairs, the female with a cub beneath one paw while the male lion rests his paw on a sphere. In this instance, it is said that milk goes into the sphere from the male lion's paw (*see* Lions). There are additional versions that state that the sphere is an "egg" from which the cub hatches. The sphere can also represent infinity. During the Republic period and in contemporary times, artisans who carved an ivory ball within a ball accomplished this representation symbolizing infinity. At the time of Dragon Lamp Festival, the fifteenth day of the first month, dragons were fashioned that played with a ball made of embroidered material. This symbolized the start of the New Year and the arrival of rain-bearing clouds of spring.

Spider

The spider, *zhi zhu,* is an auspicious insect and means symbolically that good things will come to one in the future. There are many folk stories that relate this symbolism.

During the Tang dynasty, a spider motif called *biqian* was drawn on the wall. Concubines in the palace were overjoyed when they spotted a spider as they believed that this predicted they would be blessed with a night with the emperor. They would cry out *"zhi zhu"* at the sight of a spider on a long strand of its silk, which was a rebus having a similar sound to *xi zi,* literally meaning "happiness son."

Stories of the Jing and Chu Times by Zong Lin of the Southern Dynasties tells that the seventh day of the seventh month of the lunar year is the day when the legendary Cowherd and the Weaving Maid meet on the Milky Way. On that night, women crochet with colorful silk threads. They pull threads through seven-holed comblike needles made of gold, silver, or copper. They also place fruits and melons in their yards as an offering, for they hope that the Weaving Maid will reward them with skill in their needlework. They are overjoyed if they find webs woven by spiders *(xi zi)* on the fruit because they believe that this is a good omen that foretells that the Weaving Maid will fulfill their wishes.

There is also a folk story called *"Xi mu,"* meaning "happiness mother," that tells of a mother and son who have been separated for a long period of time. One day the mother sees a spider hanging from a cloth. Given this sighting, she announces that her son will return. The son does, in fact, return shortly thereafter, as seeing the spider foretold.

A spider coming down attached to a web is called *xi* (happiness) *cong* (from) *tian* (heaven) *jiang* (down). This image predicts goodness in one's future.

Squirrel

The squirrel and the rat have the same character and word in Chinese, *shu.* In that both are usually depicted gathering fruits or other food objects, the squirrel or rat is regarded as a symbol of industry and prosperity (*see* Rat).

Depictions of a squirrel (or rat) with trailing vines is a visual rebus for a wish for one to have many sons with a continuation of the family line. This representation comes from the fact that squirrels and rats have large litters and the winding vines represent the family lineage. This is a favorite subject on folk embroidery.

A squirrel (or rat) eating grapes has the hidden meaning of a wish for one to be "promoted to the top of the imperial court." The squirrel symbolizes prosperity and the many grapes mean the accumulation of much status.

Star Gods

The three Star Gods are Fu (the God of Happiness), Lu (the God of Affluence), and Shou (the God of Longevity). These three Daoist gods had their inception during the Ming dynasty. In a drama of that period, they come to the mortal world at the festival for the New Year. Their duties were to increase happiness, length of life, and one's salary—popular wishes for all people, which accounts for the popularity of these three gods. "The Three Stars are not Taoist gods per se. There are, for example, no texts in the Ming Taoist Canon devoted to this triad. . . . The Three Stars appear instead to be gods of popular religion, quite possibly instituted at the imperial level in the early Ming."[72]

Stork

The stork is the companion of the Queen Mother of the West and therefore symbolizes longevity. When the stork pictured with the pine, it expresses a wish for a long life.

Stupa

The stupa is a reliquary that is known to predate Buddhism. However, it has become associated with Buddhism. The purpose of the reliquary was to hold, at least symbolically, a venerated relic of the historical Buddha. The stupa, an important attribute in Indian and Japanese Buddhism, never achieved such importance in China.

□ Painting of stork and oysters by Qi Baishi (1864–1957). Former Alice Boney Collection.

Su Dong po

Su Dong po, 1037–1101 C.E., was a celebrated statesman, poet, painter, and calligrapher. If that wasn't enough, it is also documented that he was a celebrated cook and connoisseur of wine. At the age of only twenty-two, he took the Civil Service Examination and impressed the official in charge, thus beginning his political career at the age of twenty-five. But the prime minister set several reforms with which Su Dong po disagreed. Rather than submitting to the demands of his superior, he rebelled and finally asked to be transferred to Hangzhou where he lived and wrote for a three-year period. His writings were found to be confrontational, and he was again transferred and ultimately imprisoned. After his release, he was placed in a remote position, but his writings described philosophic changes expressing the joys of life. With untold talent, he is said to have written thousands of poems as well as lyrics. He was innovative for his time since he wrote lyrics that were not tied to the structure of the music itself. He is seen as a principled poet who was unbending in his true beliefs.

Su Dong po's poetry is legendary to this day, and he is frequently depicted in painting as an elderly male on a mule with a wide-brimmed hat.

□ Scissors with repoussé swallow design.
Silver, Tang dynasty (618–907 C.E.).
Ji Zhen Zhai Collection.

Sun

The sun is one of the Twelve Symbols of the Emperor. On the sun disk is the legendary three-legged raven (which evolved into a three-legged chicken). The sun represents yang when paired with yin to form the universe over which the emperor rules. It is also a symbol of enlightenment.

Swallow

The swallow, *yan,* is a sign of spring. This tiny bird is said to symbolize success in one's future, happiness, and the coming of children.

The swallow receives some of its positive imagery from its habit of constructing its nest of mud to fill in areas of defects—cracks and deteriorated areas, openings in graves that have been desecrated, and holes in walls of homes. Filling areas with mud represents bringing newness to the old. It also represents the ideal relationship between an older and younger brother.

Sword

The sword symbolizes victory over evil as well as power and magic. The sword is the emblem of the Daoist Immortal Lu Dong bin, who is usually depicted with the sword slung over his back, was an immortal who traveled far and wide subduing evil.

A famous folk story tells that the best of the sword makers was Gan Jiang and his wife, Mo Yeh, of the State of Wu in the third century B.C.E. They made swords with magical powers from the liver and kidneys of a metal-eating hare of

□ Woodblock depicting a sword. Ji Zhen Zhai Collection.

the Kunlun Mountains. The tale unfolds that Gan Jiang and Mo Yeh were to forge a sword for the emperor, but the metals would not fuse. Gan Jiang recounted to his wife a tale that two other sword makers had the same problem, who threw themselves into the furnace, and afterward the metals were successfully fused. Mo Yeh subsequently cut her hair and threw herself into the furnace, which resulted in successful fusing of the metals. There are scholars who believe that this tale indicates that during that period of time, metallurgy was a difficult process where smelting often resulted in failure, that this profession had its own rituals, and that the making of swords was a profession of danger.

Swords were also said to have mystical powers. This is shown in the folktale of Yun Chung Zi, court astrologer to the emperor of the Shang dynasty. It is written that Yun Chung Zi looked into a mirror one day and saw a fox with nine tails roaming the palace. He felt this was an ominous sign and consulted with a sorcerer in the mountains. He then made a magical wooden sword that he advised the emperor to carry for protection, as it would drive away evil. The emperor wore this talisman, but one day his favorite concubine said that she disliked the sword as it made her ill and he broke it into several pieces. Soon after, as Yun Chung Zi had predicted, the empire fell.

□ Woodblock of taiji design.
Ji Zhen Zhai Collection.

Taiji Diagram

The *taiji (taiji tu)* diagram—*taiji* means supreme ultimate—symbolizes the forces of yin and yang within the Dao. It first appeared in a Daoist context during the Song dynasty.[73]

Talisman

Talismans or amulets are objects customarily worn or carried by a person for protection from evil or to enhance the powers of the wearer. In Chinese, these objects were known as *hufu,* and the earliest and most famous talismans were made of jade, the most highly revered stone in Chinese culture. Its attractiveness was no doubt related to its extreme strength and, when polished, its beautiful colors. *Yu,* the character for jade, is a pictogram of a talisman of three pieces of jade tied together.

The earliest artisans carved jade objects as talismans in various shapes that included: (a) a ring, huan; (b) a pendant that was half-ring shaped, huang; and (c) disks, bi. Cicada-shaped pieces of jade called han were also made for placement in the mouth of the deceased as talismans that would bring them everlasting life.

Some common talismans or amulets are as follows:

□ **Tiger claw** *(hu chao):* An actual tiger claw is made into a pendant and worn about the neck. It is said to protect the wearer against evil spirits and bring to the wearer the courage of the tiger. Often quite beautiful and embellished with a gold mounting, tiger claw amulets today are frowned upon by some as tigers are becoming an endangered species.

□ **Silver locks** *(jhing chuan suo):* An actual lock made of silver, frequently with symbols for long life and happiness on its sides, which is worn about a child's neck on a chain. This amulet means literally locking the child to his life—conveying to the evil spirits that the child is not to be taken away.

□ **Mirror** *(jing):* Small mirrors worn about the neck are said to drive away evil spirits who see and are frightened by their own reflections.

□ **Jade** *(yu):* Pieces of jade are carried by travelers as they are said to provide a safe journey.

□ **Drawings of cats:** For those who raise silkworms, drawings of cats are made on paper, which is then placed on walls to protect the worms.

□ **Sayings or drawing of idols:** These sayings or drawings are written or drawn on yellow paper. Then placed on doors or walls, they are said to protect one from evil spirits.

Talismans are dynamic and not limited to objects that are inanimate in nature. In the Qing dynasty, it was quite common for humans to become talismans. For instance, the Daoist figure Liu Hai, who is frequently depicted with a string of coins, has become the talisman for gamblers.

Tangerine

The tangerine, *ju*, symbolizes prosperity. The word for favorable, implying luck, *ji*, is phonetically close to the word for tangerine. Therefore, depictions or gifts of tangerines form a visual pun, expressing the wish for luck.

Placing cypress twigs topped by dried persimmons into two tangerines is an auspicious visual rebus. This rebus emanates from the fact that the word for persimmon, *shi*, is a homophone for thing, and the word for tangerine is a homophone for the word for auspicious, thereby giving the meaning that "all is well" or "all is auspicious."

Tao Tie Mask

During the Shang dynasty, quite simple, blocklike animal sculptures appeared in stone and marble. The awesome power of real animals and mythical animal spirits took full shape in the surface decoration of the Shang dynasty ritual bronzes. The dominant motif was the composite creature with a terrifying masklike face called the *tao tie*. As early as the third century C.E., the *Lu Shih Ch'un Ch'iu* authored by Lu Pu-wei described these animal motifs on bronzes: "On the huge tripods of the Chou [Zhou] dynasty, *tao tie* were carved and decorated. The *tao tie* is an animal with a head, but no body. . . ." These animal masks had already appeared in the earlier Shang dynasty and at least sixteen different types of them existed during the Shang and Zhou dynasties.

The primary mask includes two bulging circular eyes, a wide open mouth, two heavy accentuated eyebrows that are filled in with a *lei* design pattern (representing thunder), and an animal-like nose. Some scholars have described the mask as a zoomorphic face looking forward with a central nose ridge profiled by two one-legged beasts called *kuei*, dragons that confront one another. These masks have been identified as being of several types based on animals such as the ram, tiger, reptiles, and dragon.

Tao tie has the meaning of "glutton." These masks were said to be warnings against avarice and gluttony.

Tao Yuan Ming

The celebrated statesman and scholar poet of the Jin dynasty, Tao Yuan Ming (372–427 C.E.), was the great-grandson of a famous statesman. He symbolized the principled scholar poet who rejected the life of politics and court life, having served only eighty days before sending back his seals and symbols of office. He is usually depicted as a simple scholar dressed in plain robes and straw hat.

Thistle

The thistle, as it does not lose its shape or form, is a symbol for longevity and steadfastness. It is sometimes overlooked in early paintings as it seemingly blends into the landscape. However, it is seen as an important image obviously utilized by artists for its symbolism.

Thorns

Thorns are infrequently depicted in Chinese paintings, but their symbolism has been consistent through the various dynasties—that of internal or external disturbance. As Freda Murck writes, "Since Antiquity, thorns have been an image for chaotic times and the troublesome men who participated in the chaos."[74]

Three Friends of Winter

The pine, prunus, and bamboo, *sui han san you,* are the three plants that survive the winter and remain green, representing the qualities of bravery, integrity, and rebirth year after year. It is a treasured motif in Chinese art.

The "three friends" are also said to represent the qualities of a gentleman as well as the three religions of China—Confucianism, Daoism, and Buddhism. It is written that a Chinese gentleman was said to be Confucian in his career, Daoist when he returned, and Buddhist when death was imminent.

Three Luck Fruits (Three Abundances, Three Plentys)

San duo are the three fruits: citron, representing happiness; pomegranate, representing fertility and abundance (sometimes represented by the lichee); and peach, representing long life. No three fruits are more representative of Chinese culture and life.

◻ Lacquer plate with design of Three Friends of Winter. Sixteenth century. Ji Zhen Zhai Collection.

These three fruits are seen as a decorative motif in Mandarin robes in the Qianlong period. They are also a frequent decoration in porcelains of the Qing dynasty, particularly the Kangxi and Qianlong reigns.

Three Most Desirable Objects

The three most desirable objects are sons, money, and a long life. These three most desirables, also called *san duo,* the same name for the three fruits, are represented by an old man with a stork, a child, and an official. This depiction is frequently seen for advertising medicines. When the combination is depicted in paintings, the three objects are much more subtle and take symbolic forms; rather than depicting money, you'd see figures of children and elders.

Three Purities

The Three Purities are *Yuanshi taizun,* the Celestial Worthy of Primordial Beings; *Daode tianzun,* the deified Laozi (Lao-tzu); and *Lingbao tianzun,* the Celestial Worthy of Numinous Treasure. Each is a deity of his or her own heaven called *Santian.*

Thunderbolt

In ancient China, the Chinese believed that the sound of thunder represented the sound of the sky demon or the sound of the vehicle taking the souls of the dead across the sky.

With the entrance of Buddhism into China, the thunderbolt took on other significance in the form of the attribute *vajra,* also sometimes known as a thunderbolt. This weapon puts the enemies of the Buddha to death and also is the emblem of his doctrine that shatters all evil and false beliefs (*see* Vajra).

Tiger

The Qiang and Rong peoples, as well as other minorities, have had the tiger as their clan totem since the earliest times. Hence, the tiger has been present as a symbol since early Chinese history. It has been a representation of yin since the Zhou dynasty and has been paired with the dragon that represents yang. Yin and yang are the two cosmic forces that direct the movement of *qi,* the energy of all things. In relationship to Daoism, in addition to symbolizing yin and yang, the

tiger and dragon came to symbolize the west and east and the elements of fire and metal.

In Chinese lore, the king of the wild beasts is said to be seven feet in length and to live one thousand years and to turn white at five hundred years. The white tiger presides over the western quadrant of the heavens. The tiger is documented as being the king of the wild beasts and the king of the forest. It protects against evil and is fierce enough to frighten off malicious spirits.

Because of its strength and savage attributes, the tiger symbolizes the military. As a symbol of strength, it was a part of the military regalia and a sign of the third level military official in the early Qing dynasty and fourth-level military official in the later Qing dynasty. In association with the military, the tiger was also used as a symbol of identification in the conveying of messages. A tiger image composed of metal was split into two pieces and a piece of each was held by the two military officials who would be communicating. When a message was sent, one half of the tiger image accompanied the message and when the two-paired images fit with one another, the message was known to be true.

The tiger figures in the well-known folktale of Yang Xiang, who was one of the Twenty-Four Paragons of Filial Piety. Yang Xiang was with his father tilling a field of millet when a tiger confronted them. While the tiger was crouching and about to attack his father, rather than fleeing, Yang Xiang threw himself in front of his father to protect him. Yang Xiang lost his life, but his father was saved.

It has been a practice at New Year's to paint pictures of tigers and then post them on doors and door posts, as well to have children wear tiger hats, often with a *wang* (king) character indicating that the tiger is king. This practice is said to drive away evil spirits and is done to honor Shen Yu and Yu Lui. These brothers, who lived during the reign of Emperor Huang Di, were said to have the magical ability to capture evil spirits, bind them with reeds, and feed them to tigers.

The writings of the Kangxi period reveal beliefs regarding spirits. It is written that if a tiger kills a man, the man's soul and spirit is the slave to the tiger since the soul will lack the strength and courage to go to another. Yet if the soul can find a substitute, the soul may return to the world.

In Chinese art, a sage is sometimes depicted leaning against a tiger. Sometimes the sage is seen napping. This depiction is not simply an unusual portrayal but rather is the Chinese sage Cheng-zi Yuan.

The tiger is also an important ingredient in Chinese medicine and the tiger claw, *hu zhao,* is a charm to frighten evil spirits and convey courage.

Toad

The toad is a symbol of longevity and the unattainable. It has been depicted in China since the earliest times. During the Han dynasty, it was thought that the toad resided on the moon; this representation can be seen on some Han mirrors. The fact that the earliest Chinese believed that the toad fell from the sky with the dew and was therefore called a "sky rooster" may explain the Han representation. On the moon disk of the twelve-symbol imperial robes during the Qing dynasty, the toad was replaced by the rabbit grinding the herbs of immortality (*see* Twelve Symbols of the Emperor).

Folk stories about the toad take many forms. The three-legged toad is said to reside on the moon and evolves from a folk story involving the wife of the chieftain Hou yi, Chang E, who stole the elixir of immortality. In one version of the theft, she fled to the moon but there the gods punished her by turning her into a toad. But the three-legged toad is most notably associated with the Daoist figure Liu Hai, a minister of state during the tenth century. Folklore relates that Liu Hai possessed a three-legged toad that could take him anyplace that he wanted. Whenever the toad went down a well, a long cord holding a string of coins that Liu Hai carried retrieved him. Thus this figure becomes a symbol for making money and is much coveted by gamblers. The three-legged toad is utilized as a design element in a variety of media, particularly in folk art. However, it is rarely seen as a design element in rugs.

It is not uncommon for figures of the toad or frog to be depicted with pomegranates. This combination forms the rebus *ding cai liang wang,* which means having both an abundance of children and of wealth. Liu Hai's toad symbolizes wealth *(cai)* while the pomegranate symbolizes many sons *(ding).*

Toggle of Jade

A toggle is a small object, usually a piece of jade, that is held on a loop or strap. Carrying a small jade toggle was a popular custom, having its roots in the myth of the mystical power of jade amulets to protect travelers. From this comes the Chinese expression *zheng-yi-yu,* which means to tie a piece of jade with a string to a person as a symbol for good wishes and safety.

Toon Tree

The toon tree is a member of the Cedrela family, of which there are two species common to China, *Cedrela odorata* and *Cedrela sinensis.* It is a dense wood similar to mahogany and is used in furniture making as well as in Chinese herbal medicine

B

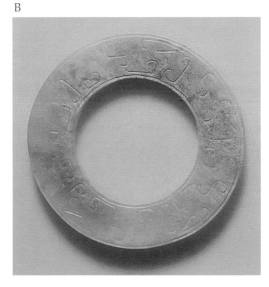

□ A Water pot in the shape of a toad. Celadon ware, Song dynasty (960–1279 C.E.). Ji Zhen Zhai Collection.

□ B Jade toggle, or bi. Warring States period (475–221 B.C.E.). Courtesy of Roger Keverne.

for various treatments including dysentery. Its leaves are also a source of food for silkworms.

Because this tree has a lengthy life span, it is a symbol for the father who lives a long life and provides stability for his family. This symbolism has its origins in the writings of the philosopher Zhuangzi.

Tortoise

The tortoise is one of the four great mythical animals, the others being the qilin, dragon, and phoenix. It symbolizes strength, endurance, and longevity.

Noting its shape, the tortoise symbolizes the universe—its upper shell being the heavens, the lower shell representing the earth, the yin and yang. In the earliest times, tortoise shells were utilized in divination. Folk legends indicate that the tortoise is also a guardian of graves and shrines, and represents the north. In the early dynasties, particularly the Han, turtles or tortoises were a favorite decorative motif for stamping seals. While the tortoise is seen in almost every medium, it is rarely seen on rugs.

There are also negative connotations regarding the tortoise. It is said that all turtles were female and that in order to reproduce they had to mate with snakes. Therefore they had no sense of shame. In contemporary China, the turtle connotes a cuckold. The wearing of a green hat has a similar connotation, as it is said that one looks like a turtle.

Trumpet Vine

Symbolically, the trumpet vine derives its attributes from its name, which means pure and chaste. However, for reasons unknown, it is rarely used as a decorative motif.

Twelve Symbols of the Emperor

Twelve symbols were prescribed for the emperor's robes during the Qianlong period in 1759. However, these twelve symbols of imperial authority appeared on the sacrificial robes of the emperor as early as the Western Zhou dynasty. The symbols were as follows:

1. Sun, *ri,* a disk with a three-legged bird.
2. Moon, *yue,* a disk representing the moon with the hare pounding the herbs of immortality under the cassia tree.
3. Constellation, *xing chen.*

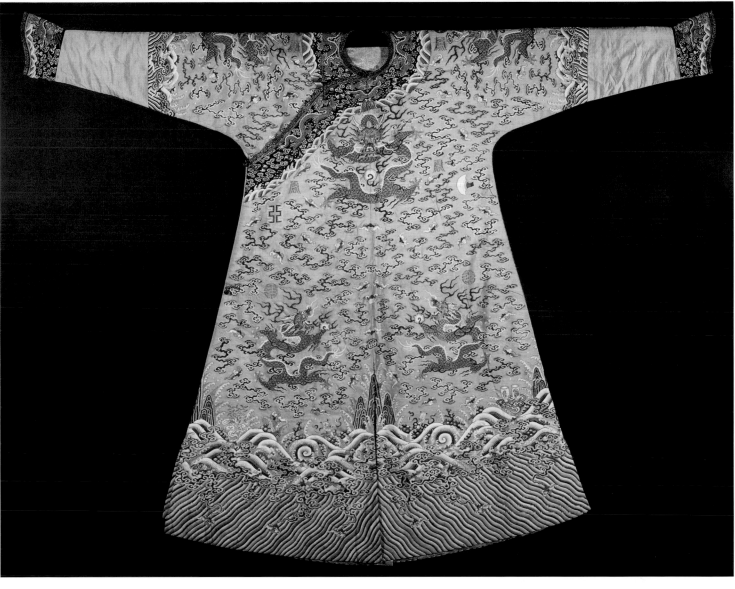

□ Imperial twelve-symbol robe.
Eighteenth century.
Linda Wrigglesworth, Ltd.

4. Mountain, *shan*.

5. Dragon, *long*.

6. Pheasant, *ye ji*.

7. Paired *fu* symbols or symbol of discrimination (represents dualistic forces of good and evil, *hua chong*.

8. Axe, *fu* (different tone than number 7), sacrificial weapon.

9. Paired cups (sacrificial cups), *zong yi*.

10. Water weed, *zao*.

11. Fire symbol, *huo*.

12. Grain or millet, *fen mi*.

A

B

□ A Woodblock depicting an
umbrella.
Ji Zhen Zhai Collection.

□ B Lohan with usnisa.
Glazed pottery,
Ming dynasty (1368–1644).
Courtesy of Roger Keverne.

Each of the symbols appeared on a specified area of the robe and had a specific meaning: the sun, moon, and stars represented enlightenment; the mountain, protection; the dragon, adaptability; the pheasant, literary refinement; fu, discrimination between right and wrong; the axe, power to execute; the sacrificial cups, filial piety; the water weed, purity; fire, brilliance; and the grain, ability to feed.

In wearing the twelve symbols, the emperor symbolized the universe. Twelve-symbol robes for the emperor were not only on a background of imperial yellow but also of other colors in accordance with the whim of the emperor.

Twelve Terrestrial Branches

In early Chinese history, an instrument for measuring the days and years was established based on a combination of two cycles, the Ten Celestial Stems and the Twelve Terrestrial Branches. Each of the stems and branches was given a name and is associated with a direction or animal. Combining the name of a stem with one of the branches produced a cycle of sixty years. Each of the years corresponds with an animal, making twelve animals in a cycle. These animals are the animals of the zodiac.

Twins

Twins of the opposite sex were seen as harbingers of ill in ancient China, and it was not uncommon for one of the twins to be put to death. When both of the children were sons, twins were looked upon with great piety. The twins sometimes refer to He He (*see* He He).

Umbrella

One of the Eight Buddhist Symbols, the umbrella symbolizes the spiritual authority of Buddha and also represents one of the Eight Precious Organs of Buddha, his sacred spleen.

Since officials were shaded by an umbrella and protected from the elements, the umbrella came to symbolize the warding off of evil spirits and also was a sign of authority and stature. It is associated with Buddhism and is not utilized independent of the Buddhist religion.

Usnisa

Usnisa is a slight protuberance on the head of the Buddha or a lohan. It symbolizes the attainment of wisdom and knowledge.

Vajra

The *vajra* is the thunderbolt emblem of Buddha's doctrine. It symbolizes the striking down of any who oppose the word of Buddha. It is a symbol of the god in Lamaism (*see* Lamaism).

Vase

The vase with cover is one of the Eight Buddhist Symbols and one of the symbols that is found on the footprint of the Buddha (*see* Buddha's Footprint). It is a reliquary or sacred urn, symbolizing everlasting harmony and supreme intelligence's triumph over birth and death. Symbolically, it represents the stomach of the Buddha, his knowledge and truth.

The symbolism of the vase is related to the sound of the word for vase, *ping,* which is the same as the word for peace, *ping.* This homonym gives rise to many rebuses.

A vase with flowers representing each of the seasons expresses a wish for peace the year round, *si ji ping an, si* meaning "four," *ji* meaning "season," and the vase, *ping an,* meaning peace. Three halberds in a vase, *ping sheng san ji,* expresses a wish to rise peacefully three levels in civil service, *sheng* meaning "on" and san *ji* being "three halberds." A vase with the Five Nourishing Fruits wishes fertility and peace.

□ A Vase with ruyi. Detail of kesi tapestry. Nineteenth century. Phil Wood collection.

□ B Detail of enamel design on porcelain saucer depicting a sacred vase. Xianfeng mark and period (1851–1861). Ji Zhen Zhai Collection.

□ C Ruyi scepter in the shape of a lotus. Ivory. Eighteenth century. Charles Tiee Collection.

A

B

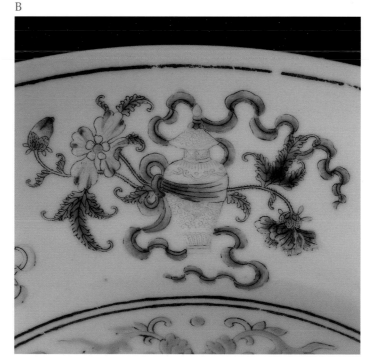

C

Vines with Gourds and Foliage

Vines symbolize ceaseless generations—stretching and never ending—with the attached fruit representing progeny. Vines are most frequently seen in combination with the squirrel, rat, gourds, or grapes.

Visra Vajra (Crossed Thunderbolt)

The *vajra* is a symbol found in several religions. Its origins are not clear, but many scholars feel that it is related to the lightning bolt of Jupiter. In Buddhism, it symbolizes the power of the law, the weapon by which enemies of Buddhism are put to death (*see* Vajra). The *visra vajra* are crossed *vajra* ("thunderbolts"). They are placed at the four corners of the Buddhist altar and symbolize the three mysteries—act, word, and thought—that are understood in the four directions.

Wan

□ Embroidery of bat holding *wan* symbol on a *wan* background. Qianlong period (1735–96). Ji Zhen Zhai Collection

Lei wan is the Chinese name for swastika. The *wan* character appears repeatedly in Chinese objects from the earliest times to the present; however, the meaning accorded to this pattern is varied. According to the *Kangxi Zi Dian,* the original root of the word *wan* comes from *wan gai,* referring to tens of thousands of bees; the word *wan* in Chinese numerology means ten thousand. Thomas Wilson, author of *The Swastika,* published in 1884, quotes the following information given to him by Yang Yu, a contemporary Chinese minister: "Empress Wu (c.624–705 C.E) of the Tang Dynasty invented the *wan zi* within a circle word form to represent the sun. The Buddhist monk, Dao shu (?–825 C.E) described . . . that the original Buddha had a *wan* mark on his chest. . . . Emperor Dai Zhong (763–779 C.E) forbidden [sic] to use the *wan zi* on fabrics. But, Feng zhi (c. eighth century C.E) recorded that the Luo yang people used it on the 7th Day of the 7th Moon each year to wear on their webs [probably referring to hand-knitted mystic knotted nets for the Double Seven Maiden's Festival]. . . . Kong Wenzhong (1038–1088 C.E.) recorded that the Luo yang people considered spiders weaving it (*wan zi* patterns) on fruits and melons to be good luck."[75]

In later Western writing, the *wan* symbol was considered to be a square within a square and a Buddhist emblem commonly used to mean endless returning, referring to infinite reincarnations. The word *wan* was thought to have come from the written word and symbol that resembles the Chinese word *hui,* meaning "returning," which graphically resembled a reverse swastika. On the other hand, other scholars believed that the *wan zi* symbol came from Hindi-Buddhist roots, in the

form of extended crossing double arms symbolizing fire called Sauvastika (*swastika* in Sanskrit). Believed to be an auspicious sign representing the toe prints of Buddha, the wan is generally regarded as an insignia for the "seal of Buddha's heart" to be placed on the chest of Buddha figures acknowledging the divinity and the sacred mind of Buddha. Still other scholars thought the word *wan* referred to the Daoist God of Brain. These scholars considered the two words *wan hui* to be the twin Daoist youth gods He He, Harmony and Compliance.

In spite of contrasting views on its origin, the *wan* symbol is historically tied to Buddhism, and in Chinese folklore it symbolized good luck and eternal abundance. As the symbol for ten thousand or infinity, the *wan* has origins that are not clear. While some feel that it is a variation of the simple diaper pattern (a repeated geometric pattern used in borders), it has also been said to be a symbol of the four points of the compass. Still others feel that it is a Buddhist importation. What remains since that period is its symbolism for ten thousand or infinity.

When the *wan* symbol appears in color, it has additional meaning:

- Yellow *wan* character symbolizes infinite prosperity.
- Green *wan* character symbolizes infinite virtues of agriculture.
- Blue *wan* character symbolizes infinite celestial virtues.
- Red *wan* character symbolizes infinite sacred virtues of the Heart of Buddha.

The *wan* has been used as a design motif in every imaginable medium. It appears on porcelains, woodcarvings, the chest of Buddha images, textiles, and paintings. It always carries the same meaning and forms many rebuses, such as that found on a Qing robe in the Minneapolis Museum, where one finds a pair of catfish on a background of the *wan* pattern with bats forming the rebus *nian nian wan fu,* "May year by year have ten thousand happinesses."[76]

On Chinese rugs, the *wan* pattern is most frequently seen as a scrolling border pattern.

Water Buffalo (Ox)

The water buffalo is a symbol of the coming of spring with abundance, as well as of fertility for the coming year. These symbols arise from the way that the water buffalo is utilized in China. As China has always been an agrarian society whose farmers do not rely on mechanical devices for plowing but rather on the water

- Rhyton cup in the shape of a water buffalo head. Soapstone, eighteenth century. Ji Zhen Zhai Collection.

buffalo to pull the plows, the water buffalo has always been seen as a positive image. Relying on the animal for cultivation, the water buffalo is not a food source. Additionally, Buddhism forbids the eating of meat.

A water buffalo with children on playing on its back is frequently portrayed in Chinese art. It symbolizes harvest and fertility.

Water Ewer (Ritual)

Water ewers used in Buddhist ceremonies symbolize the ritual of washing away the defilements blocking one's way to enlightenment. These ritual ewers took special shapes. One type, the so-called Monk Head ewer, takes its name from its resemblance to the winter hats that were once worn by Buddhist monks. The other type is the Sino-Tibetan ewer, whose top represents the Buddhist canopy, with the spout resembling the trumpeting snout of a *makara,* a crocodile-like animal that became popular in Chinese art during the Tang dynasty.

Watermelon

The watermelon, *xi gua,* was seen as a symbolic object in the late Qing dynasty. This gourdlike fruit is filled with seeds, symbolizing fertility. The seeds sometimes symbolize children.

Water Weed

One of the Twelve Symbols of the Emperor, the water weed is a symbol of purity (*see* Twelve Symbols of the Emperor).

Wax Plum

The wax plum is said to resemble prunus.[77] Curator Therese Tse Bartholomew states, "In an album of paintings illustrating the flowers of the twelve months, Yun Ming (c.1670–1710) used the last leaf to show the wax plum in combination with nandina (heavenly bamboo and podocarpus [luohan pine]) to form a pun on the famous theme of the 'three friends' pine, bamboo and prunus."[78] As the pine, prunus, and bamboo signify strength and eternity when they survive the winter, so does the nandina symbolize eternity.

Wenchang, God of Literature

Wenchang, the God of Literature, was a popular god during the Qing dynasty. He was worshiped as early as the fifth century but then as a snake god. Sometimes he can be recognized as a figure accompanied by a snake. During the Song dynasty, "the god revealed himself in anthropomorphic form as a Taoist god, the Divine Lord of Zitong. From the Song Dynasty onward, Wenchang was widely worshipped by the literati, particularly by candidates in the civil service examinations; he was also venerated for his powers of healing and exorcism."[79] In later Qing sculptural figures, he is frequently depicted as a seated figure with formal robes and hat, sometimes holding a scroll and brush. Because Kuixing is also sometimes called the God of Literature, the two figures can be confused. However, Kuixing's contorted face and posture are usually unmistakable.

Wheel of the Law

The Wheel of the Law is one of the Eight Buddhist Symbols and represents the Buddhist doctrine. A symbol of good fortune, it further represents karma, the ever-turning wheel of transmigration, the cycle of birth and death.

Willow

The willow tree, *liu*, is multidimensional and highly symbolic to the Chinese. The word meaning to part, *li*, is similar to the sound for the word for willow. Therefore, when the willow is depicted, it usually suggests sorrow and separation. But it is also a sign of spring and represents of female beauty as women were likened to the willow. A beautiful woman was said to have the waist of a willow branch and her eyebrows were as its leaves. Willow sprigs were worn in women's hair in the spring to ward off illness and protect their eyes.

For Buddhists, the willow tree is a symbol for humbleness and is believed to have the powers to expel demons and ill will. To ward off evil, the corkscrew branches are bound together into a whisk and used to sweep graves during the Qing Ming Festival in a show of filial piety. In another sign of warding off evil, willow branches were a common gift to civil officials who were sent to distant areas, expressing a wish for protection as they traveled.

With such diverse symbolism, the willow is much portrayed in Chinese art in all media. The willow also has long been utilized in traditional Chinese medicine for disorders of the bowel.

Willow Pattern on Blue-and-White Porcelain

No pattern on porcelain has endured as well as the so-called blue-and-white willow pattern. The stories of the origins of this pattern are unclear. Some speculate that the story itself originated in part in China during the eighteenth century and was altered as it was told and retold in the Western world by travelers. Others feel that it is an English tale. In applying the term willow pattern in a general way, it is clear that copies of blue-and-white porcelain were initially imported from China into England during the last quarter of the eighteenth century. As the quality of English pottery increased, so did the trade with China ebb. It is known that Thomas Minton first developed the willow pattern in 1792 in England. His famous Minton ware, a cream-colored, blue-printed, earthenware bone china, popularized the willow pattern. There is no documentation as to how he came to develop the pattern, but the standard pattern included a bridge, a mini pagoda, three figures, two birds, a boat on the water that surrounded the pagoda, and land from which grew a willow tree.

From the time that the pattern first appeared, there were various changes made to it, with deletions of some of the items, additions of others, and changes in the border. The early versions that were done in China were hand painted, while those that were done in England were usually done in a transfer-print method. For more than a century and a half, this pattern has been carried by every British pottery manufacturer though its popularity has come and gone many times. Many companies including Royal Worcester, Wedgwood, Davenport, and Swansea, to name but a few, have incorporated the pattern.

The basic story on which the willow pattern is based tells of a wealthy Mandarin who had a position of great power and influence since he had an imperial appointment. It was through this appointment that he gained his riches by taking bribes from merchants. Although he lived in a house of uncommon beauty that showed his riches, had many servants, a recently hired trusted secretary named Chang who kept track of his books, and a daughter, Koong-se, whose beauty was envied by all, his life was not one of joy since his wife had suddenly died. He felt alone and vulnerable to those who began to talk of his greed. Fearing the future, he suddenly retired and dismissed Chang. But Chang and his daughter had secretly fallen in love. Koong-se had lingered in the moonlight on the path outside the banquet room, and this became the meeting place for the star-crossed lovers. The father had become suspicious of Koong-se's behavior and then word came to him of the clandestine meetings. He forbade his daughter to see Chang since he was deemed beneath her status. The father banished Chang from his property under the threat of death. What he did not know was that Chang and Koong-se had already promised themselves to one another. The evil old man had a wall built around the gardens to

the water's edge and moved his daughter to rooms that had an exit only through the banquet room, where he would see her if she ventured out. She was in fact imprisoned. Her only confidante, her handmaiden, was dismissed, and her hand was promised in marriage to a noble duke who was unknown to her but whose wealth impressed her father.

On the day the duke was to be introduced to her, Koong-se paced the water's edge and pondered her fate. Then she saw a small boat made from a shell that carried a bead, which she recognized as the one she had given Chang. She knew her lover was close at hand. In the tiny boat, she found that he had written a poem that disturbed her, for she interpreted the poem to be a sign that he would destroy himself if he could not be with her. She scratched a message for him to not despair and in the darkness of night sent the boat into the waters. Time passed and she wondered if her message had been received or had floated endlessly.

Could it be that her fate had been sealed? One day her father came joyously carrying a chest of jewels and announced that the duke would be visiting that very evening to complete plans for their marriage. She could not be in greater distress, and when the duke arrived, she sat in silence while the old man and duke drank wine in celebration. But Chang had crossed into the gardens with the duke's entourage, and as Chang and Koong-se attempted to steal away into the night, they were seen. The old man and the duke, in a drunken stupor, pursued them across the bridge. Koong-se and Chang made their way to the home of her former handmaiden and were given refuge. But the duke and the old man were unrelenting and announced that Chang should be put to death for stealing the jewels of the duke, although it was Koong-se who carried the jewels unbeknownst to Chang. As the authorities besieged the home of the handmaiden, Chang fled and threw himself into the river. All thought that Chang had been swallowed up by the river's current, but Chang later returned for Koong-se and they made their way to a distant island, where as time passed Chang gained fame for his writings. The old man learned of his fame and the duke sent guards to the distant island with instructions to kill Chang and bring Koong-se back. This was not to be, for Chang fought bravely but was killed. In distress, Koong-se locked herself in their home, set it on fire, and perished. It is said that Koong-se and Chang were transformed into two doves that symbolize fidelity while the duke died of a terrible illness, alone and childless.

Wish-Granting Jewel

In Sanskrit, the wish-granting jewel is called *ratna* or *mani*. In Buddhism, it symbolizes the trinity and represents the jewel of riches and generosity. It is sometimes seen in sculptures as a colored ball. *Mani* means free from stain or impurity and is

represented by a pearl. In Chinese art, the pearl is sometimes depicted with flames, to symbolize the dispelling of evil, and sometimes without.

There are seven Buddhist jewels represented in Chinese art:

- **Golden wheel**, which represents universal perfection of the law
- *Mani* or **jewel**, which grants wishes
- **White horse or sun steed**
- **White elephant**, the royal mount that stands for the propagation of the doctrine
- **Royal consort or ideal woman**
- **Perfect military leader**, whose sword represents knowledge against the enemy
- **Perfect civil officer**, whose generosity fights against poverty and whose justice is for all

Wolf

The wolf exists in the northern areas of China and is highly destructive to the relatively poor residents of these areas. Hence, the wolf is a negative symbol often standing for being treated unjustly by those in power and being unjustly taxed. The wolf is rarely depicted in Chinese art because of its negative connotations.

Women in a Garden of Flowers

Depictions of women in the garden with flowers have an erotic connotation, suggesting the hope of attracting a butterfly, the male.

Xi

Xi is the Chinese character for joy. The character itself and its many stylized forms are utilized as symbol of a wish for joy.

Xi Wang mu

The mythological Queen Mother of the West is Xi Wang mu of the Kunlun Mountains. Although she appears in the late Shang, early Han dynasty, her name appears on early oracle bones of the thirteenth century. As the Queen Mother of the West, she initially is described in early writings of the second century B.C.E. in unflattering terms, for example, as a deity with unkempt hair and fangs. In somewhat later depictions, she assumes the regal qualities more befitting her position as a Daoist

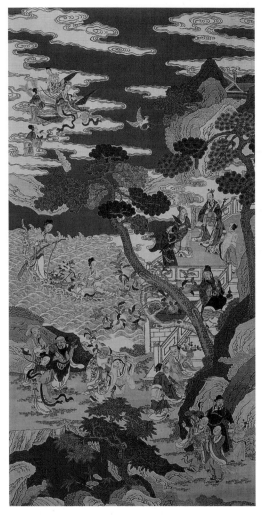

Birthday party of Xi Wang mu.
Kesi tapestry,
Ming dynasty (1368–1644).
Chris Hall Collection Trust.

goddess who uses her sacred crane to travel between heaven and earth. She is also known as *Jinmu,* or Metal Mother, since she is associated with the element metal and is recorded as being the ruler of the Western Paradise. It is she who holds the herbs of immortality and grows the peaches of longevity in her garden. The fruit was said to ripen only once every ten thousand years, on the birthday of the Queen Mother, at which time all of the other gods were invited for the celebration. She has the ability to confer immortality.

Her emblems are the bluebirds, who gather berries for her to eat from the void of the north, and the panther. Since the Yuan dynasty (1260–368 B.C.E), one of the key iconographic symbols that identifies her in depictions is a phoenix in her head-dress. She is known as a divine teacher and one who can control longevity (symbolized by her association with peaches) and therefore the length of one's life. This power has contributed to her remaining a goddess who is worshiped even today in China and Taiwan. She is further associated with virtue and integrity.

Xianglong Lohan

Among the great lohans, there was one who tamed the dragon that later became a disciple and companion known as Xianglong Lohan. Xianglong Lohan means "the lohan who subjugates a dragon"; it is a symbolic reference to human emotions.

According to Tibetan literature, Xianglong Lohan is the fourth of the sixteen (or eighteen) lohans and his name is Jialijia.[80] He symbolizes the need for control of one's emotions. If one is on the good path of helping others, one's bad emotions must be controlled.

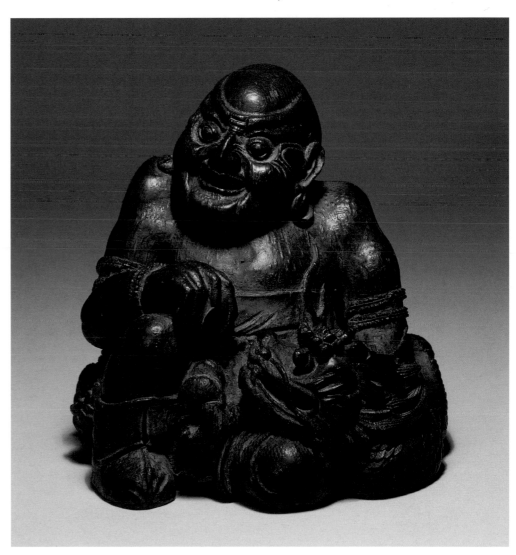

□ Xianglong Lohan. Bamboo, seventeenth/ eighteenth century. Ji Zhen Zhai Collection.

Xuanwu

Xuanwu is known as the Guardian of the Four Quarters (or Directions) and is associated with the north. During the Han dynasty, he was known as Xuanwu but underwent a transformation during the Northern Song dynasty and became the Perfected Warrior, Zhenwu (*see* Zhenwu).

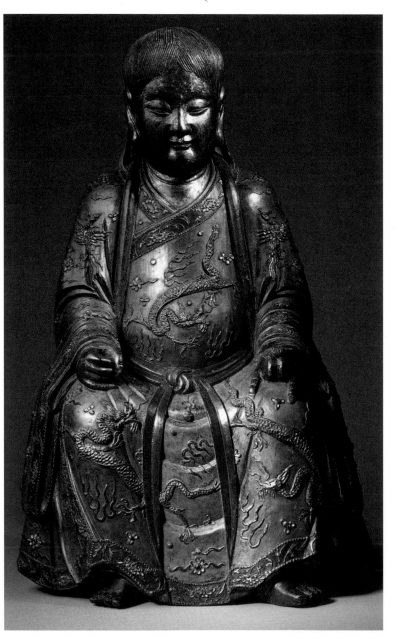

▫ Xuanwu.
Lacquer, 1732.
Gerard Hawthorn, Ltd.

Yarrow

Yarrow, *ai*, or artemisia is one of the Eight Ordinary Symbols. It was a folk belief that yarrow would drive away poisons. Therefore, on the fifth day of the fifth month, it was customary to place yarrow on the door of one's home. The artemisia leaf became a common decorative motif, particularly during the eighteenth century (*see* Artemisia Leaf).

Yin and Yang

Yin and yang, symbolized by an egg containing two opposing equal elements, are the negative and positive principles of universal life ascribed to ancient Chinese cosmology. Its principles are based on belief that the universe is run by a single principle, the Dao, which is then separated into two opposing forces, yin, ascribed to female, and yang, ascribed to male. All forces in the universe can then be ascribed to one of these two forces. From yin and yang, came the five elements: water, fire, metal, earth, and wood. All phenomena can be understood by using the yin-yang principle and the five elements.

The cyclical nature of yin and yang and opposing forces of change demonstrate that all phenomena can change into their opposites in an eternal cycle. Since one principle produces another, all phenomena have within themselves the seeds of the opposite. No one phenomena is devoid of its opposite. These principles are presented in the two oldest recorded books of the Chinese, *Yi Jing (The Book of Changes)* and *Shi Jing (The Book of Odes).*

Yu Long (Fish Dragon)

The carp, which appears in partial dragon form, is called a Yu Long dragon. It represents a carp that is ascending into the heavens as a dragon and is a lucky sign for scholars who hope to pass the Civil Service Examination. To dream of the Yu Long is a lucky omen. It portends success because the carp ascended into the sky and returned a dragon.

Zhaijie

Zhaijie literally means fasting and purification. Imperial pendants with the characters for *zhaijie* on one side and Manchu characters on the other side were worn over sashes during Buddhist ritual holidays to remind the wearers to fast for purification (*see* Sash).

Zhang Qian

Zhang Qian was an explorer during the Han dynasty. He is most commonly depicted in a river raft in carvings of jade and wood and as well as in paintings. Tales of his pursuits were legendary and have been incorporated into folk stories, one being of his travels down the Heavenly River. The legend tells how he traveled for seven days and seven nights up the Yellow River, discovering all of the animals of Chinese mythology. On the seventh night, he found no stars reflected in the river. The next day, he saw a woman weaving the net of the zodiac, but when he asked her name and where he was, she replied that he should consult with the stargazer upon his return. He then knew that he had traveled the length of the Yellow River as far as the Milky Way that continues on to heaven as identified by the goddess Qi Nu.

Zhang Qian later became a Daoist immortal and symbolized striving with nature. He is usually depicted in flowing open robes, relaxing in his raft, and carrying the elixir of immortality in a gourd tied about his waist.

Imperial *zhaijie* toggles.
Stained ivory,
Yongzheng period (1723–35).
Ji Zhen Zhai Collection.

Zhenwu

Zhenwu is known as the Daoist god, the Perfected Warrior. In the Han dynasty, he was known as Xuanwu and is symbolized by a tortoise encircled by a snake. He represents the north on building tiles, while the dragon is found on the east, bird on the south, and tiger on the west. It wasn't until the Song dynasty that Zhenwu achieved the status of the Perfected Warrior, which was associated with healing, because he was said to have healed the Emperor Renzong. In the Ming dynasty, he became the most popular Daoist god, even greater than the deified Laozi (Lao-tzu). At that point not only was he associated with healing but also with the protection of the country and the emperor. A temple dedicated to Zhenwu stands in the Forbidden City. There is also a Daoist temple devoted to him in Kaifeng.

Statues of Zhenwu, usually depicting him as a seated figure, were not uncommon during the Ming and early Qing dynasties. Frequently he is mistakenly identified as a simple official, but his long hair and bare feet distinguish him. Sometimes he has the attribute of a sword by his side, the symbol of purification and exorcism.

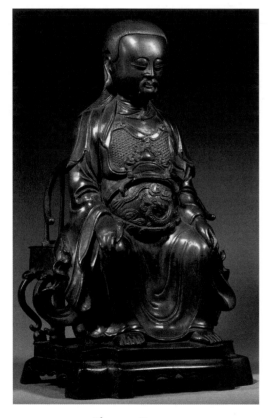

□ Zhenwu. Bronze,
sixteenth century.
Gerard Hawthorn, Ltd.

Zhong Kui

Zhong Kui is known as the Demon Queller, and his legend existed as early as the Tang dynasty. During the Song dynasty, he was absorbed into the Daoist group of gods. Zhong Kui is depicted as a fierce, wild-eyed man who wields a sword to drive away the evil spirits. Folktales record that he is associated with the number five, referring to the Five Poisons that he subjugates on the fifth day of the fifth month of the Chinese calendar.

A famous folktale tells how the Tang dynasty Emperor Xuanzong fell asleep after a day of archery practice. He began to dream and in his dream, he saw a small demon that went around the palace grounds stealing things. When the emperor approached him and confronted him about his stealing, the demon replied that he was Xu Hao, *xu* meaning stealing indiscriminately for fun and *hao* meaning replacing man's joys with sorrows.

The angered emperor was about to call his guards to arrest this thief when a larger demon appeared and captured the thief, tore him to shreds, and ate him. When the emperor asked his name, he said he was Zhong Kui, the Demon Queller, who had failed his Civil Service Examination and committed suicide by smashing his head against the palace steps. Because he vowed that he would rid the world of evil demons, the Emperor Xuanzong gave him an honorable burial. Just then the emperor awoke and summoned his court painter so that he would paint Zhong Kui

as he had seen him in his dream. The painter produced a painting of Zhong Kui just as the emperor remembered him; the painter was rewarded with gold. And so began the tradition of painting Zhong Kui, which became highly popular, particularly during the late Qing Dynasty.

Zodiac

There are countless folktales of the origins of the zodiac. One tells that it originated in the ancient Chinese art of divination and character reading. Emperor Huang Di in 2637 B.C.E. is said to have introduced the first cycle of the zodiac. This character reading is said to have developed along with the Chinese writing that was connected with philosophy. Influenced by the classical philosophy of Confucius, Laozi (Lao-tzu), and the *Yi Jing,* according to Chinese legend, the order of the twelve signs was determined by Buddha. One story tells that Buddha invited all animals to attend a celebration for the New Year; however, only twelve attended. The first to arrive was the rat who jumped off of the back of the ox so it could be first. The ox, serious and industrious, was second, and then came the tiger and cat. The dragon, outspoken, came shortly before the snake, which was philosophical. The horse arrived with the goat (or sheep/ram), the monkey soon after, and then the rooster, and finally the dog and pig. Buddha gave each animal a year of its own, matching each with its personality.

Another story tells how Buddha called all animals to his bedside but only twelve arrived. To honor the twelve that appeared, he created a year for each of them because they were so devoted, and matched their characteristics with the year chosen. Yet another story tells how the twelve animals quarreled as to who would head the cycle of years. The gods were asked to decide the results of a swimming contest across a river, each to be assigned a year in order of their finish. All of the animals jumped in, but the rat jumped on the back of the ox. Just as the ox was to finish first, the rat jumped from his back and won. The pig, the laziest, finished last.

What is known is that there are Twelve Terrestrial Branches with corresponding points of the compass, and each is assigned a symbolic animal (*see* Twelve Terrestrial Branches). Writings from the Tang dynasty mention the denoting of years with the names of animals, but it was not until the Mongol dynasty in 1371 that the use of animals to signify years became popular.

□ Detail of painting of Zhong Kui by Wang Zhen (1896–1936). Private Collection.

REBUSES AND CHINESE CHARACTERS

SYMBOL	REBUS		
☐ Auspicious animals	rui shou	瑞獸	
☐ Badger	huan tian xi di	歡天喜地	badger with magpie flying
☐ Bamboo	zhu jie xu xin shi wo shi	竹節虛心是我師	
	gao feng liang jie	高風亮節	
	zhu mei shuang xi	竹梅雙喜	
	zhu bao ping an	竹報平安	
☐ Bat	hong fu qi tian	洪福齊天	
	fu dao yan qian	福到眼前	
	wu fu	五福	
	wu fu peng shou	五福捧壽	
	fu shou shuang quan	福壽雙全	
	fu qing	福慶	
	shuang fu	雙福	
	wan nian lian fu	萬年連福	
	fu dao	福到	
	hong fu	洪福	
☐ Bean curd	dou gan	豆干	
	da guan	大官	
☐ Bee	wu gu feng shou	五穀豐收	bees depicted in art form express a wish for a good harvest of the five grains.
☐ Birds with long tail feathers	dai dai shou xian	代代壽仙	shoudainiao, rock, and daffodil have the meaning of every generation in the family enjoy
☐ Boat	guan dai chuan liu	冠帶傳流	
☐ Bok choy	qing qing bai bai	清清白白	

☐ Books	shang shu hong xing	尙書紅杏	
☐ Box	he he ruyi	和合如意	
☐ Brush	bi ding ruyi	必定如意	
	bi zhong	必中	
☐ Buddha's hand	duo fu duo shou duo zi	多福多壽多子	
☐ Butterfly	mao die	耄耋	
	liu die	六蝶	six butterflies
	liu die	六耋	old age
	hua jia zi	花甲子	
☐ Cake	nian nian gao sheng	年年高昇	
	nian gao	年糕	
☐ Camellia	chun guang chang hou	春光長候	
	chun guang chang ju	春光常駐	
	chun guang chang shou	春光長壽	
☐ Carp	jin yu man tang	金玉滿堂	
	jin yu tong he	金玉同合	
☐ Cassia tree blossoms	chang gong zhe qui	蟾宮折桂	chang (toad) gong (palace) zhe (break) qui (cassia tree)
☐ Cat	shuang huan	雙歡	
	shuang xi	雙喜	
☐ Catfish	nian nian wan fu	年年萬福	
	wan wan nian hong fu	萬萬年洪福	
☐ Chestnut	zao li zi	早立子	
☐ Chicken	gong ming fu gui	功名富貴	
	qiao zu er dai	蹺足而待	
☐ Children	si xi	四喜	
	wu zi deng ke	五子登科	
	chang chun bai zi	長春百子	

Coin	ya sui	壓歲	
	lian san yuan	連三元	three coins on a string.
Crab	er jia chuan lu	二甲傳臚	
Crane	song he tong chun	松鶴同春	
	liu he	六合	deer and crane; universe
	he lu tong chun	鶴鹿同春	
Cricket	guan jiu yi pin	官居一品	cricket and chrysanthemum
Date	zao sheng gui zi	早生貴子	
Dragon	yi long jiu zi, ge zi bie	一龍九子各子別	
Duck	yi jia lian ke	一甲連科	duck in the reeds
	yi jia yi ming	一甲一名	duck with a reed
Eagle	ying xiong	英雄	
Egret	yi lu	一鷺	one egret
	yi lu	一路	one road or all the way
Elephant	tai ping you xiang	太平有象	
	qi xiang	騎象	
	ji xiang	吉祥	
	ping an	平安	vase and saddle
Five Blessings	wu fu lin men	五福臨門	
	wu fu he he	五福和合	five bats and box
Flowing water	shan gao shui chang	山高水長	
Goldfish	xi jian da li	喜見大利	
Gourd	hu lu	葫蘆	
Halberd	ping sheng san ji	平升三級	
	ji qing he ping	吉慶和平	
	yi ding sheng gui ji	一定升三貴級	
Hanging sonorous stone	ji ching ruyi	吉慶如意	

◻ Hat	dai zi shang chao	帶子上朝	
	zhuang yuan ji di	狀元及第	
◻ Heron	yi lu lian ke	一路連科	
◻ Hibiscus	yi lu rong hua	一路榮華	hisbiscus and heron
◻ Jue	tai shang liang jue	抬上兩爵	
	jue lu chong gao	爵祿崇高	
◻ Lantern	feng deng	豐登	
◻ Lily	bai he	百合	
	bai shi ruyi	百事如意	
◻ Lingzhi	ping an ruyi	平安如意	lingzhi and vase
◻ Lions	jiu shi tong ju	九世同居	
	shi shi ruyi	事事如意	
	tai shi shao shi	太師少師	
◻ Liu Hai	Liu Hai xi jin chan	劉海戲金蟾	Liu Hai with toad
	Liu Hai sa qian	劉海撒錢	Liu Hai with coins
◻ Lotus	nian nian you yu	年年有餘	
	lian zi	蓮子	lotus seeds
	lian zi	連子	having sons consecutively
	yi lu lian ke	一路連科	
	ci he	慈和	
	xi de lian ke	喜得連科	one rise further and further
	yin he de ou	因合得偶	lotus and rootstocks
◻ Magnolia	yu tang fu gui	玉堂富貴	
◻ Magpie	zhu mei shuang xi	竹梅雙喜	
	xi shang mei shao	喜上梅梢	magpie at the top of a plum
	xi shang mei shao	喜上眉梢	happiness before your face
	xi zai mei shao	喜在梅梢	magpie at the top of a plum
	xi zai mei shao	喜在眉梢	happiness up to the tips of one's eyebrows

	xi huan	喜歡	
	xi de bai zi	喜得百子	joy of having many sons
	shuang xi	雙喜	two magpies
▫ Maple tree	feng hou gua yin	封侯掛印	
	an ju le ye	安居樂業	quails, chrysanthemum, maple tree, and fall leaves.
▫ Mirror	hong yun gao zhao	鴻運高照	
	tong xie	同鞋	
▫ Monkey	ma shang feng hou	馬上封侯	
	feng hou bao shou	封侯抱壽	
	bei bei feng hou	輩輩封侯	
	feng hou	封侯	
▫ Mountain	shan chang shui yuan	山長水遠	
▫ Musical stone	fu qing	福慶	
	fu shou	福壽	a bat with peach
▫ Nandina	zhi xian zhu shou	芝仙祝壽	
▫ Narcissus	qun xian zhu shou	群仙祝壽	
▫ Nine	jiu jiu	九九	nine nine
	jiu jiu	久久	a long time
▫ Panther	bao xi	報喜	
▫ Peach	fu ru dong hai, shou bi nan shan	福如東海壽比南山	
▫ Peacock	que ping zhong xuan	雀屏中選	
▫ Peony	rong hua mu tan	榮華富貴	hibiscus and peony
	mu tan man tang	富貴滿堂	wild apple and peony
▫ Persimmon	shi shi ji xiang	事事吉祥	
	bai shi ji li	百事吉利	
	li shi	利市	
▫ Plum blossom	ping an ruyi	平安如意	

Pomegranate	liu kai bai zi	榴開百子	
	shi liu kai xiao kou	石榴開笑口	
Qilin	qilin song zi	麒麟送子	
Qin	yi qin yi he	一琴一鶴	May you be a good official.
Quail	an jiu	安居	
	shuang an	雙安	
Ram	san yang	三羊	three rams
	san yang	三陽	new start
	san yang kai tai	三陽開泰	
Rooster	gong ming	功名	
	guan shang jia guan	官上加官	cock with cockscomb flower
	jiao wu zi	教五子	
Ruyi	ping an ruyi	平安如意	
	shi shi ruyi	事事如意	
Sacred Lily	wan nian ruyi	萬年如意	
Shoe	tong xie	同鞋	
Shou Lao	fu lu shou xi	福祿壽喜	
Spider	zhi zhu	蜘蛛	
	xi zai yan qian	喜在眼前	
	xi cong tian jiang	喜從天降	
Three Friends of Winter	sui han san you	歲寒三友	
Three luck fruits	san duo	三多	
Toad	ding cai liang wang	丁財兩旺	
Vase	sui sui ping an	歲歲平安	grains and vase
	si ji ping an	四季平安	
	ping sheng san ji	平升三級	
Wan	nian nian wan fu	年年萬福	

Endnotes

Introduction

1. *Webster's Third New International Dictionary of the English Language Unabridged*, S.V. "symbol."

2. Schuyler Cammann, *China's Dragon Robes* (Chicago: Art Media Resources, Ltd., 1952), 107.

Symbols from A to Z

1. Cammann, *China's Dragon Robes*, 95.

2. Qian Chaochen, *Shanhaijingshu (Stories of the Book of Mountains and Seas)* (Xinhua, Beijing, China: Zhongguohuaqiao Publishing Co., 1991).

3. Cammann, *China's Dragon Robes*, 129.

4. Jiaju Ma, *100 Ancient Chinese Miniature Stories* (Taiwan: Hua Hsia Publishing Co., 1995), 41.

5. Cammann, *China's Dragon Robes*, 102.

6. Feng Menglong, *Feng Menglong Quanji-Qingshi (Complete Works of Feng Menglong: History of Romance* (Jiangsu, China: Jiangsu Ancient Book Publishing, 1993), 328. Wang Tzejun, *Zhongguo Yanqingxiadaguan (Collected Works of Chinese Romance Novels)* (Chengdu, Sichuan, China: Chengdu Publishing Co., 1992), 346.

7. Louise Allison Cort, and Jan Stuart, *Joined Colors* (Washington D.C.: Arthur M. Sackler Gallery, Smithsonian Institute, 1993), 56.

8. Helen White, *Snuff Bottles from China* (London, England: Bamboo Publishing, 1990), 144.

9. Language Research Association, *A New Chinese-English Dictionary* (Hong Kong: Guangtai Publishing, 1983), 154.

10. James Watt, *Chinese Jade from Han to Qing* (New York: Asia Society-Weatherhill, 1980), 50.

11. Cammann, *China's Dragon Robes*, 106

12. Cort and Stuart, *Joined Colors*, 53.

13. Li Xueying, and Shu Tong, *Zhongguo Chuantong Tuanshangxi (Appreciation and Analysis of Traditional Chinese Graphical Motifs)* (Hebei-Xinhua, China: Hebei Art Publishing, 1994), 314.

14. Kyoto National Museum Bulletin, no. 4. (March 1982).

15. C. A. S. Williams, *Outlines of Chinese Symbolism and Art Motives* (1941; reprint, Rutland, Vt.: Charles E. Tuttle, 1981), 72.

16. *Zhongguo Jixiang Tu'an* (1978), 478.

17. Zhai Sidao. *Kai Yuan Tian Bao Yi Shi (Affairs of the Period of Tian Bao, 742–759 C.E)* (Thirteenth century; n.p.; Beijing: Sichuan Xinhua Shi, 1990).

18. Chen Shijiang, *Fodianjingjie (Special Analysis of Buddhist Scriptures)* (Shanghai, China: Shanghai-Xinhua, 1992), 536.

19. Stephen Little, *Taoism and the Arts of China* (Chicago: Art Institute of Chicago, 2000), 115.

20. Cammann, *China's Dragon Robes*, 78.

21. Watt, *Chinese Jade*, 20–21.

22. Wang Li, et al., *Shenxiangshijie (World of the Deities)* (Shanghai, China: Shanghai-Xinhua, 1990), 518–520.

23. Little, *Taoism and the Arts of China*, 139.

24. Williams, *Outlines of Chinese Symbolism*, 292.

25. Rosemary Scott, *Imperial Taste: Chinese Ceramics from the Percival David Foundation* (Los Angeles: Los Angeles County Museum of Art, 1989), 19.

26. Alfreda Murck, "Images that Admonish," *Orientations Magazine*, June 2001, 54.

27. Liu Donsheng, et al., *Zhongguoleqituzhi (Records of Chinese Musical Instruments with Illustrations)* (Xinhua, Beijing, China: Light Industry, 1987), 25, 282–83.

28. Cort and Stuart, *Joined Colors*, 40.

29. Anne Birrell, *Chinese Mythology: An Introduction* (Baltimore, Md.: John Hopkins University Press, 1993), 44.

30. Dorothy Ko, *Every Step a Lotus* (Toronto, Ontario, Canada: The Bata Shoe Museum Foundation, 1957), 32.

31. Schuyler Cammann, *Substance and Symbols in Chinese Toggles* (Pennsylvania, Pa: University of Pennsylvania Press, 1962), 115.

32. An Zuo-zhang, *Zhongguo Jiang Xiang Ci Dian (Dictionary of Chinese Ministers and Generals)* (Jinan, Shandong, China: Mingtian Press, 1990), 135.

33. E. T. C. Werner, *A Dictionary of Chinese Mythology* (New York: Julian Press, 1961), 227.

34. Therese Tse Bartholomew, "Botanical Puns in Chinese Art from the Collection of the Asian Art Museum of San Francisco," *Orientations Magazine*, September 1985, 34.

35. Little, *Taoism and the Arts of China*, 267.

36. Wang et al., *Shenxianshijie (World of the Deities)*, 376.

37. Cort and Stuart, *Joined Colors*, 50.

38. Murck, "Images that Admonish," 56.

39. Xu Zhong yu, *Literature of Su Dong po* (Sichuan, China: Si-chuan Xin-hua Shi, 1990), 210.

40. Qian Yuen-mi, *Ben Chao Quan Mu Jing Hua (Important Chinese Herbs and Formulas)*, 2d ed. (Beijing: Quangdong Science & Technology Publishing Co., 1990), 327.

41. Bartholomew, "Botanical Puns," 21.

42. Wang et al., *Shenxianshijie (World of the Deities)*, 312.

43. Chen Shigiang, *Fudianjingjie (Special Expositions on Buddhist Scriptures)* (Shanghai, Xinhua, China: Shanghai Ancient Books Publishing, 1992), 438.

44. Wen Yunchang, and Jingquan Wei, *Zhongguo Yibaijixiangshen: One Hundred Chinese Auspicious Deities* (Beijing: Minzu Publishing, 1994), 85.

45. Williams, *Outlines of Chinese Symbolism*, 163–68.

46. John A. Goodall, *Heaven and Earth: 120 Album Leaves from a Ming Encyclopedia: San-ts'ai t'u-hui* (1610; reprint, London: Lund Humphries, 1979), 167.

47. Cort and Stuart, *Joined Colors*, 56.

48. Wen and Wei, *Zhongguo Yibaijixiangshen: One Hundred Chinese Auspicious Deities*, 33, 34.

49. E. Dale Saunders, *Mudra* (New York: Pantheon Books, 1960), 165.

50. Eva Rudy Jansen, *Ritual Symbolism Used on Buddhist Statuary and Ritual Objects* (Havelte, Holland: Binkey Kok Publications, 1990), 29.

51. White, *Snuff Bottles from China*, 46.

52. Therese Tse Bartholomew, "The Hundred Flowers: Botanical Motifs in Chinese Art," *Asian Art Museum of San Francisco Journal*, no. 46 (1985).

53. Anne Birrell, *Chinese Mythology* (Baltimore, Md.: John Hopkins University Press, 1993), 154.

54. Wolfram Eberhard, *A Dictionary of Chinese Symbols* (New York: Routledge and Kegan Paul, 1986), 230.

55. Cammann, *China's Dragon Robes*, 96.

56. Birrell, *Chinese Mythology*, 143.

57. Bartholemew, "The Hundred Flowers."

58. V. R. Burkhardt, *Chinese Creeds and Customs*, vol. 3 (Taipei, Taiwan: Hua Xia Publishing Co., n.d.), 74.

59. Chen Yongzheng, *Zhongguo Fangshu Dacidian (Encyclopedia of Chinese Daoist Techniques)* (Guangdong, China: Zhongshan University Press, 1991), 7.

60. Robert L. Thorp, *Son of Heaven: Imperial Arts of China* (Seattle, Wash.: Son of Heaven Press, 1988), 93.

61. Williams, *Outlines of Chinese Symbolism*, 323.

62. Eberhard, *Dictionary of Chinese Symbols*, 240.

63. Wang, et al., *Shenxiangshijie (World of the Deities)*, 33.

64. C. S. Wong, *A Cycle of Chinese Festivals* (Singapore: Malaysia Publishing House, 1967), 29.

65. Saunders, *Mudra*, 172.

66. Will H. Edmunds, *Pointers and Clues to the Subjects of Chinese and Japanese Art* (London, England: Samson Low, Marston and Co., 1934), 254–55.

67. Chen Xiasheng, "Jixiangruyi" ("The Auspicious Ruyi") *National Palace Museum Monthly of Chinese Art* (Taipei, Taiwan) 143 (February 1995): 55; Chiang Futsong, *Introduction to Masterpieces of Chinese Ruyi Scepters in the National Palace Museum* (Taipei, Taiwan: National Palace Museum, 1974), 47, 51; Zhong Yonglin, "Ruyi," *Hong Kong Sunday Weekly*, 18 September 1994, 76–77.

68. Chiang, *Masterpieces of Chinese Ruyi Scepters*, 88–90.

69. Chen, "Jixiangruyi," ("The Auspicious Ruyi"), 66–75.

70. Jiang Zihua, *Giushenxue Cidian (Encyclopedia of Ghosts and Immortals)* (Shensi Xinhua, Sian, China: Shensi Renmin Publishing Co., 1992), 44, 79.

71. Dieter Kuhn, "Silk Weaving in Ancient China: From Geometric Figures to Patterns of Pictorial Likeness," *Chinese Science* 12 (1995); 80.

72. Little, *Taoism and the Arts of China*, 271.

73. Ibid., 131.

74. Murck, "Images that Admonish," 55.

75. Thomas Wilson, *The Swastika* (Washington, D.C.: Smithsonian Institute, 1894), 779–803.

76. Robert P. Jacobsen, *Imperial Silks: Ch'ing Dynasty Textiles in the Minneapolis Institute of Arts* (Chicago: Art Media Resources, Ltd., 2001), 271–77.

77. Maggie Bickford, "Bones of Jade, Soul of Ice: The Flowering Plum in Chinese Art," *Orientations Magazine*, July 1985, 78.

78. Bartholomew, "Botanical Puns," 21.

79. Little, *Taoism and the Arts of China*, 267.

80. Ge Wanzhang, "The Sixteen Lohans," *National Palace Museum Monthly of Chinese Art* (Taipei, Taiwan) 156 (March 1966).

Index